EDWARDSVILLE PUBLIC LIBRARY
112 South Kansas St.
Edwardsville, IL 62025

My brother's keeper

My brother's keeper

Documentary Photographers and Human Rights

contrasto

© 2007 Contrasto Due srl
Via degli Scialoia 3, 00196 Roma
www.contrastobooks.com

© 2007 Unione Tipografico-Editrice Torinese
Corso Raffaello 28, 10125 Torino
www.utet.com, utet@utet.it

Photographs by
© Bob Adelman; © Gianni Berengo Gardin / Contrasto;
© Carla Cerati; © Luciano D'Alessandro; © Lucinda
Devlin / Courtesy Galerie m Bochum; © Donna Ferrato
/ Grazia Neri; © Marc Garanger / Corbis; pages 50
(below), 52,53,54 © Lewis Hine / Hulton Archive / Getty
Images / Laura Ronchi; page 51 © Lewis Hine / Time
& Life Pictures / Getty Images / Laura Ronchi; pages
49, 50 (above), 55 © Lewis Hine / Bettmann Archive
/ Corbis; © Ulrik Jantzen / Das Büro; © Philip Jones
Griffiths / Magnum Photos; © Igor Kostin / Corbis;
© Josef Koudelka / Magnum Photos; © Li Zhensheng
/ Contact / Grazia Neri; © Peter Magubane; © Juan
Medina / Reuters; © Gilles Peress / Magnum Photos;
© Raghu Rai / Magnum Photos; pages 35, 37, 38, 39
(below) © Jacob Riis / Hulton Archive / Getty Images /
Laura Ronchi; pages 36,39 (above), 40, 41 © Jacob Riis
/ Archivio Bettmann / Corbis; © Sebastião Salgado /
Amazonas Images; © David Seymour / Magnum Photos;
© W. Eugene Smith / Magnum Photos; © Tom Stoddart
/ Hulton Archive / Getty Images / Laura Ronchi.

Texts © the authors

Cover image: Chilanga, Zambia 2002,
photograph by Tom Stoddart

Editor
Alessandra Mauro

Editorial Staff
Suleima Autore
Franca De Bartolomeis
Alessia Tagliaventi
Alice Tudino

Translations
Dalia Habib
Maria Lanzarotti

Graphic design
A+G Design

Layout
Daniele Genchi

ISBN 978-88-6965-061-1

Distribution:
Thames and Hudson
for North America:
Consortium Book Sales & Distribution

Printed in Italy by EBS, Verona

Summary

This book is the fruit of the collaboration between Utet and Contrasto. The initial Idea was conceived within the Utet "Human Rights" project directed by Marcello Flores, and collaboration between editors has rarely been so free, intense and rewarding. Editing was carried out together with Franca De Bartolomeis, thanks to her sharp sensibility and in-depth knowledge of photography. Alessia Tagliaventi and Alice Tudino contributed enthusiastically to the iconographic research and wrote the presentations of the authors (their names can be found at the end of their respective texts). Susie Linfield gave her complete support to the project showing the true meaning of clarity and method. All the authors involved, the heirs and agencies that represent them responded to our requests with full participation. Our heartfelt thanks to all. *a.m.*

_Introduction

Marcello Flores

Marcello Flores[*]
Introduction
Images and the culture of rights

If, despite delays and contradictions, the culture of human rights has managed today to become a necessary aspect of contemporary public discussion, the impact of images deserves a great part of the credit in spreading and rendering that culture readily perceptible and comprehensible with a strength that is both emotional and descriptive.

From its outset the history of photography has been closely connected with contemporary war and how it developed from the mid-nineteenth century right through the twentieth century. The events of war have been crucial, directly and indirectly, to the establishment and reinforcement of the culture of human rights. This aspect alone would be sufficient to demonstrate the position of absolute importance held by the relationship between photography and rights, between human rights and images.

The violation of rights is, in real terms, the area that image has brought into common consciousness and public discussion with an impact that cannot be compared to thirty or even fifteen years ago, let alone a century. When human rights were not a central theme in political debate and collective movements – during the sixties and seventies, when, apart from the US civil rights movements, a hypothesis of revolutionary palingenesis or radical social reform prevailed – some images consolidated the very idea of violence, injustice, horror, abuse of power, humiliation and the violation of human dignity.

My generation, hardly exposed as today's youth to the images of piled up corpses and skeletal survivors of the Nazi death camps, matured thanks to one of the few images that became the symbol of an era: the appalling and heartbreaking photograph of Kim Phuc, a nine-year-old Vietnamese girl who, on 8 June 1972, fled naked from the horror of her village destroyed by napalm, while the armed marines behind her seemed indifferent to the violence committed by their fel-

* Professor of Comparative and Contemporary History, University of Siena, Director of Master in Human Rights and Humanitarian Action.

low soldiers. An icon of the war, the "girl in the picture", as she became known from a book that told her story (Denise Chong, *The girl in the picture. The story of Kim Phuc and the War in Vietnam*, Codice edizioni, Turin, 2005), was a new image of war, different from those that were created and consolidated during the Second World War, or before that during the Spanish Civil War or even the First World War.

The best known photographs of the wars before Vietnam, though diverse and numerous, have the collective destructiveness produced by war as a common feature, even when the images deal with single individuals. The physical destruction of cities and villages, pity for the fallen, homage to the courage of those who fight for freedom and scorn for attacking armies and the powers they represent: these are the most common sentiments consolidated in collective memory by the images of the most destructive "total war" of human history.

During the seventies perception and sensitivity regarding violence, whether caused by war or dictatorship, oppression of minorities or groups considered inferior or unworthy, and discrimination of every kind (sexual, religious, cultural, ethnic or social) had been modified, though still held hostage by the ideological and political contraposition of the Cold War. When compared to the years just after the war, the cultural detachment of the sixties favoured a more attentive and innovative reflection regarding the Shoah. We were repressed in collective consciousness during the first two decades after the war, though 1948 did play a crucial role in attaining the revolutionary formulation of the Universal Declaration of Human Rights.

Frozen for the most part in the context of the Cold War, or exploited by the two superpowers for the propagandistic advantage to create consensus among the independent countries of their respective blocs, during the seventies the message of the Declaration found a new lease of life, acquiring a central position during the Conference on Security and Cooperation in Europe. This concluded on August 1st, 1975, with the Helsinki Final Act, the third section of which is expressly devoted to human rights.

Another fifteen years would have to pass, until the fall of the Berlin wall and Soviet communism, so that the end of the Cold War could leave room for a new "universal" discourse in place of the ideologies that had clashed for about half

a century. The liberalist presumption (parliamentarianism plus market) that the historical battle had been won, thus forming a "unified idea", clashed with a reality where, alongside the democratic transition of dozens of new countries that had once been under authoritarian regimes, new conflicts began, new tragedies, new contradictions. The wars in ex-Yugoslavia, the genocide in Rwanda, the growing inequality between north and south, the consolidation of religious fundamentalism, the lack of answers to environmental issues, the negligent delay in tackling new pandemics which science could easily control and resolve, and, finally, the threat of international terrorism and the perverse and ineffective response called preventative war all represent just the tip of the iceberg.

In this sphere the "culture of rights", that body of regulations, conventions and treaties which followed the 1948 Declaration to better define areas of intervention and specify objectives for some particularly important groups and issues, has undergone a new phase of theoretical intensity and grounded intervention, with a disproportionate increase of people battling, through NGOs and International Institutions, to extend rights and ban violations wherever they occur.

While the considerations of jurists and the decisions of international tribunals extend the field and range of human rights and philosophers, historians, economists and psychologists seek fresh understanding of the roots of violence and resistance, humiliation and the quest for a common dignity. Public opinion also seems better informed and touched – emotionally and intellectually – by events and realities that have their focal point in issues of human rights.

It has often been a matter of late or selective information, privileging closer regions or areas where western involvement has been more evident and consistent. A matter that centers more on the victims and sympathy for their plight than on identifying those responsible and the possibility of effective intervention to resolve or alleviate emergencies. However, though partial and reductive, the mere existence of this perspective has been a major contribution to increasing awareness regarding themes, concepts, events and personal histories, which, in turn, has allowed the greater public to become familiar with the new and difficult universalism of human rights.

Human rights have become, at least from the mid-seventies onwards, a body of formally recognised principles officially accepted by the international com-

munity – though in the thirty years plus that have passed since the Helsinki Agreement, the terrible violations and collective tragedies that public opinion has impotently witnessed, or become aware of too late, have been numerous, excessive, and unjustifiable when we consider the possibility we had of averting them. The most important collective battles have been conducted by appealing to human rights and have led in Eastern Europe, Southern Africa, Asia and Latin America – to a democratic transformation, however incomplete or at times partial, of the majority of the world's governments and states. Most of the new constitutions that have been adopted – or reformed or updated – all over the world in the last fifteen years have centered on the solid nucleus of human rights, finding consensus and seeking guidelines for civil society in this new historical era dominated by globalization.

The language of human rights, at times in a distorted manner that abuses its very meaning, has come to be part of our daily lives, a part of the values that we try to convey to younger generations and incarnate in appropriate behaviour. It is more and more present in literature and cinema, research and higher education, as well as in the fields of information and mass communication.

It could not have been possible, since this development had indeed taken place in a much richer and articulate manner than can be summarized here, for the world of image to remain untouched and not take on a proactive, leading role. Indeed, the increase in quantitative and qualitative attention given by professionals in the field of images to human rights has been uninterrupted and seems, fortunately, destined to persist.

This is what this volume tells us, through a careful and difficult selection of themes and authors. It is not so much a means of portraying, illustrating or accompanying a spoken or written discourse on human rights, but rather an attempt to explain and interpret, in light of the expressive force of the image, the intermingling of knowledge and emotion that it is capable of conveying. This capability is indispensable in that it creates more and more space for the culture of human rights to truly become the universal language of this new century.

_Right under
our eyes

Alessandra Mauro

Alessandra Mauro
Right under our eyes
Examples of photography and denunciation

"Images at their passionate and truthful best are as powerful as words can ever be. If they alone cannot bring change, they can at least provide an understanding mirror of man's actions, thereby sharpening awareness and awakening conscience." With this act of faith in the strength of consciously honest photography Cornell Capa launched his project on concerned photography in 1967, giving space and voice to all those authors who, following the example of Lewis Hine, wished to expose the truth in things, things that needed to be appreciated. Forty years after Capa's words, we still expect to find an undistorted image reflected in the mirror of photography in works that have chosen this means to describe the world and denounce crimes.

The *brother's keepers* who appear in these pages are a group of photographers whose different profiles, aesthetic choices and technical abilities are identifiable from an ample span of time. They have in common the decision, either taken at a precise moment or resulting from a constant vocation and life-defining choice, not to turn away but to commit themselves to precisely revealing violence that needed to be shown, to be corrected.

There are twenty stories in all, and each one is exemplary in its own way. Some are exemplary in the authors' involvement: their determination to get to the bottom of a reality that called for investigation, a social issue, a drama unfolding under the photographer's eyes to which he or she felt the need to bear witness, either through a professional or ethical necessity, or simply because of deep emotional or personal empathy. Others are exemplary through the subjects themselves: the sheer exposition of the violence and emergencies at hand. Finally, these photographic stories call out to other stories and authors, in both past and present, whose work reveals important social issues, often questioning the difference between docu-

mentation and interpretation, editorial requirements and ethical urgency. Many of the stories here were not the fruit of editorial request: no newspaper, at least initially, commissioned them, though the pages of a magazine or daily newspaper provided their first and most obvious platform. We have given space to those photographers who approached their work with awareness and autonomy, free from possible constrictions and influences. We are not dealing with images which became, perhaps against the photographer's will, inadvertently significant to the point of becoming an indispensable historical document (for example the photographs from the nightmare of World War II concentration camps or the Cambodian genocide). On the contrary, every single photograph in this book was conceived from the author's conscious choice to shoot, to show and to tell.

There are times when the denunciation has a clear objective set within a global vision, with precise economic and social implications, as in the work on Vietnam by Philip Jones Griffiths. It may have been, perhaps, an event that completely crushed the photographer, drawing him or her in completely. Perhaps even to the point of risking the photographer's own life, as in the case of Igor Kostin's work on Chernobyl. But, as in the case of Josef Koudelka and the Soviet Invasion of Czechoslovakia, it could also stem from a spontaneous urge to go out into the streets and take pictures simply because the story was unfolding right outside the door, beckoning the photographer. In all cases, the intention has been to use photography to denounce violence with a simultaneous awareness of the limited power of this medium, and a consciousness of its importance in bringing a corrupt image of reality to public attention.

"There can be no doubt," Capa reminded us forty years ago, "that we live in a visual world and there are even less doubts regarding the possible direction of our future". The tireless founder of the *International Fund for Concerned Photography* firmly believed in the photographer's individuality and integrity, as well as the credibility and quality of his or her images: both vital requisites in the possible creation of a visual history of our times.

If we compiled a volume of visual history today, we would reveal a series growing progressively richer, not only in meaning but also in the interpretive contribution of the photographer. For, never before has the attentive and com-

mitted photographer been less inclined to merely shoot what he or she sees. Therefore, bringing a story to light, tearing an image from oblivion, means not only accounting for a fact, a person, a violence, but also conveys a vision, provided this vision is honest, profound and sincere: in the words of Georges Didi-Huberman: "To know, one must imagine." More and more in contemporary photojournalism do we find that to take a part means to interpret, to create a photograph that stands out from the crowd and questions, first the photographer and then the observer, how we perceive and participate in this *visual world* in which, for better or worse, we live.

_The Ethics of Vision

Susie Linfield

Susie Linfield*

The Ethics of Vision
Photojournalism and human rights

"There is no document of civilization which is not at the same time a document of barbarism," Walter Benjamin famously wrote. When it comes to photography, the opposite is also true. Every image of barbarism – of humiliation, terror, extermination – embraces its opposite, though sometimes unknowingly. Every image of suffering says not only, "This is so" – but also, by implication: "This must not be." Every image of suffering says not only, "This goes on" – but also, by implication: "This must stop." Every document of barbarism, by showing us what civilization is *not* – showing us what happens when we allow the world to be "unmade" – reminds us of what civilization is. This is the dialectic at the heart of the photograph.

In the 18th century, the French revolutionists proclaimed the "natural" rights of man and the citizen, and the Americans the "unalienable" right to life, liberty and the pursuit of happiness. In the 19th century, Marx – who, as the critic John Berger observed, "came of age [in] the year of the camera's invention" – conceived of a worldwide proletariat that transcended national borders. But it is in the 20th century – and specifically the post-World War II era – that the consciousness of something called "universal human rights" takes hold. It is in our era that a new claim is made – a claim that would have sounded strange, if not absurd, for most of human history: every person, entirely irrespective of circumstance, is entitled to dignity, safety, protection and freedom.

This idea of human rights emerges precisely because it is not true: precisely, that is, because it has not been made real. We know of human rights – we *conceive* of human rights – because we live in a world in which they do not exist for most of the people on Earth. (As the historian Lynn Hunt wrote, "We are

* Director, Cultural Reporting and Criticism Program, New York University

most certain that a human right is at issue when we feel horrified by its viola-
tion.") The Universal Declaration of Human Rights, approved by the United
Nations in 1948, was born not in the early, optimistic years of the 20th century
but in the aftermath of the destruction of the Jews; born, that is, in the rubble
of a stunned world that had descended into an orgy of depraved violence.

The modern human-rights movement, then, grew not out of pride at what
we accomplished in the 20th century but out of shame, indeed terror, at
what we destroyed. The Holocaust taught us things about ourselves we did
not want to know yet could not afford to disown. "Human rights is not so
much the declaration of the superiority of European civilization as a warn-
ing by Europeans that the rest of the world should not seek to reproduce its
mistakes," the historian and human-rights theorist Michael Ignatieff writes.
"The Universal Declaration set out to reestablish the idea of human rights at
the precise historical moment in which they had been shown to have had no
foundation whatever in natural human attributes."

In this light, the doctrine of human rights represents our attempt to *conquer*
our natures, or at least our history. It is the struggle to create something new
and artificial, not the return to something old and authentic. It is our project
– our life-and-death project – to create a kind of "species solidarity" that is
deeper and stronger than culture, nation or politics.

No one saw the paradox at the heart of human-rights concepts more acutely
than Hannah Arendt. She argued that the person who makes an appeal to
human rights is the person who has been stripped of community and nation:
the person, that is, who is a citizen of nowhere, and who therefore lacks the
political rights that, she believed, were the only real protection against unbri-
dled cruelty. (It is politics, not morality, that sets limits.) In Arendt's view,
only he who has lost everything, and who therefore belongs to nothing, must
call upon something as vague, weak and abstract as "human rights." This lost
person is to be found in the internment camp, the displaced-persons camp,
the refugee camp and, finally, the concentration camp; he embodies not the

noble ideal of the rights-bearing man but the degraded reality of the abandoned pariah. "We became aware of the existence of a right to have rights... only when millions of people emerged who had lost and could not regain these rights," Arendt wrote in "The Origins of Totalitarianism." "It seems that a man who is nothing but a man has lost the very qualities which make it possible for other people to treat him as a fellow-man."

Photographs of suffering perfectly mirror this absence at the heart of human-rights ideals. What do human rights look like? They don't look like anything at all. What does a person with human rights look like? Well, like a person: that's it. What photojournalists can do particularly, peculiarly well is to show how those *without* such rights look.

Some, like Jacob Riis, have depicted a poverty so debased, so all-encompassing, that it reduced its victims to an animal-like existence. Others, like Lewis Hine, shocked a nation with images of child exploitation in packing plants, glass factories and cotton mills – and this at a time when child labor was widely accepted as a natural fact of life (as it still is in many countries today). They have shown us what people struggling for freedom look like: Peter Magubane in apartheid South Africa, recording the revolt of fearless, sometimes jubilant students in Soweto; Josef Koudelka in Prague, during the socialist spring that turned into the bitterest of Stalinist winters; Bob Adelman in the American south, documenting the stoic dignity of the civil rights activists. They have shown us what people at war look like: Philip Jones Griffith in Vietnam as it fought the Americans, Marc Garanger in Algeria as it resisted the French. They have shown us what political madness looks like, as in Li Zhensheng's photos of the orgies of public shame that defined China's Cultural Revolution. They have shown us mass death, as in Gilles Peress's disjunctive, unsettled photos from Bosnia and Rwanda; and the struggle against it, as in Sebastião Salgado's stately, sorrow-drenched images from the manmade famines of the Sahel. And increasingly, they show us the violence that occurs amongst the closest of intimates. We see Donna Ferrato's decade-long series, started in the 1980s, on battered wives in the United States; and Ulrik Jantzen, two decades

later, photographing Bangladeshi women – bleeding, blackened, scarred, screaming – who have been burnt with acid by angry "suitors" and their families as a punishment for refusing marriage.

Photojournalists have shown us a world unfit for habitation. They enlarge our conception of what human beings do to each other, though often in ways that grieve, shame, terrify and disgust us. In doing so they have forced us to envision what a better world, or at least a less-bad world, would be.

The Realism of Suffering

Why are photographs so good at showing us the bad? Partly, I think, because photographs bring home to us the reality of physical suffering; and they do so with a truthfulness – a "this happened-ness" – that neither literature nor painting can claim. They force upon us the often unwelcome news that we are, first and foremost, physical creatures, and fragile ones at that. (Auschwitz survivor Jean Améry wrote of how, under torture, he was amazed to discover that all those attributes that a man might think of as "his soul, or his mind, or his consciousness, or his identity, are destroyed when there is that cracking and splintering in the shoulder joints.") Photographs show us how easily the body can be maimed, shattered, broken, and how pathetically inadequate our defenses against such wounds are. Photographs present us, in short, with human cruelty – unadorned, baffling – and with our vulnerability to it. "The violation of the human body... has a visceral, irrational, and irrevocable quality about it," the Iraqi human-rights activist Kanan Makiya has written. "It is the bedrock under all the layers of horrible things that human beings do to one another." These crimes against the body are also, of course, crimes against the victims' dignity, wholeness, even sanity; what Primo Levi called "the memory of the offense" lives on long after the physical pain has subsided. That ruinous endurance is the point, the function, the *desire* of such assaults. The human body is "the original site of reality," the critic Elaine Scarry wrote. "What is remembered in the body is well remembered."

The photograph of suffering confronts us, too, with the particular, *individual* experience of suffering, and therefore with the aloneness, the lostness, that defines us all. Victims of human-rights abuses are, of course, members of larger groups that are exploited, oppressed, even exterminated. But they experience their pain and their deaths, as do we all, not historically or collectively, but through the prism of their own, unique selves. (This is abundantly evident when we read Holocaust diaries, such as those of Anne Frank and Michael Zylberberg; it is the utter singularity of their voices, not the spectre of "six million," that defines every word they wrote.)

Look, for instance, at David Seymour's "Tereska," a Polish child who survived – or did she? – a Nazi concentration camp: her startled face arrrests us with its suggestion of hidden, unknowable horrors. (I have seen this photo many times, but it never becomes less scary.) Look at Carla Cerati's mental patient as he clutches his shaved head in his hands: their elegant, perfect fingers seem to fight against his anguish. Josef Koudelka shows us crowds in the streets during the Czech revolution (for what is a revolution without crowds?); but he shows us, too, their singular faces: angry, defiant, stoic, worried (for what is a revolution without individuals?). Raghu Rai shows us one tiny, glass-eyed baby, out of so many thousands, killed in the Bhopal disaster – and a solitary hand caressing her dead, doll-like face. Many millions of Africans have died of AIDS, and many millions more will surely do so. Tom Stoddart shows us one Janet John, a Tanzanian woman of 23, though she looks decades older. She is shrunken, bony, with an ear that now looks too big and a jaw that juts out too far. Barefoot and draped in rags, she stares listlessly, bleakly at the floor of her home. She is part of a collective tragedy, yes, but it is the individuality of her desolation – absolute, unredeemable – that engulfs us. It is far easier, I suspect, to think about nameless, abstract millions than to consider the catastrophe that has befallen Janet John, who seems to know that her all-too-early death is near.

Documentary photography's ability to confront us with powerful images of suffering – images that we do not, cannot, always understand or "master"

— has been the subject of much consternation, and inspired sometimes vitriolic attacks. Critics have charged that the photograph of suffering reduces its subjects to objects, exploits them as spectacles, freezes rather than alters power relations, and even re-violates the victims. Photographs of war, violence and poverty, especially when depicting the Third World, have been denounced as neo-colonialist, racist, patronizing, obscene. The human-rights activist Jorgen Lissner, for instance, wrote that the photo of a starving African child "is pornographic, because it exposes something in human life that is as delicate and deeply personal as sexuality, that is, suffering. It puts people's bodies, their misery, their grief and their fears on display with all the details and all the indiscretion that a telescopic lens will allow."

And yet those photographers who have worked hardest to avoid "pornography" and "indiscretion" are fiercely derided also. Take, for instance, Sebastião Salgado, who frequently lives among the subjects of his photographs for long periods. Salgado, a Brazilian economist, has spent decades documenting the Third World's immiserated workers, peasants, refugees and displaced people: the "losers in globalization's great game," as David Rieff aptly put it. Salgado's pictures are imbued not just with respect but with reverence, if not awe. They are painstakingly, dramatically composed; painterly in their use of light; and eerily, undeniably beautiful. And they have been attacked as "sentimental voyeurism," "kitschy," "self-aggrandizing," "meretricious" and even "insulting." In the "New Yorker" magazine, the critic Ingrid Sischy charged: "Salgado is far too busy with the compositional aspects of his pictures – with finding the 'grace' and 'beauty' in the twisted forms of his anguished subjects... This is photography that runs on a kind of emotional blackmail fuelled by a dramatics of art direction."

Too graceful or too clumsy; too beautiful or too ugly; too clear or too confusing... For these critics, the documentary photographer's vision is simply not pure enough, clean enough, platonic enough: it is fatally contaminated by both personal subjectivity and collective history. Indeed, an extraordinary amount of anxiety about the very act of looking seems to engulf if not paralyze contemporary critics and viewers; the postmodern theorist Fredric Jameson is far from

alone when he insists, "The visual is *essentially* pornographic, which is to say that it has its end in rapt, mindless fascination."

These critics seek an unblemished gaze, an innocence of vision that will, presumably, result in images perfectly poised between hope and despair, resistance and defeat, intimacy and distance. They demand photographs that will embody an absolutely equal I-thou relation between photographer and subject. (But where in the world can such relations be found?) They want the worst things on Earth – the most agonizing and unjust things on Earth – to be represented in ways that are, somehow, not radically incomplete, radically imperfect or radically discomfiting. Is there an unproblematic way to show the destruction of a person? Ultimately, what all these angry denouncements of the documentary photo reveal is something both simple and dangerous: a desire *not to look at the world*.

Photography and the New Internationalism

It is truism, indeed a cliché, of modern thought that photographs of suffering desensitize us: the plethora of awful images has, apparently, taken the sting out of horror. In her classic book "On Photography," Susan Sontag claimed, "The shock of photographed atrocities wears off with repeated viewings... In these last decades, 'concerned' photography has done at least as much to deaden conscience as to arouse it." Barbie Zelizer, in her study of Holocaust photographs, similarly argued, "Photography may function most directly to achieve what it ought to have stifled – atrocity's normalization... The act of making people see is beginning to take the place of making people do." Countless other critics have made this point: it defines the conventional wisdom.

And yet the argument remains entirely unproven. It implies that a golden age existed, an age in which people throughout the world responded with empathy, generosity and saving action when confronted with the suffering of others. But when, I wonder, was this utopia? The early 20th century? The 19th century, the 18th – or perhaps the 12th, 9th, or 5th? How, and where, can we find it – and the good Samaritans who presumably used to populate our Earth?

In fact, I suspect that this argument is exactly wrong. For most of human history, most people have known little – and cared less – about the suffering of strangers. "The feeling of humanity evaporates and grows feeble in embracing all mankind," Rousseau observed. "It is proper that our humanity should confine itself to our fellow citizens." (And this from the thinker who invented the phrase "rights of man"!) It is the family, the clan, the tribe, the ethnic group, the religious community or the nation that have traditionally mattered most. They will continue to do so. The only difference is that, today, those outside one's immediate circle of concern occasionally matter too.

And it is the camera – the still camera, the film camera, the video camera and, now, the digital camera – that has done so much to globalize our consciences by bringing the bad news, particularly of war and genocide, to all of us. We know of suffering in far-flung parts of the world in ways that our forebears never could, and the images we see – in some places, under some conditions – demand not just our interest but our response. Far from dulling our senses, photography has been a key component in the creation of what we think of as the modern human-rights consciousness.

Not that photographs and films necessarily prevent, much less stop, atrocities: our innocence on that front ended long ago. No country – western, African, Middle Eastern, Asian or Latin American – was willing to send troops to stop the carnage in Rwanda, nor will they do so today in Sudan. And yet photography has been central to fostering the idea that the individual citizen and the "international community," not the nation-state, is the final arbiter of human-rights crimes. It's impossible to imagine transnational groups such as Amnesty International, Human Rights Watch, or Doctors Without Borders in the pre-photographic age.

The internationalism of our time is, admittedly, peculiar. It takes as its subject not the exploited worker in need of revolution, nor the colonial subject in need of independence, but the victim of massacre, torture or starvation in need of outside intervention. This subject, for good or ill, could come into being – did

come into being – only in tandem with the mass dissemination of photographic images. "What happens in the jails of Kigali, Kabul, Beijing, and Johannesburg has become the business of television viewers across the world," Michael Ignatieff has rightly observed. This may not be the internationale that socialists and anarchists dreamed of for 200 years, and it may dangerously conflate political crises with humanitarian ones. But it is the internationalism that we have.

The intimate connection between an international human-rights consciousness and the photograph is especially evident when we look at one of the earliest humanitarian movements: the Anglo-American campaign, founded in the late 19th century, to stop King Leopold's atrocities in his personal colony, the Congo. These crimes included slave labor, systemic whippings, tortures, rapes, amputations and executions; historians have estimated that up to ten million Congolese died from overwork, beatings, starvation, exposure, disease and murder in the years 1880-1920. It is perhaps fitting, then, that it is in the Congo reform movement that the phrase "crimes against humanity" was used for what may have been the first time.

What we now call "atrocity photographs" were a key part of the movement's strategy. Some of the images appeared in the press. But often, and most dramatically, they were projected as slides in "magic lantern shows" at jam-packed lectures and protest meetings in America, England and throughout Europe. (In the same period, Jacob Riis was creating lantern shows of his photographs to expose tenement poverty in New York City.) Many of the Congo photos were taken by Alice Seeley Harris, a Baptist minister's wife active in the movement. The photographs were shocking, indeed literally outrageous, to Victorian audiences then – and, *pace* Sontag, are still devastating now. The desecrated bodies we have seen – from Warsaw and Lodz, Cambodia and Bosnia, Sudan and Sierra Leone – have not lessened their power. On the contrary: we look at these pictures in full knowledge of the atrocities that would follow, and this makes them more rather than less awful to behold. For we know, now, that the Congo was an early part of a terrible, ongoing story rather than its final chapter.

One Congo photo shows two youths of indeterminate age. Their skin is coal-black, their hair cropped short. One, named Mola, sits on a curved wooden chair; his hairless chest is bare, while a white cloth drapes over his abdomen and genitals; the other, named Yoka, stands next to him, in a white tunic and long white skirt. Both are barefoot. And both, we see clearly, have had their right hands chopped or beaten off just below their wrists (Mola's left hand is mutilated too); the black stumps, which rest delicately against the ice-white clothes, assault and accuse us. Mola and Yoka stare directly, unflinchingly, at the camera, and at us. Mola's brow is slightly furrowed, as if in suppressed fury; Yoka looks blank and stunned.

Another photo shows a man named Nsala sitting on the ground. His arm wraps around his knee; he is barefoot, almost naked; he stares at something on the ground, something clumpy and indistinct. We see trees in the background, and three other people, yet there is something desolate and foreboding about this picture, though its horror emerges only through its caption. Nsala is staring, we learn, at the hand and foot of his five-year-old daughter, who had been muti-lated, murdered and eaten by African representatives of the Anglo-Belgian India Rubber Company. His wife, too, had been killed, and eaten, in the attack on their village, which had been punished for failing to meet its rubber quota.

The Congo reform movement's ability to force its audiences to visualize Leopold's cruelty – to see a man staring at the mutilated remains of his own daughter – was a new and powerful tool. No doubt the movement's supporters were in some ways condescending, even racist and imperialist. Their fellow-feeling was not perfect. But they were also genuinely angered, saddened and, most of all, moved to action: the photographs they saw inspired pity and senti-mentality, but not only that. In fact, these photographs expanded viewers' very concept of the human, creating a connective tissue of concern that transcended geography, culture and race. "The presence of photography in the 20th century's first great human rights movement is not coincidental," cultural theorist Sharon Sliwinski argues. "Indeed, the very recognition of what we call human rights is inextricably bound to a particular kind of aesthetic encounter... The conception

of rights did not emerge from the articulation of an inalienable human dignity, but from a particular visual encounter with atrocity."

Mark Twain, in his brilliant 1905 satire "King Leopold's Soliloquy," recognized as much. Twain's mad king rails against "the calamity" of "the kodak," which has challenged his power in unprecedented ways. Previously, Leopold recalls fondly, tales of atrocities could be refuted as "slanders" spread by "busy-body American missionaries and exasperated foreigners... Yes, all things went harmoniously and pleasantly in those good days." But the camera, alas, changed all that: "Then all of a sudden came the crash! That is to say, the incorruptible *kodak* – and all harmony went to hell!" The camera, Leopold sadly realizes, is "the only witness...I couldn't bribe... Ten thousand pulpits and ten thousand presses are saying the good word for me all the time... Then that trivial little kodak, that a child can carry in its pocket, gets up, uttering never a word, and knocks them dead!"

And yet, and yet: Leopold ends on a hopeful note. He knows, he says, that most people will "shudder and turn away" from the evidence of his crimes: "That is my protection... I know the human race."

The Ethics of Vision

The ability of photographs of suffering to conjure great emotion – and, as in the case of the Congo, to stretch our capacity for empathy – is their great strength. But this power, precisely because it is divorced from narrative, context and analysis, is equally a danger, and one of the reasons that Weimar-era theorists such as Bertolt Brecht, Siegfried Kracauer and Walter Benjamin distrusted the photograph. Brecht, in 1931, described photographs as "a terrible weapon against the truth." Kracauer's indictment was equally harsh: "The flood of photos sweeps away the dams of memory," he wrote. "Never before has a period known so little about itself... The 'image-idea' drives away the idea." Susan Sontag is the best-known contemporary proponent of this view. "Photographs, which cannot themselves explain anything, are inexhaustible invitations to deduction, speculation, and fantasy," she wrote. "Strictly speaking, one never understands anything from a photograph."

Ironically, the more searing a photograph – the more easily and quickly it conjures up our innate, unreflective sense that "This is wrong!" – the more dangerous it can be. Think, for instance, of Don McCullin's photographs of grotesquely emaciated children during the Biafran secession of 1967-70. The children, often shown naked and holding pathetic tin pots, are utterly abject: distorted, distended, deformed, with legs like sticks, bellies like balloons and eyes like deep, dead pools. McCullin's photos caused worldwide revulsion, and anger too: rightly so. And it is the Biafran war that led to a rethinking of humanitarian aid, and to the founding of Doctors Without Borders (*Medecins sans frontiers*, or MSF) in 1971.

But though photographs can do much to expose a crisis, they can do little to explain it – and can sometimes actually mislead. The case of Biafra is again instructive. Rony Brauman, a founder of MSF and its president from 1982 to 1994, points out that the Biafran movement's leader, Colonel Chukwuemeka Odumegwu Ojukwu, was a major contributor to the suffering of his people which McCullin's photos so dramatically documented. Ojukwu, Brauman explains, "had declared himself prepared to see all the Biafrans perish" rather than relinquish his ethno-nationalist dream, and had "refused absolutely" to allow the delivery of aid donations that traveled through "enemy" territory. The unlucky Biafrans had a leader, in other words, who had made a conscious decision to allow them to die; and it was only the dying, not the reasons behind it, that McCullin's pictures could show. One cannot help but think of other "leaders" who have sacrificed their people, often to photogenic effect: of Saddam Hussein, who stole oil-for-food money even as his people withered; or, more recently, of Hezbollah, which used civilians as "human shields," and gist for propaganda, in its war with Israel last summer.

Think, too, of another widely-photographed event: the hundreds of thousands of Rwandan Hutus who poured into Goma, Zaire after the genocide. It is true that they were living in horrendous conditions and suffering from cholera. But it is also true – something the photographs of them could not reveal – that many were mass murderers. They were refugees, yes, but they were criminals

first; and their refugee status could not mitigate, much less erase, their crimes. A decade later, Gilles Peress, who had photographed both the genocide and its aftermath, recalled, "When I arrived in Goma,... I was cold. I had seen the machetes on the border. I had seen the look in... the eyes of these men who had killed in such numbers... So, cholera happened. It didn't move me."

Or consider Marc Garanger's 1960 photo of Ben Cherif, a leader of the Algerian National Liberation Front, after capture by the French. He sits on the floor, a cement wall behind him; he is almost certainly in a prison. Cherif is a striking, handsome man, with a long oval face and fierce black eyebrows. He stares boldly at us, his head held high; his hands clench into fists, straining the chains that bind them. The photo reminds us of the Algerians' great bravery in their fight for independence, and of the high price they paid. But it can tell us nothing about the revolutionaries' tactics, nor about the nightmare of violence, repression and religious madness that Algeria devolved into once she was "free."

This does not mean that the images of Iraqis under sanctions, or of Lebanese under bombardment, or of Algerians under colonialism, or of diseased Rwandan refugees, are lies. On the contrary: the suffering they depict cannot be denied, nor should it be. But it does mean that we, the viewers, must move beyond the suffering – must look outside the frame – to understand the complex political realities that these photographs document. This is the beginning of ethical vision.

The Flood of Abominations

There is a kind of photograph that King Leopold could not have imagined; nor, surely, could the early practitioners of photojournalism, who believed that photographs might heal the world. This is the photograph that documents cruelty in order to celebrate rather than condemn it. It is this kind of photograph that has come to the fore with an appalling robustness in both the Western and Islamic worlds since the terrorist attacks of 9/11.

Such photographs have, alas, a long history. In the United States, hundreds of photographs of American lynchings were taken, mainly though not solely in the years 1870-1940. They show black men – bludgeoned, swollen, burned, castrated – as they sway, necks broken, on twisted ropes hung from trees. Even more grotesque, these photographs show crowds of whites – ordinary people, often with their children and sometimes dressed in their Sunday best – as they smile, laugh, and cheer at the mutilated corpses. The lynchings, it is clear, were a kind of holiday for the white community, an exercise in kinship, a social ritual. (Thus did the anti-lynching activist James Weldon Johnson write, "In large measure the race question involves the saving of black America's body and white America's soul.") These lynching photos – a bizarre combination of friendliness and agony – were often made into postcards, casually sent to relatives and friends throughout the country. But though created as confirmations of white superiority, they have caused widespread shame, revulsion and fury – and, sometimes, bewilderment – when displayed to contemporary Americans. This is not utopia, but it is progress.

The lynching photos belong to a large and ignoble genre of photographs taken by perpetrators the world over to both document and exult in their power. The Nazis – far from hiding their crimes – took hundreds of thousands if not millions of photographs, some officially sanctioned, some taken spontaneously by soldiers and civilians on the ground. Auschwitz, for instance, had a staff of two official SS photographers (one was later convicted of war crimes), assisted by a crew of inmates. The Warsaw Ghetto was flooded with German soldiers and workers, some on "Strength through Joy" trips, who photographed its ragged, emaciated, terrorized inhabitants. German soldiers on the Eastern front, and elsewhere, shared explicit photographs of their "accomplishments" with loved ones back home. (An exhibit of such photos caused a national furor when it traveled through Germany in the 1990s.) In fact, it is probable that no state and no army has ever been as intent on self-documentation as the Nazi state and the Nazi army: a propaganda team of writers, photographers and filmmakers accompanied every German army division.

While the Nazis were unusually diligent self-recorders of barbarism, they were not unique. Official photographers in Stalin's prisons, and Pol Pot's too, made "portraits" of victims (some had been tortured) before their executions. Saddam Hussein's Baathist henchmen graphically documented some of their crimes, including tortures and executions, in photographs and films. Sierra Leone's Revolutionary United Front – famed for hacking off the hands and limbs of thousands of their countrymen – photographed themselves, perhaps astonishingly, in the act of committing atrocities; the photographs will reportedly be used as evidence in upcoming war-crimes trials. The Liberian warlord Prince Johnson filmed his underlings as they tortured his rival, President Samuel Doe, who would soon bleed to death; the two-hour video, which includes the amputation of Doe's ears as he sits, naked, in a pool of blood, became "the hottest ticket in town," according to the Polish journalist Ryszard Kapuscinski, who reported from Monrovia.

But it is in the last few years that the deliberate creation and propagation of monstrous images – images designed to shock and awe – has assumed international importance. Most notoriously, the Abu Ghraib photos – taken *for the purpose* of humiliating the helpless Iraqi prisoners depicted in them – have zipped around the world, and have now been seen by millions if not billions of people. Like the lynching photos, they are repulsive not only because of the acts they record – though those are bad enough – but for the joy they reveal as the young American soldiers torment their victims. (And like the lynching photos, though far more immediately, these images of celebration turned into images of shame when they came to light.)

Paired with the Abu Ghraib pictures, in a weird dialectic of thanatos, is the flood of sadistic images emanating from jihadist groups. The Islamic websites that post these horror shows – documenting, indeed advertising, the excruciating torture-murders of Daniel Pearl, of Nicholas Berg, of Kenneth Bigley, of the dozen Nepalese workers and of too many other quivering, petrified prisoners – are immensely popular; so, too, are the Western websites that, in a perverse example of global solidarity, post the snuff films of jihad

just as soon as they appear. It is estimated, for instance, that more than 15 million viewers have downloaded Berg's 2004 beheading. (Later that year, footage of Islamic terrorists beheading a young Japanese hostage was broadcast on a large screen during a rock concert held in a city east of Tokyo.)

Some terror groups now regularly send photographers, just as the Nazis did, to film their "missions," including attacks in Iraq and against Israel. The value of these missions is, in fact, inextricable from their documentation. As the "Financial Times" of London recently noted, "The use of photography and film has always been central to modern propaganda, but what distinguishes this new variant of Islamic extremism is that its spectacles seem to be choreographed purely so that they can be filmed and distributed over the internet." Terrorist leaders like the late Musab al-Zarqawi in Iraq have launched sophisticated media recruitment campaigns through the internet which rely heavily on atrocity footage. Meanwhile, Arab television stations such as Al Arabiya, al-Jazeera and Hezbollah's Al Manar shower their viewers with gore – including footage of bleeding and dead babies – all day, every day: "Carnage," the journalist Thomas L. Friedman noted, "[is] now the Muzak of the Arab world." But these spectacles of atrocity also air on such general sites as YouTube and Google Video, with their millions of daily viewers throughout the world. What we are witnessing, I fear, is not so much a clash of civilizations as a mutual dance of barbarisms.

Against this tsunami of abominations, there are signs of democratic images fighting back, such as those supported by an organization called Witness. Based in Brooklyn, New York, it encourages grassroots groups throughout the world (most recently in Bulgaria, Burma, Senegal, Mexico, and the Congo), training them to use video and film in the exposure of human-rights crimes. Witness's footage has been screened on television stations through the world, and on the web; shown in war-crimes trials; and used by activists in their organizing work. Perhaps most important, its documents of violence are embedded within a context of history and politics – of meaning and understanding – rather than used for entertainment or to foster retribution.

Violent images can inspire viewers to heal the world – or to seek revenge. Images of suffering can be the starting-point to human solidarity – or the end-point to fanaticism and hate. How we use these images is, quite simply, up to us; surely the stakes could not be higher.

In our time, as in Walter Benjamin's, civilization and barbarism are intimately entwined: yet there is no excuse to confuse them. "The aims of life are the best defense against death," Primo Levi wrote, "and not only in the Lager." Will the culture of life vanquish the culture of death? Only a fool would be sure of the answer.

_How the other half lives

Jacob Riis

Jacob Riis
How the other half lives
Immigration and poverty in New York
at the end of the nineteenth century

On his arrival to New York from Copenhagen in 1870, Jacob Riis, a Danish carpenter, had to cope with the typical hardships that all immigrants faced: recession, destitution and life in New York's slums. After years spent searching for a job, he started working as a police reporter for the *New York Evening Sun* and then for the *New York Tribune.* In his job he often followed the police in their raids on the city's poorest and seediest neighborhoods, especially near Mulberry Street. His reports reveal a distinct sensitivity for the shabbiness and degradation in which the down-and-outs of the Lower East Side lived, victims of ruthless property speculation and of the greediness of corrupt politicians. In one of his reports Riis wrote: "In one single block of buildings consisting of 132 rooms, 1324 immigrants, mainly workmen, slept in bunks with more than ten people huddled in every room." With the vivid memory of the years spent in the slums, Riis developed a keen interest in the matter and started to explore ways to take action. After seeing the first journalistic photographs on the *Daily Graphic*, Riis realized that words alone were not sufficient enough to raise the general interest of the public. He then turned to photography, confident that the shocking visual impact could give rise to a strong reaction which would drive the government to find a permanent solution. With his *Detective* camera, he roamed New York's slums far and wide, with a functionary of the Health Board and two amateur photographers who helped Riis master the basics of the craft, after seeing that he was still a beginner. Soon, however, Riis felt the urge to become independent. He bought a tripod and an updated version of the magnesium-powder flashlight – Riis was one of the first, along with Lewis Hine, to use one – and went into the shacks to unearth from the darkness the faces of the inhabitants of the destitute dwellings. "The blinding light cruelly reveals the humble details of those sordid interiors, while tenderly lighting up

the faces of the people condemned to live within," wrote Beaumont Newhall, a historian of photography, about Riis's work, "he was always sympathetic to people, whether he was photographing Street Arabs stealing in the street from a handcart, or the inhabitants of the alley known as Bandit's Roost, peering unselfconsciously at the camera from doorways and stoops and windows."

Riis did not seek some kind of "effect" but the truth – his images record the details of a wretched life endured by entire families: men, women and children who had to work unpaid and off – the-books in those very same shacks where they heaped together to sleep. Ragmen, bread and vegetable sellers, dyers or washers all shared the scarce living space available with a heap of personal objects, fruit of the work that allowed them to survive. It is clear from his reports that he was not always welcome: "…Had I not long before been driven forth with my camera by a band of angry women, who pelted me with brick-bats and stones on my retreat, shouting at me never to come back."

Yet often Riis found the way to portray his subjects without causing hostility or disturbing them: "Children know generally what they want and they could go for it by the shortest cut… Their determination to be 'took,' the moment the camera was in sight, in the most striking pose they could hastily devise, was always the most astounding bar of success I met."

By bringing to light the standards of living of the destitute masses, Jacob Riis attracted the attention not only of public opinion, but also of an editor who, in 1890, published *How The Other Half Lives*. It was the first book ever published in which the description of New York's slums is complemented by illustra-tions, photogravures and drawings taken from his photographs. At the time, publishing techniques were far from perfect and only 17 out of the 35 images submitted were halftones. Only in 1947, as a result of the prints made by the photographer Alexander Alland for the Museum of the City of New York, did Americans have the chance to fully appreciate the relevance and beauty of the Danish photographer's work. Yet the social investigation that Riis car-ried out through the years, in cooperation with a group of criminologists and sociologists, was a socio-political implication of what both public and private associations should have done to improve the quality of life for poor American citizens and immigrants alike. Theodore Roosevelt, a police commissioner at

the time, read Riis's book and defined him as "the best American I ever knew." Roosevelt himself coined the term *Muckraker* in reference to the type of work Riis did, defining all of those journalists, reporters, and photographers who expose and denounce hidden social issues associated to violence, corruption and exploitation.

Beaumont Newhall stated: "The importance of these photographs lies in their power not only to inform, but to move us. They are at once interpretations and records; although they are no longer topical, they contain qualities that will last as long as man is concerned with his brother." *a.tu.*

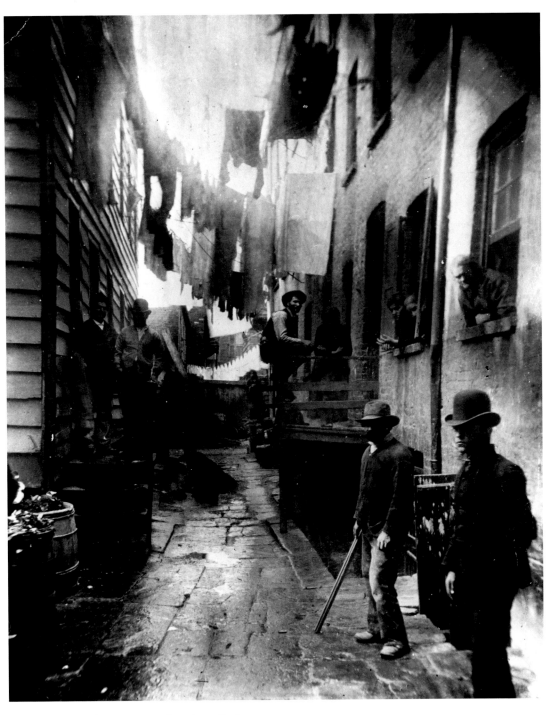

_ New York 1888. A group of men in an alley known
as 'Bandits' Roost,' behind Mulberry Street.

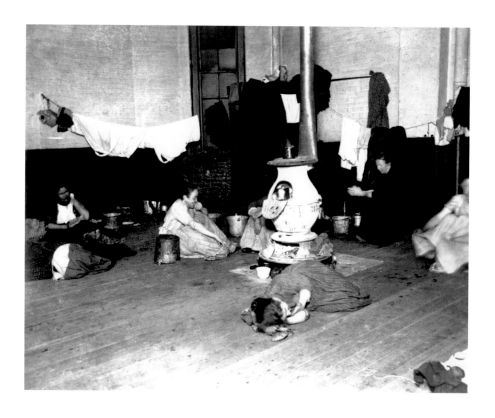

_ New York 1890 ca. A group of women and children
have temporarily transformed a Manhattan police
station into their home.

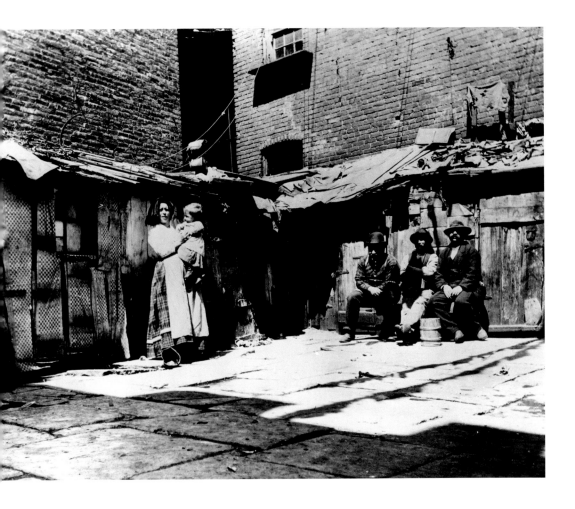

_ New York 1890 ca. A family of Italian immigrants
in front of their shacks on Jersey Street.

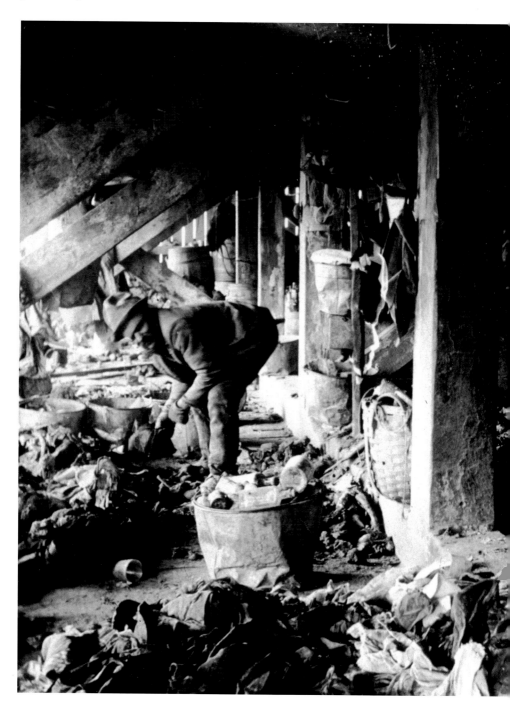

_ New York 1890 ca. A man rummaging among the
garbage under the rubbish dump in the 47th Street.

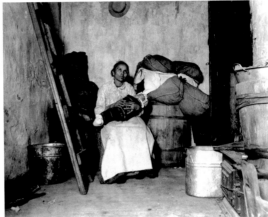

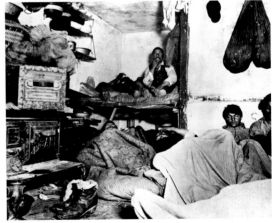

_ New York 1890 ca. An Italian mother holding her child in her arms in a shack just behind Jersey Street.

_ New York 1885 ca. Life in a single crowded room.

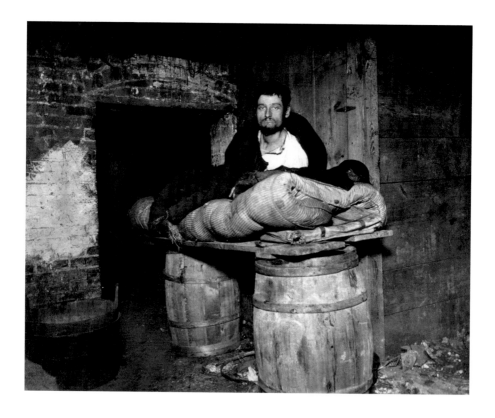

_ New York 1886. A homeless man sleeps in Manhattan in a corner of a basement, on a mattress balancing on two wooden barrels.

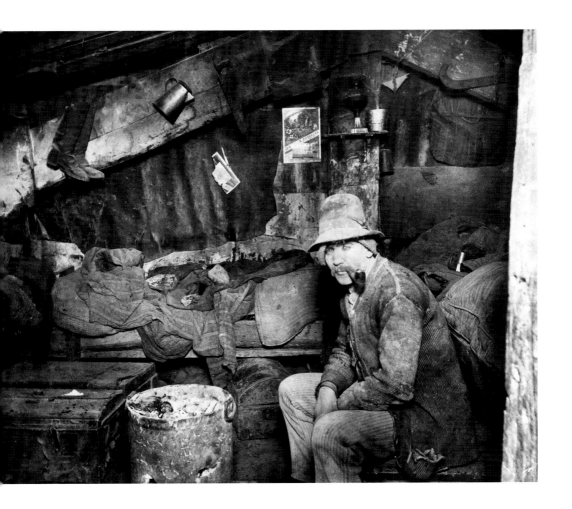

_ New York 1891. A ragman has made himself at home in a building's basement, somewhere in the city center.

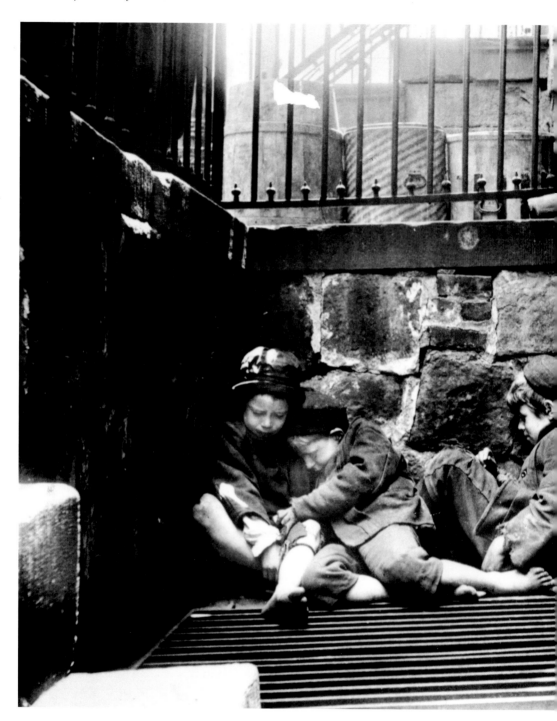

_ New York 1890 ca. Three street children huddle up to
keep warm in a hidden corner of Mulberry Street.

_Correct and appreciate

Lewis Hine

Lewis Hine
Correct and appreciate
Child labor in the USA

"There were two things I wanted to do. I wanted to show the things that had to be corrected; I wanted to show the things that had to be appreciated."

Lewis Hine was an educator and a humanist. After studying sociology and earning a master's degree in Education, he taught at the Ethical Culture School in New York.

He strongly believed in the power of knowledge as a driving force behind social transformation, and in education as a tool to aid man's evolution.

He was one of the first to grasp the enormous potential of photography: its disruptive force as a means of analysis and exposure, and its persuasive power on public opinion.

He started to make use of photography as a sociologist, to use it as a support for his teaching activities, setting a new standard for documentary photography. The streets of Ellis Island, crowded with thousands of women, men and children who had landed in the New World dreaming of a new future, were the crossroads that formed his stance, indicating the right direction, a road to follow. In 1905 immigration started to be a weighty phenomenon in American society, and was accompanied by growing feelings of intolerance and discontent. Lewis Hine immersed himself in the streets inhabited by immigrants, following them into their squalid homes and observing them in their jobs. Hine exposes the hopefulness in his subject's gazes, their eyes clinging to a betrayed dream of a new life. Hine's critical eye is essential; as he aimed his camera with its magnesium-powder flashlight, he understood that the cracks in the wall, the dim lights and dirt were all tied to hope, dreams and exertion. With the eye of a sociologist, but also of a man who was well acquainted in his youth with tough factory work and poverty line wages, he undertook the prospect of exposing a world of broken promises and

disappointed expectations. The dream of a better future was to fade away in the city slums and in never-ending toil and child exploitation in the most serious situations.

When, in 1908, the National Labor Committee asked Lewis Hine to record and research child exploitation, he decided to commit himself entirely to photography, well aware of his ability to raise indignation in the public. He had a deep desire to bring changes to a society which was thriving on the hardships of its most vulnerable and weakest members. He traveled extensively around the United States for ten years, documenting the working conditions of factories, mills, and farms which made use of child labor. It often turned out to be a risky job: the foremen did not accept his presence because they did not want harsh reality of the immorality of child labor to reach the public.

At times Hine had to adopt a false identity to gain access to work premises, he even posed as an industrial photographer, an insurance agent, and a Bible salesman. He kept a notebook hidden in his pocket in which he carefully recorded the age, working conditions, years of service and schooling of the children he portrayed. For many years the National Labor Committee used his notes for analyzing child labor conditions.

In the Child Labor Bulletin of 1914 Hine wrote: "For many years I have followed the procession of child workers winding through a thousand industrial communities from the canneries of Maine to the fields of Texas. I have heard their tragic stories, watched their cramped lives and seen their fruitless struggle in the industrial game where the odds are all against them. I wish I could give you a bird's-eye view of my varied experience." His photographs have accomplished much more than this. Their publication drew the general attention of the public to the incontrovertible evidence of unacceptable abuse and of intolerable social injustice. These images proved to be crucial in the legislative battle against child labor and forced the authorities to discuss and implement some basic laws and regulations to protect children. In 1910, Hine wrote to the sociologist Frank Manny, an old teacher and friend of his: "I am sure I am right in my choice of work. My child labor photos have already set the authorities to work to see if such things are possible. They try to get around the issue by crying forgery, but that is the value of the dates and the

witnesses." His photographs, taken indoors with simple devices and often with poor lighting conditions, testify to a strong social commitment, where formal and aesthetic sense are shrewdly employed to enhance his condemnation. When he had the opportunity, Hine made the children pose in front of or next to the enormous machinery to underline their physical frailty, the discrepancy between their bodies compared to the equipment and tasks they undertook. Such disparity informs the observer of the countless risks that these children had to face daily. Hine took his job as a moral duty. His works are a groundbreaking combination of social investigation and documentary photojournalism, where man is always the central figure, bearing all the weight of the photograph. An interpreter of the proliferating industrial society surrounding him, Hine firmly believed in the importance of work and human dignity. Workers were his favorite subjects, and he was confident that real progress could only be achieved through the recognition of human rights and responsibilities, which were the system's authentic driving force. Years after they had finished their cooperation, Owen Lovejoy, General Secretary of the National Labor Committee and Hine's supervisor, wrote: "The work that you did under my direction was more responsible than any or all other efforts to bring the facts or conditions of child labor employment to public attention." Hine always strived to bring to light the dark recesses of growing American society, helping it keep in step with the hopes and necessities of man. "There is a strong need for light," he once wrote, "a flood of light". *a.ta.*

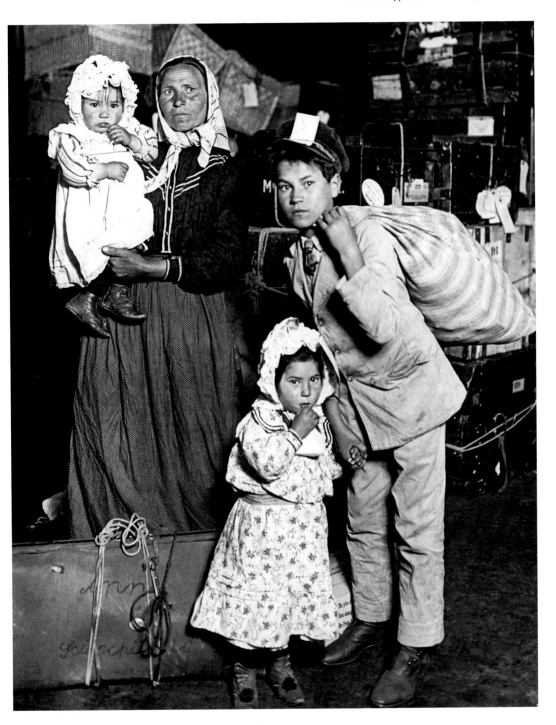

_ New York 1910 ca. An Italian family on their arrival
in Ellis Island.

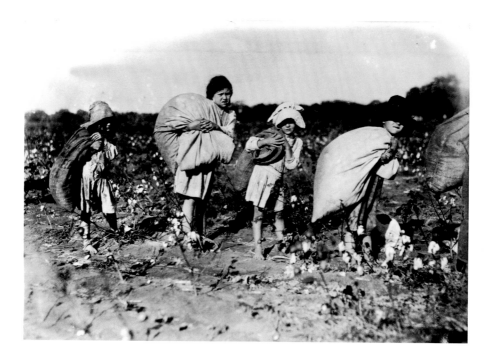

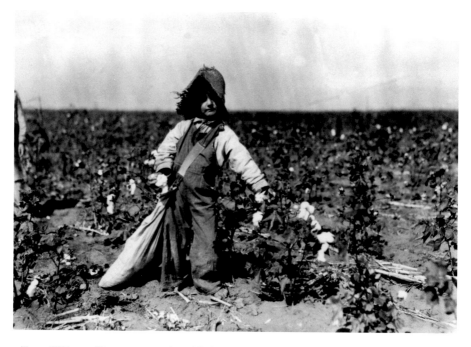

_ Texas, USA 1913. Young cotton pickers fill their sacks.

_ USA 1912 ca. A child works barefoot in the cotton fields. His clothes are tattered and oversized.

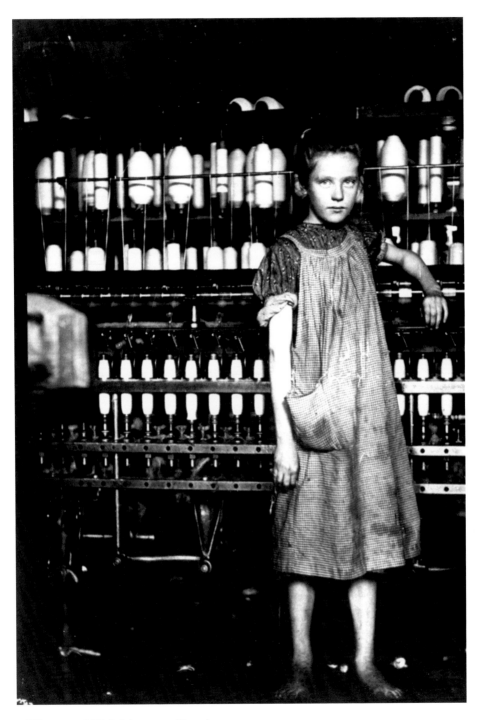

_ USA 1910 ca. Addie Laird, 12 years old, works as a
spinstress.

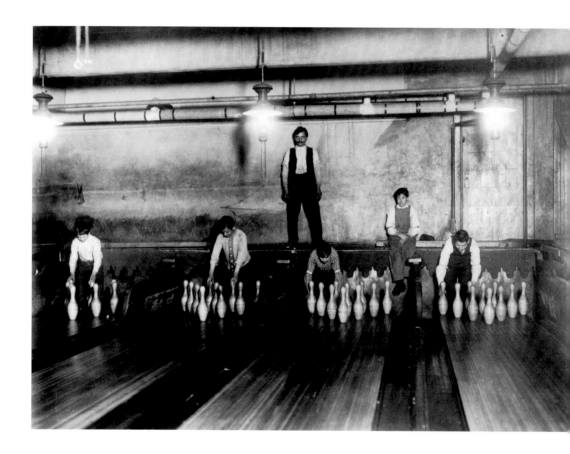

_ New York 1909. A man stands in a bowling lane and
checks that the young workers are resetting the pins.

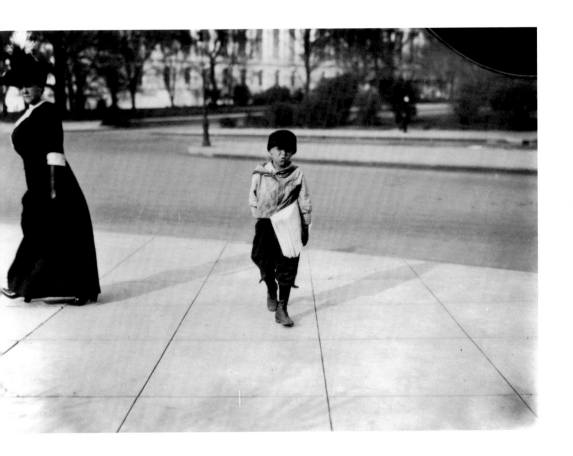

_ USA 1912. A young newsvendor wearing dirty and
tatty clothes.

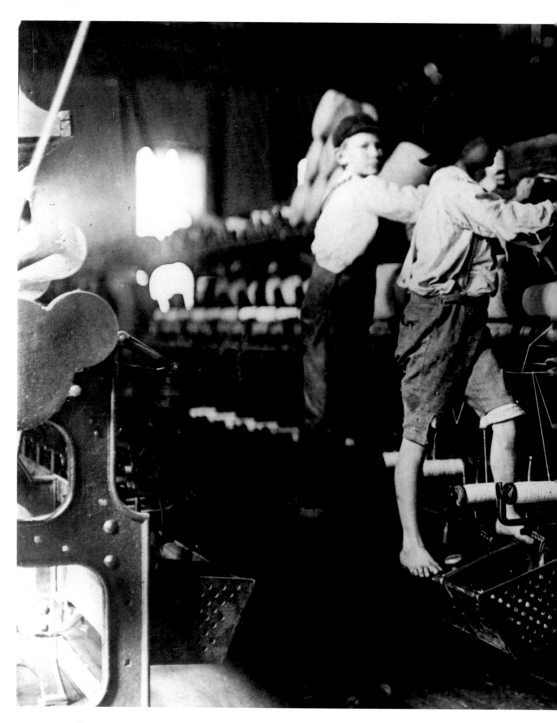

_ Georgia, USA 1910. Two children at work in a factory
climbing an electric loom.

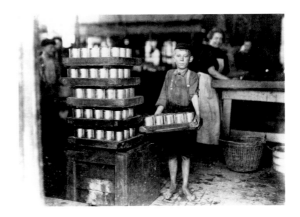

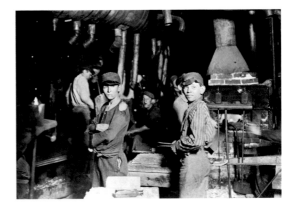

_ Baltimora, Maryland, USA 1909. A child transports tins in a canning factory.

_ Indiana, USA 1908. Children at work at midnight in a glass factory.

_Between dreams and denial

David Seymour

David Seymour
Between dreams and denial
Children in the aftermath of war

Post-war Europe was little more than a continent reduced to debris, inhabited by people worn out by hardship. Over thirty-one million children were born amongst the war's ruins, often in cities wrecked by bombs or lacking basic services such as water, electricity, schools and hospitals. Many children were alone during the tragedy of concentration camps, bombings, in the front-line of war, or in retaliations. This had created, among other consequences, an authentic small and transnational army of orphans in a number of cities. For this reason, on 11 December 1946, the United Nations General Assembly passed a resolution formally creating UNICEF, the United Nations International Children's Emergency Fund, to meet the emergency needs of children in all countries, irrespective of whether they came from victorious or defeated countries.

By the end of its first year, UNICEF had distributed vital goods to starving young children in 13 different countries, from cities to the most remote mountain villages. Two years later, UNICEF asked photographer David Seymour to document this huge effort of international aid. Seymour, also known as "Chim", is a legendary figure in the world of photojournalism and one of the founding members of the recently established Magnum Photos. He accepted the task with a moving and personal approach. His own family history was affected by suffering, which bestowed upon him an intelligent sensitivity that would distinguish him throughout his lifetime, enabling him to thoroughly understand the agony of other's struggles, the desperation of exile, and the desolate emptiness of the post-war period. Seymour was a Polish Jew born in Warsaw, and grew up between Moscow and Paris. Later, he moved to America to escape Nazi occupation and violence. Returning to a different Europe, wrecked by the war's devastating effects, was nevertheless a homecoming for Seymour, a return to the places of his childhood.

For three years, Seymour traveled through Poland, Hungary, Austria, Italy and Greece, the poorest countries of the continent, seeking in the children's eyes both the wounds of war and the hope and promise of a new beginning. "Wherever I went, I saw children playing out their dreams of a full and peaceful life amidst the ruins of their parents' world. To give them back that world, helping them understand and take in the traumatic experiences they had endured by curing both body and soul, was a challenge I had never faced before."

He had left Europe in May 1939, when he embarked with a group of Spanish emigrants fleeing from Franco's Spain towards Mexico. He could not return until the folly of war had ended some years later. When he did, after the Liberation, he found a notice from the Gestapo still attached to the door of his home in Paris. This man, who had lost his parents among the rubble, victims of Nazism in 1942, produced an intense account about loss, deprivation and hope, and about a humanity that fought and assisted with simplicity and courage. There is no artifice in his photographs. They are bare and sincere images, taken to show, to understand, and to give evidence to a memory that must not be forgotten. The photographs portray the distraught gazes of children traumatized by bombs, some maimed, some ill, nearly all hungry and barefoot, cramped in makeshift dormitories or in the trucks used to evacuate all areas still burning from battle. Alongside all the gazes he captured – at times naive, at times unexpectedly harsh – there is a feeling of deep compassion, tenderness, and of great humanity. His photographs never lack hope. Though maimed, a child is still a child and cannot help but to hold expectations and desires for the future. "The most eloquent photograph I had taken," said Chim, "shows a group of children amidst the ruins of the city wrecked by bombs, who are playing with stones. This embodies their direct answer to the destruction surrounding them. They wanted a school to take the place of the homes they no longer had... In all the five countries I visited, I sensed the same terrible urge and challenge: in the youths sitting on the stairs of bombed and naked houses, with the sun peering through the derelict staircase; among the Italian children playing with the empty cartridges among Montecassino's ruins; and in the little girls illegally selling cigarettes and soap in the streets of Naples."

Chim loved to portray everyday, ordinary moments rather than peculiar or

unique events. His photography is delicate and gentle, brimming with empathetic respect.

On the tenth anniversary of his death, Henri Cartier-Bresson wrote: "Chim picked up his camera the way a doctor takes his stethoscope out of his bag, applying his diagnosis to the condition of the heart. His own was vulnerable." The attention of his camera, focused on a ramshackle world, was not so much aimed at specific and extraordinary moments extracted from a continuum, but at a more extensive period, which bound the tales of the present to the past and the future in one single vision. Seymour's photographs challenge us to remember so that we do not to repeat the same mistakes again, and confirm the necessity to rebuild starting from this memory. *a.ta.*

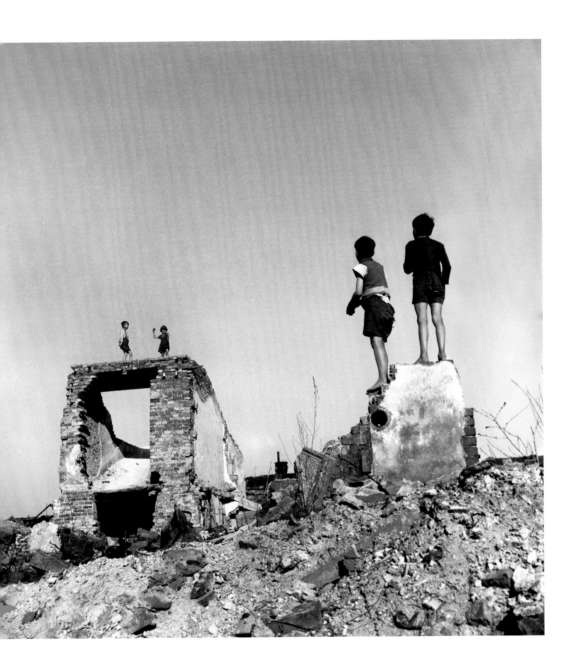

_ Vienna 1948. Some youths playing among the rubble of derelict buildings in the working-class neighborhood of Favoriten.

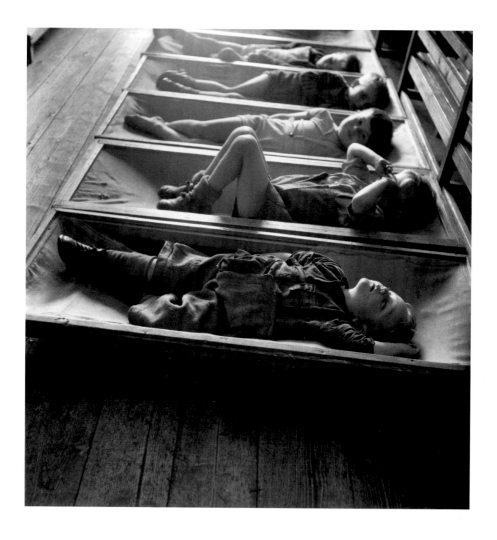

_ Vienna 1948. Some children resting in the Sudeten
refugee camp, in an old, wrecked armory.

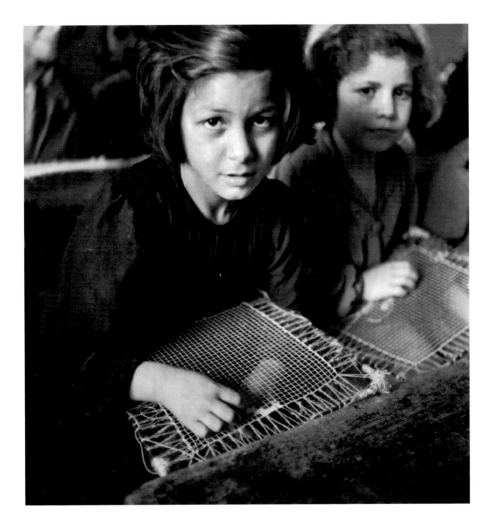

_ Naples 1948. The Albergo dei Poveri, the detention
centre where the Juvenile Court sent young thieves,
beggars and prostitutes.

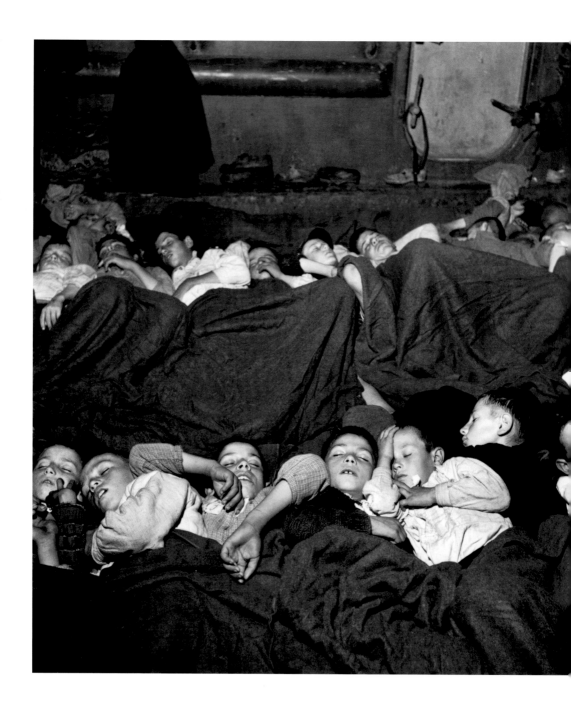

_ Greece 1948. A group of children sleep in a refugee
camp, far away from where the civil war is waging.

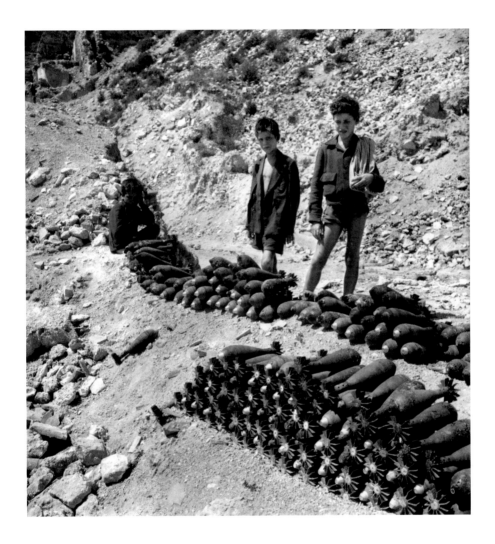

_ Montecassino 1948. Some youngsters with their "booty" of mortar shells, ready to be sold to ironmongers. The seemingly harmless shells maimed and injured many children.

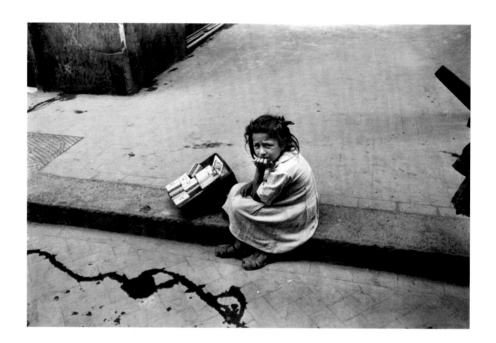

_ Naples 1948. Angela sells black-market American
cigarettes, loose or in packets, to people in bars.

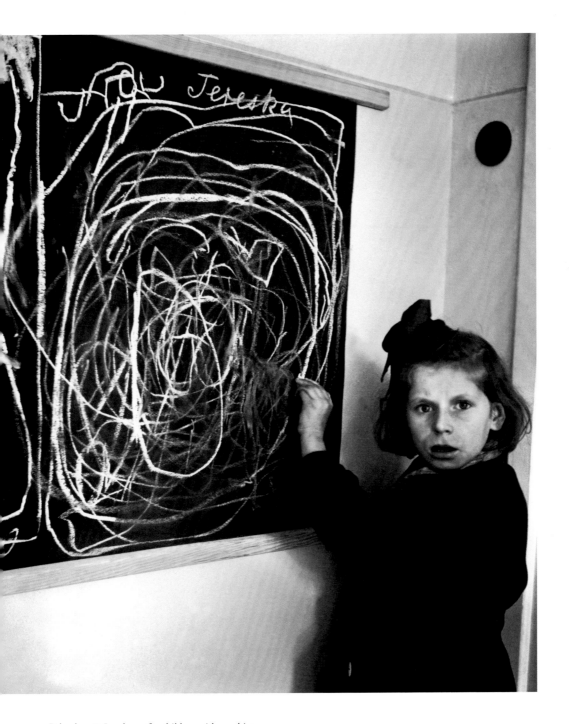

_ Poland 1948. In a home for children with psychiatric problems, Tereska, who grew up in a concentration camp, draws her "home" on the blackboard.

_"The casserole
tied to the tail"

Marc Garanger

Marc Garanger
"The casserole tied to the tail"
The Algerian War

"I am showing these images for all those who have endured this war, to rise the shroud of silence in which it is blanketed, to free speech." This is what Marc Garanger wrote in the preface of the book *La guerre d'Algérie*, published In France by Seuil, in 1984.

When Marc Garanger joined the Ain Terzine regiment 100km south of Algiers as a conscript in March 1960, an authentic colonial war was waging in the country. The FLN (Front de Libération Nationale) was leading the rebellion against the French domination that had lasted one hundred and thirty years. The French government had lost control of the situation after six years of terrorist attacks and harsh repression on behalf of the French army, with great loss of civilian life. Garanger had a degree and was therefore handed over to the government's secretariat. He had ten years experience as a photographer and some of the photographs taken in Algeria proved popular: soon he became the regiment's photographer. He was a soldier tormented by his conscience, caught up, like many others, in a traumatizing experience. "The Algerian War is a trap I fell into, just like some hundreds of thousands of French people of my generation," he reported.

He was a photographer under the command of an occupying army, but his perception did not dissimulate his soul's rebellion and the camera became a means with which he cried out his dissent to that war; he refuses to accept the horror, the violence and the lies, and has a strong will to give evidence of what he was experiencing. "I never stopped for twenty four months, confident that one day I would have been able to be a witness, to report what I had seen through my images."

The Algerian War is an unhealed wound in French and European history: a war without a name, without a commemoration, without a face, forgotten. A war that had been disregarded and repressed the illustrated press because of the

mood of prohibition, censorship and self-restraint. Marc Garanger is the only professional photographer who revealed the hidden side of the conflict, one of racism, injustice, torture and execution. It is this face of colonialism that France still struggles to accept, an issue which still treated with a degrading silence.

Only a few voices denounced the misdeeds: one of these belonged to Jean-Paul Sartre, who strongly and unrelentingly protested against the silence of the French in the face of this horror with the hope that the government would realize that colonialism was a collective responsibility: "It is no good, my fellow citizens, you who are aware of all the crimes committed in our name, it is no good at all that you do not speak about this to anyone, not even to your soul, for fear of having to pass judgment on yourselves. At first you did not know, I want to believe, then you doubted, now you know, but you still remain in silence."

Garanger's intention was to break this silence with the strength of images. He revealed the life of civilians and the evacuation of entire villages, ordered by the French government in order to concentrate most of the rural population in camps guarded by soldiers. Between 1957 and 1960 the forced movement of more than two million Algerians away from their hometowns – which were then destroyed – had major social and economic consequences. Garanger took photographs of arrests, the convicts locked up in prisons converted from old pigsties. He watched the barbaric interrogation of a shepherd during which he shot photographs. These images are blurred, maybe out of decency or maybe out of shame, because the scandal of torture was too unbearable for a citizen of a so-called civilized country to witness. A country that constantly calls on the respect of human rights. "My spirit's insurrection was proportional to the horrors I had witnessed." Garanger's condemning outlook framed the anger, more than humiliation, in the eyes of Ben Cherif, commander of the FLN, taken prisoner in October 1960. But maybe his most renowned photographs are a series of portraits of Algerian women taken in the Berber villages surrounding army barracks over a ten-day period. More than two thousand images were taken under orders of the army, which had determined that all Algerians had to have an identity card. "The women's humiliation can clearly be read in their eyes", wrote Garanger. "They could not refuse to obey and had to remove their veil. They had never posed before and had never seen themselves in a photograph.

All this took place in total silence, while they glared at me angrily. I worked as fast as I could, taking a picture every two minutes. Later on many tore up their document ..."

The photographer captured the proud desperation of these women, who seem even more vulnerable without their veils. The pictures are pierced by their fiery glare, the first evidence of their silent protest.

Then, in 1961 Garanger, used his only permit to smuggle into Switzerland and publish some photographs in *L'Illustré* magazine, with an article written by Charles-Henri Favrod.

The portraits' format is larger than the one used for the identity cards with the deliberate intention of restoring the women's dignity. The complexity of these images stems from the various levels of interpretation that the peculiarity of the situation created, and by the relationship between the photographer and the subject. What is clear is the French colonial army's determination to keep control of the situation, the tense atmosphere of potential threat and coercion, the Muslim prohibition of the portrayal of human forms plus the oppression of a population and of its culture. It was only in 1984 that Garanger could gather, not without difficulty, his photographs into a book: "It was shielded by a lead cover, it was a taboo war. I was threatened." He is convinced that many other photographs, taken by anonymous soldiers, could still surface. If only there was the will to look into this issue, there would be an enormous amount of material for historians to study. In July 1962 Algeria conquered its independence. In the same year, Sartre wrote an article entitled "The Sleepwalkers" in which he states: "In the past seven years France has acted like a mad dog who is dragging a casserole tied to its tail – every day it is increasingly scared of the din it is creating by its own movements. Nobody ignores the fact that we have ruined, starved, massacred a population of poor people to make it drop to its knees. It is still standing. But what price did it have to pay!"

Just like the images of Abu Ghraib, these pictures of colonial violence cannot but imply the collective responsibility of all the western nations. Sartre summed up this feeling as well: "Man, over here, stands for accomplice, because we all took advantage of colonial exploitation." *a.ta.*

_ Vauban, Algeria 1960. A bird's-eye view of a fortified
village under French military control.

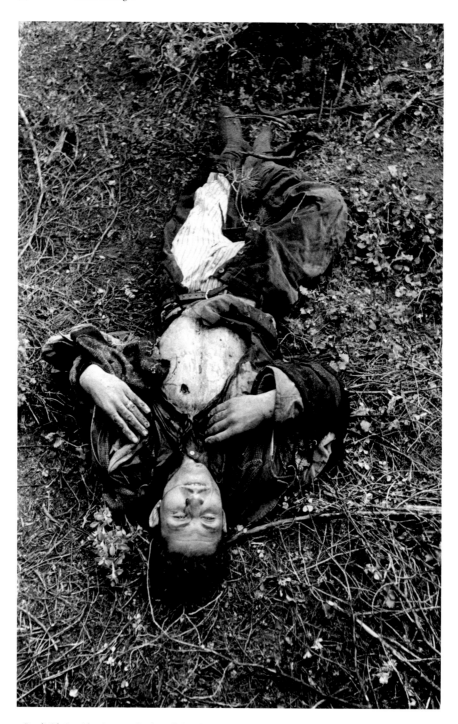

_ Bordj Okriss, Algeria 1960. Said Boukali, Algerian,
was killed by a shot in his chest.

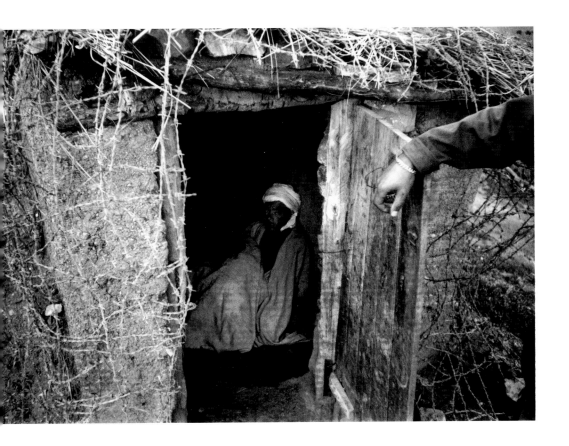

_ Ain Terzine, Algeria 1961. An Algerian prisoner of
war is guarded by a French soldier, in the pig-sty close
to the house of the director of the military camp di-
rector, which was used as a prison.

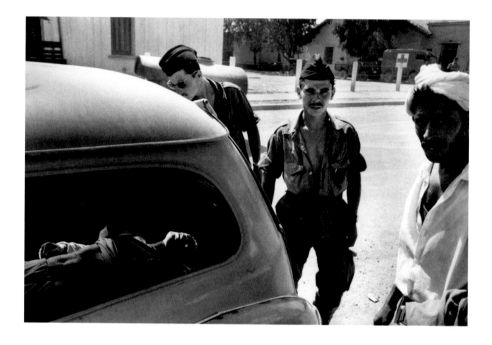

_ Sidi Aissa, Algeria 1961. Some French soldiers di-
scover the body of an Algerian man in a parked car.

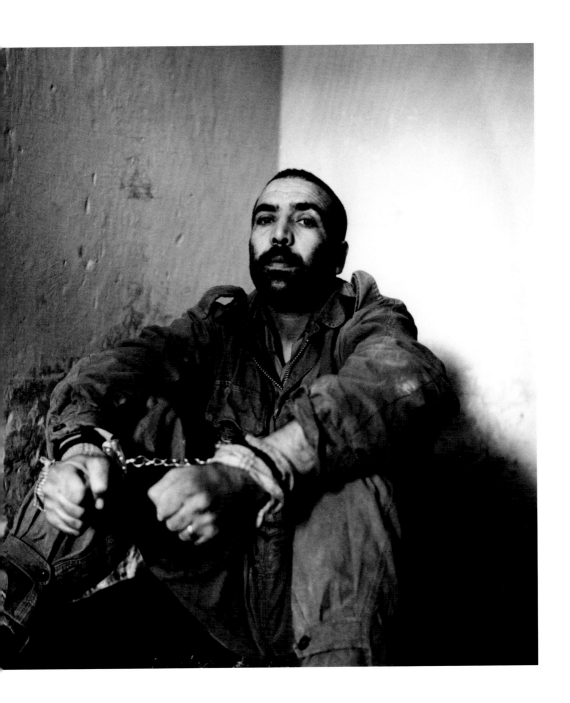

_ Aumale, Algeria 1960. Ben Cherif, commander of
the FLN in Algeria, is held prisoner by the French.

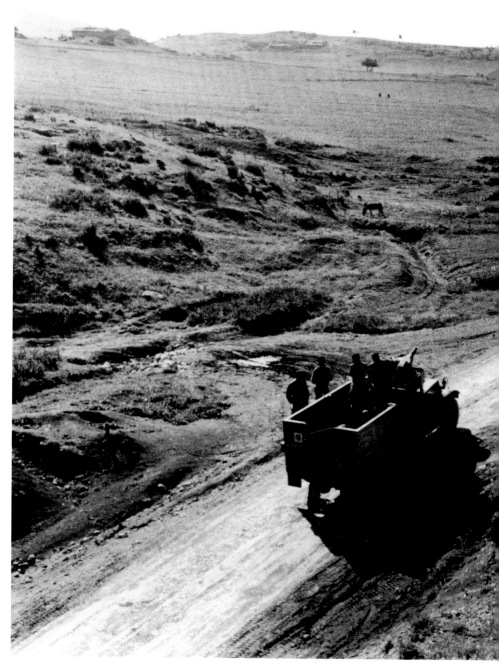

_ Ain Terzine, Algeria 1960. The French army forces the people in the village of Rouabas to move from their *mechta* to the village of Meghnine, some kilometers away.

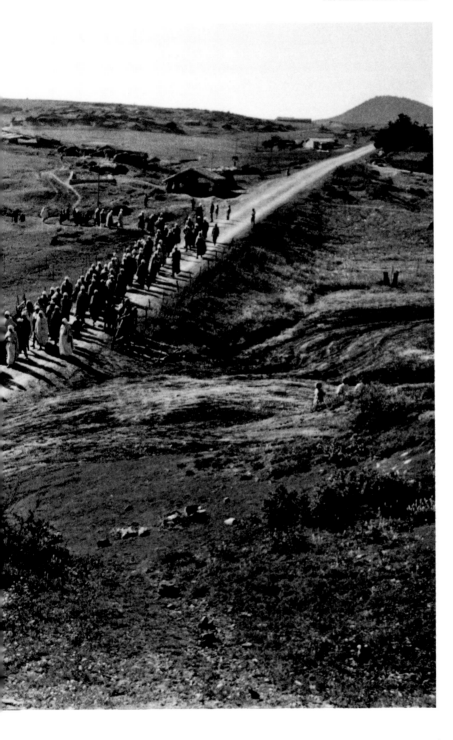

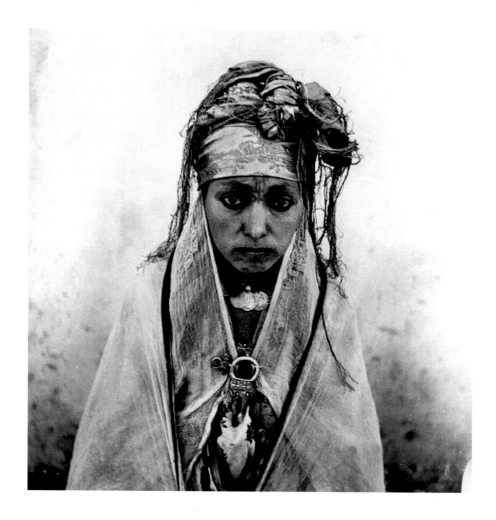

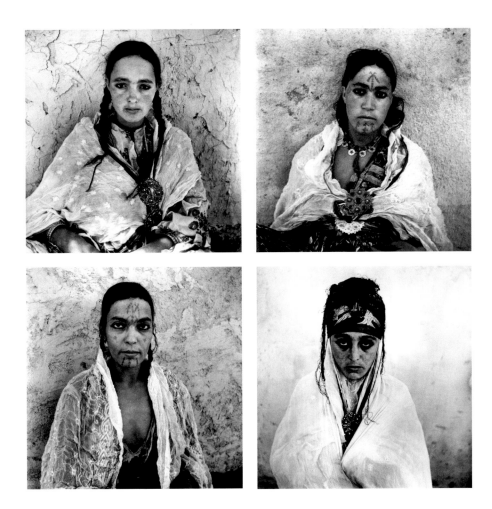

_ Algeria 1960. Some portraits of Algerian women
which had been forced to pose without their veil for the
ID photographs.

_"Between the
camera and me "

Peter Magubane

Peter Magubane
"Between the camera and me"
South Africa under Apartheid

"Few photographers, during their career, have suffered more than Peter Magubane," wrote John Morris. And, without a shadow of a doubt, the life and career of the black South African photojournalist are inextricably entwined with the Apartheid he described so skillfully. The story of the racist system's brutal measures of punishment can be read clearly through his photographs, and on his skin: he spent more than 580 days in solitary confinement, fed on bread and water, another six months in prison without having committed any crime, was subject to various types of torture, had his nose broken and was banned for five more years.

Magubane has been physically attacked by the police more than once, and has been subject to interrogations during which he has had to stand for five days and five nights in a row, despite having no crime to confess. As a black and brave photojounralist, he was an intolerable thorn in the side for a system where racism is law. In South Africa, this was an oxymoron that the government did not approve of. As Magubane said, "It wasn't easy in the Apartheid years, but I'm a stubborn Zulu – no one gets between me and my camera. You had to think fast and be fast to survive in those days." Since his school days, Peter Magubane dreamed of working for *Drum*, the magazine founded in 1952 by a white South African editor, Jim Bailey, similar to *Life* and *Paris Match*. Bailey wanted to create a genuinely indigenous magazine and was aware of the fact that an illustrated magazine could have had a large amount of readers among the semi-literate black population.

The founder wrote: "It was clear from the beginning that I was producing a means, not a voice. And that that means had to spread valid black opinions, not mine or those of other whites in general." *Drum* had a fundamental role in South African journalism, giving young writers and photojournalists the opportunity to work. Magubane joined *Drum* as a driver, then as an assistant in the darkroom and finally, thanks to his stubborn keenness, he started working as a photogra-

pher. His first assignment was to cover the African National Congress convention in 1955. He was 23 years old. Since then, and for more than fifty years, he says he has never looked back. His dedication to his job led him to narrate the life of his people in pictures, and the way in which the system of *separate development* influenced their lives day by day. He showed the degradation of black workers living in overcrowded dormitories, the humiliating *pass* system that limited freedom of movement, and the brutality of the South African police in repressing any form of dissent. He recorded his people's fight for freedom against oppression and for the recognition of basic human rights.

Despite the efforts of the authorities to silence him and eliminate his pictures, his work is now famous throughout the world.

"It was under Tom Hopkinson, editor of *Drum*, that I started to consider photography from a different point of view and became conscious of the value of photojournalism, of its importance and strength, especially in countries with oppressive governments like South Africa. In those days, photojournalism was an absolute novelty for black people," Magubane stated. Often the press was not allowed to record certain events and the photographers were not allowed to take pictures in situations involving the police. In 1953, following the disobedience campaign conducted by blacks, other people of color and Indians, the government promulgated the Public Safety Act, granting the power to declare martial law. In 1955, the persecution of opponents increased, setting off a new season of long trials for treason and initiating the practice of banishing opposition activists, confining them to remote areas. While working on a report on people who had been banned, Magubane wrote: "The police constantly harassed us, ordering us to leave the area, at times even pointing their weapons at us." To follow and document the trials, Magubane had to invent a series of contrivances, such as hiding his Leica camera in a loaf of bread or in a Bible. The protests grew stronger; in 1956 Nelson Mandela, leader of the African National Congress, was arrested for the first time and racial tensions rose until the outbreak in the Sharpeville massacre on March 21, 1960. The Sharpeville shootings were a crossroads in the struggle of black rights, and left an indelible mark on the photographer's soul. The police opened fire on a crowd of a thousand blacks who were peacefully gathered in a congregation, leaving 69 dead and 180 injured. Magubane arrived when the shooting had

just finished and was met by a terrible scenario. "I had never seen so many dead people. Working was not easy."

For decency and compassion's sake, as well as feelings of shame, Magubane took pictures of the corpses only from a certain distance. One of his photographs would soon show the world the 69 coffins containing the victims placed in a long, macabre line.

After Sharpeville, the authorities intensified the repression of the black protest movements and the surveillance of a photographer who was rising to fame not only in South Africa, but also abroad. Magubane was monitored, followed and arrested, but the charges against him were dropped. However, 1969 was an important year in his life. On his way to Pretoria to deliver clothes and fruit to Mandela's wife who had also been imprisoned, he was arrested and brutally interrogated. Locked up for months in solitary confinement, in September 1970 he was acquitted, though he was banned for five years, during which he was not allowed to pursue photography. As Magubane wrote, "being banned leaves you naked. Unless you decide to fight with all your might, you go mad … your relations, your friends are afraid to come near you, they are even afraid of greeting you. You are no longer a human being, it is as if you were a leper." A year later he was arrested again and jailed for another 98 days in solitary confinement. But the "stubborn Zulu," as Magubane calls himself, started working again after being banned for five years and was in Soweto when, in 1976, the revolt started. The riots grew out of the protests of black youths against the government's decision to force all schools to use Afrikaans as the language of instruction. The police fired on the crowd again causing panic and chaos. The repression was brutal. Magubane was there and documented those days and the violence; "I was demonstrating with my camera," he stated. Two weeks later he was arrested once more, but in the meanwhile his photographs had gone around the world and everyone saw with horror and shame a reality that had been ignored and tolerated for too long. After Soweto, South Africa would never be the same: the white government did not manage to regain control of the situation. The world saw Soweto in flames and considered it one of the most glaring symbols of brutality. This was also due to the courage, the eyes and the lens of Peter Magubane. *a.ta.*

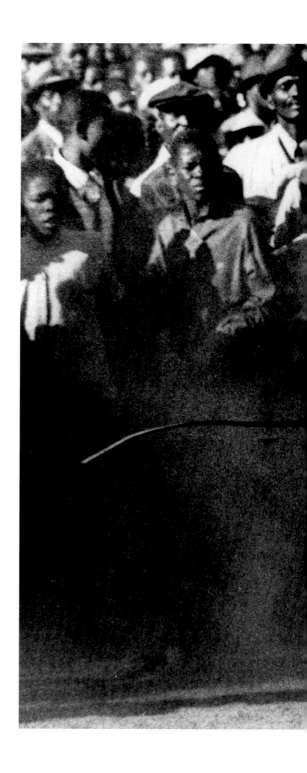

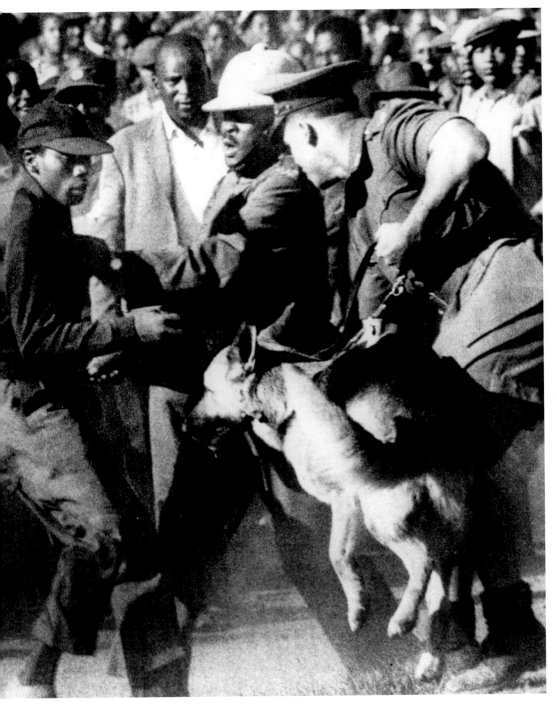

_ Soweto 1956. Police dogs at the Orlando Stadium, used to keep fans under control during a football match.

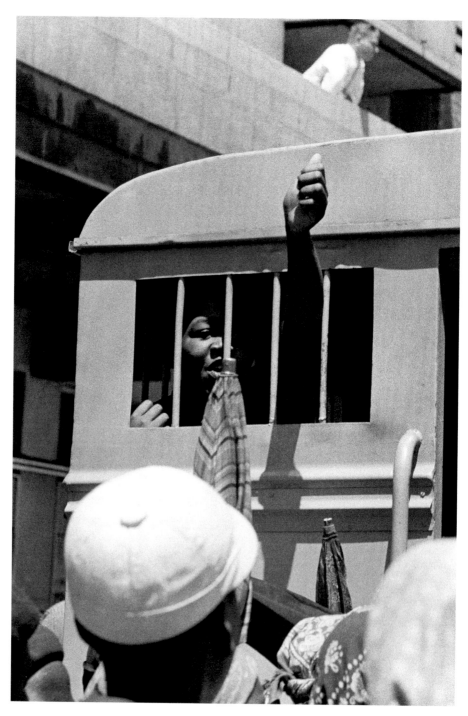

_ Pretoria 1956. A woman locked up in a police van,
after being arrested for taking part in the women's
march.

_ Johannesburg 1957. The bathrooms in the City
Deep Mine.

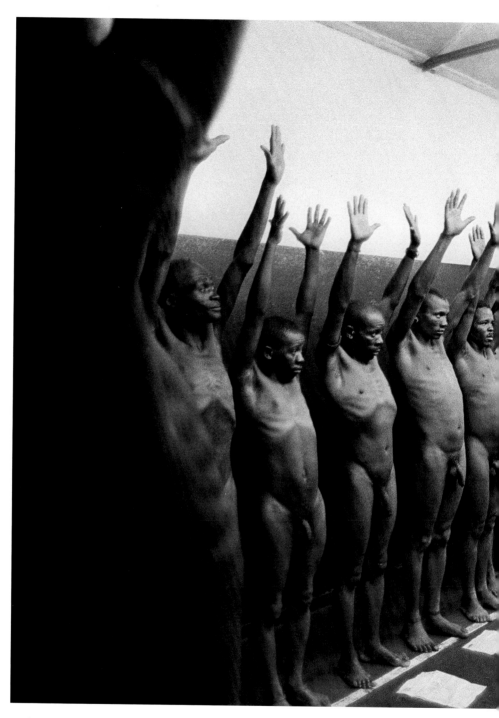

_ Johannesburg 1957. Aspirant miners have to strip
off their clothes and dignity to undergo an X-ray
exam at the Wenela Mine Recruiting Corporation.

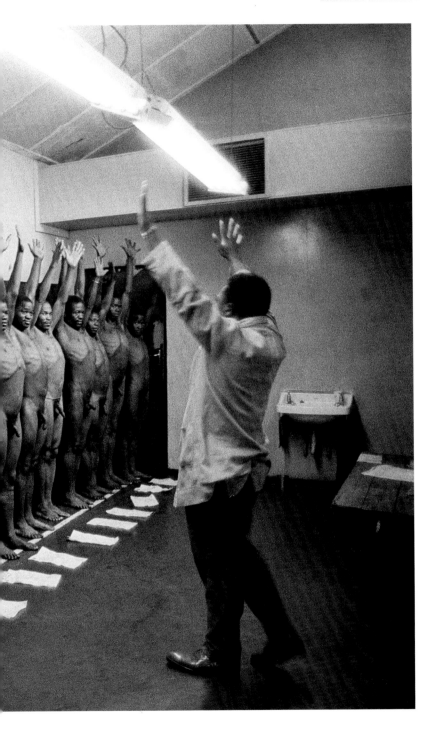

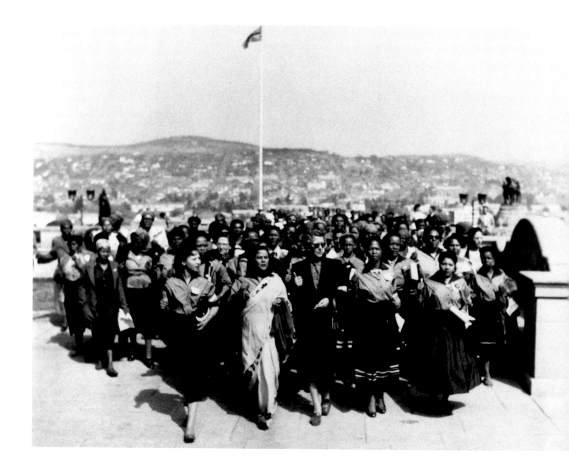

_ Pretoria 9 August 1956. The South African Wom-
en's Federation organizes a mass protest in all the
country against the Pass Law that obliged black peo-
ple to carry a pass book which recorded all their de-
tails and movements.

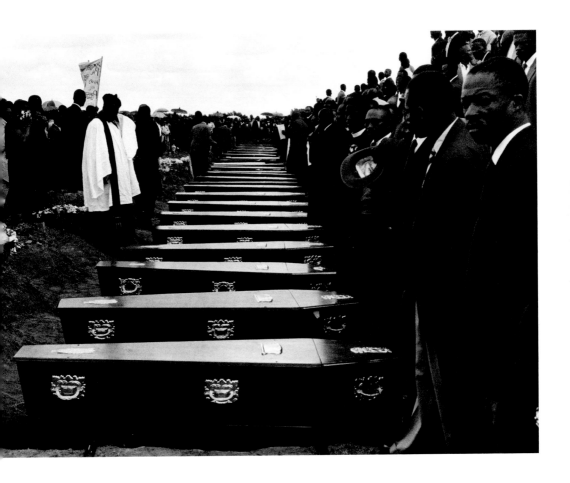

_ Sharpeville 1960. The coffins of 69 black South Africans massacred by the police during a protest against the Pass Law.

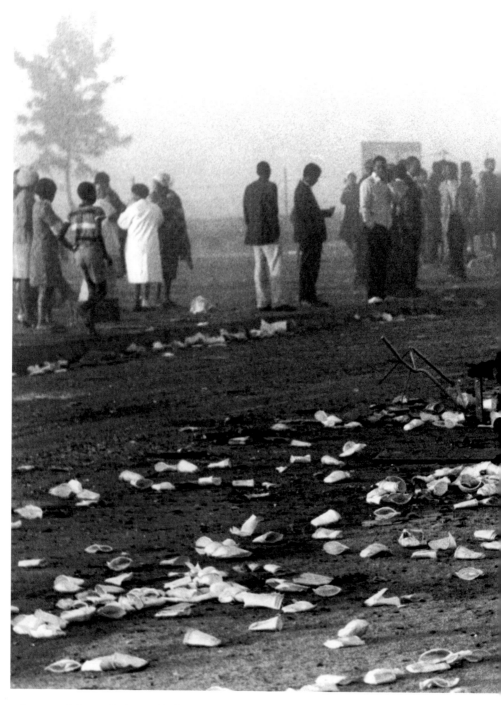

_ Soweto 1976. A street in the city the day after the
fights of 16 June.

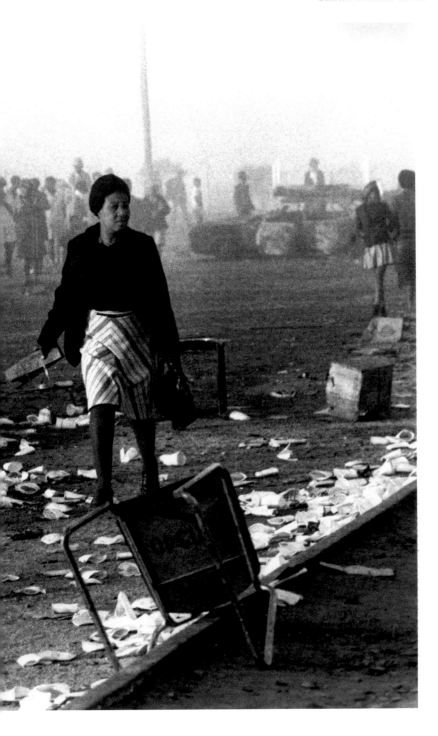

_The truth
marches on

Bob Adelman

Bob Adelman
The truth marches on
The fight for civil rights in the USA

"When you take a cross-country drive and find it necessary to sleep night after night in the uncomfortable corners of you're automobile because no motel will accept you; when you are humiliated day in and day out by nagging signs reading 'white' and 'colored'; when your first name becomes *nigger*, your middle name becomes *boy* (however old you are) and your last name becomes *John*... When you are harried by day and haunted by night by the fact that you are a Negro, living constantly at tiptoe stance, never quite knowing what to expect next ... then you will understand why we find it difficult to wait."

This is what Martin Luther King wrote in prison, after being arrested during the days of the Civil Disobedience Campaign in Birmingham, Alabama. It was April 1963, a crucial year for the history of the United States. From the mid-fifties, a wave of protests against racial discrimination and segregation endured by the black population swept America, particularly in the Southern states. Martin Luther King, one of the most charismatic leaders of the Civil Rights Movement, promoted non-violence and organized demonstrations, marches, boycotts and sit-ins, bringing this battle to the centre of the nation's attention. In the early sixties Adelman was an assistant photographer. He was 32 years old and he was deeply affected by the struggle carried out by students and young Afro-Americans. Until that moment, racism seemed an untouchable aspect in the life of a nation where discrimination was sanctioned by the law through racial segregation in all public areas: restaurants, hotels, means of transport and bathrooms. Prisons were also overcrowded with black people.

The supremacy of the white race was the mainstay of American social structure. "I sensed that we might be at a turning point and tried as best I could to make a historic document," Adelman stated later on. In those years, history was being made in the Southern states: in 1955 in Montgomery, Alabama, Rosa

Parks, a middle-aged black seamstress, refused to relinquish her seat to a white man on a bus. It was an act of defiance and courage that triggered the biggest social movement in American history. In 1963 Martin Luther King organized a civil disobedience campaign that lasted for over a month in Birmingham, where continuous violence and bombings had been carried out against the houses of black people. Adelman volunteered to help out the activists of the Civil Rights Movement with his photographs. He took pictures of the marches, of the peace rallies, of King's speeches and of the violent resistance of the police and the authorities. At first his images were used by the Movement to make posters and publicize the civil struggle. Some of his photographs, portraying the demonstrators standing up to the police's fire hoses, became emblems of the Movement. Adelman captures this symbolic moment in which the black community stands together as the activists support each other instead of running away. Adelman stated that after seeing those images Martin Luther King said: "I'm surprised that of all that pain, some beauty came." The photographs of the rallies and of the acts of disobedience reveal the strength of conviction, the faith in justice and the urge to help build the "beloved community" promoted by Martin Luther King. Adelman said: "My belief in racial justice and nonviolence is so strong that I risked my life, endured physical violence and repeated arrests to bear witness to a historic social transformation."

As the importance of the Movement grew, Adelman's work attracted the attention of the press, and the photographer started to work with national and international newspapers, strengthening the resonance of his images. Adelman wrote: "Our photographs thrust the cruel racist system into the spotlight, helping to change the hearts, minds and habits of the nation."
Birmingham was a victory for the Movement and proof that it was possible to conquer civil rights in the streets through the direct and non-violent action of men and women.
On 28 August 1963, 250,000 people of diverse ethnicities gathered in Washington. The Civil Rights Movement had organized the March for Jobs and Freedom in front of the Lincoln Memorial. It was a joyful event: the people marched along singing, "Whites and blacks together." They rallied to

ask for the end of the government's support of racial segregation and racial discrimination in employment. "I went as a participant photographer," reminisces Bob Adelman, "there aren't many occasions and places where ideals and the real world come together, but that was one of those places." The last of the black leaders to speak to the crowd that had gathered for the event was Martin Luther King. He was already renowned for his excellent oratory skills, but the words he spoke that day are especially memorable. Disregarding his prepared speech, he started to improvise: "I still have a dream. It is a dream deeply rooted in the American dream. I have a dream: that one day this nation will rise up and live out the true meaning of its creed: *We hold these truths to be self-evident that all men are created equal.*" That powerful speech echoed in the square and on American televisions: it was a parable for the future that tied together the emancipation of slaves in Egypt and of present-day African Americans searching for an American Promised Land without racism. Bob Adelman was near the stage and took many photographs of Martin Luther King: "It was probably the greatest moment in his life and the greatest moment in mine," he said. "As the crowd dispersed with King's dream echoing in our minds, I remember I thought of the words of the Battle Hymn of the Republic and of Lincoln: *His truth is marching on.*"

In 1964, the Civil Rights Act put a formal end to segregation. It was a great victory for the Movement, but Martin Luther King knew that the formal attainment of civil rights would remain weak if it wasn't supplemented by a genuine access to social rights. He continued to shower American politics with requests for factual equality, asking for the reorganization of economic and political priorities. He thundered against poverty and the war in Vietnam. He attacked the pillars of America's social hierarchy. In April 1968, while he was at a rally in Memphis, he was shot and killed: the name of his assassin is still to be ascertained. A few days later, at his funeral in Atlanta, thousands of people gathered, grief-stricken, both touched and indignant, with King's words and his dream in their heads and hearts. *a.ta.*

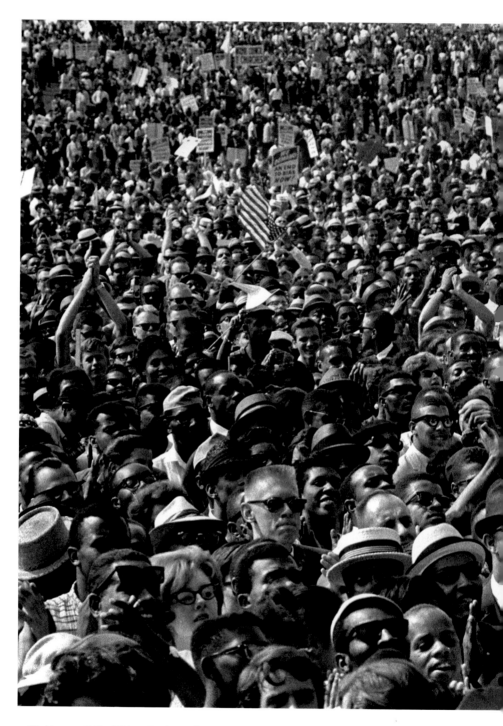

_ Washington D.C., USA 1963. An enthusiastic
crowd during the speeches of the memorable "March
on Washington."

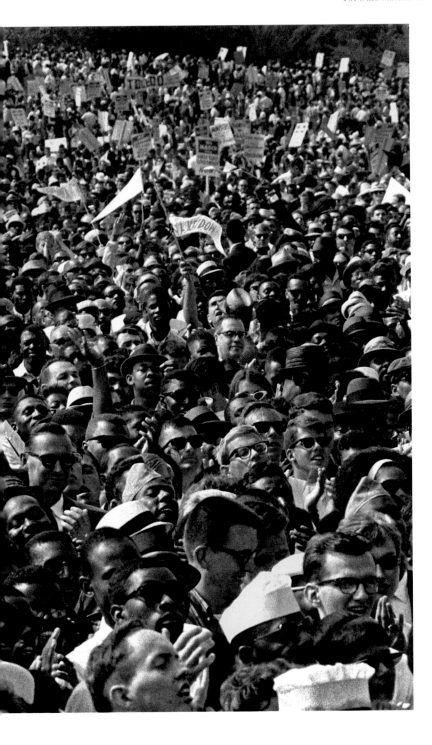

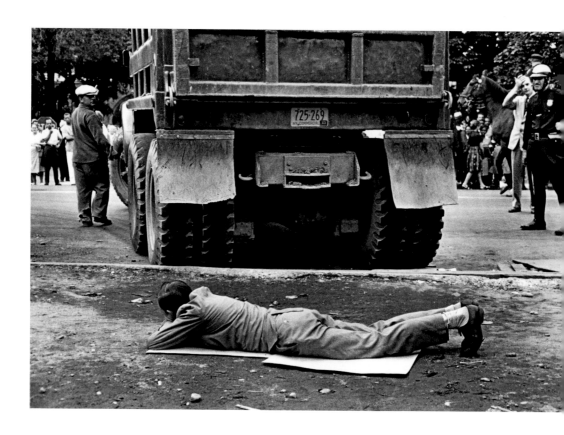

_ New York, USA 1963. A man demonstrating for
equal employment opportunities blocks trucks in a
building site for blacks and whites.

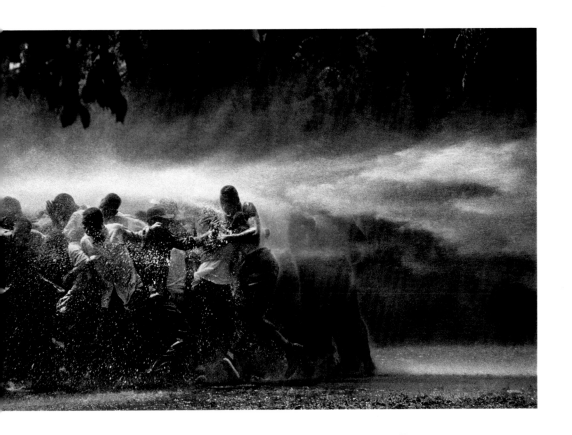

_ Birmingham, USA 1963. Firemen knock over some peaceful protesters in Kelly Ingram park with powerful jets of water from fire hoses. The protesters manage to stand by holding each others hand.

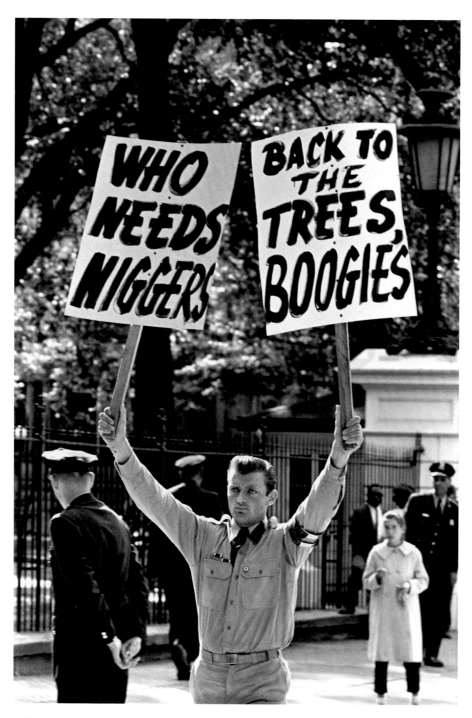

_ Washington D.C., USA 1962. A white man displays racist placards in front of the White House, while protesting against CORE (Congress of Racial Equality) demonstrators.

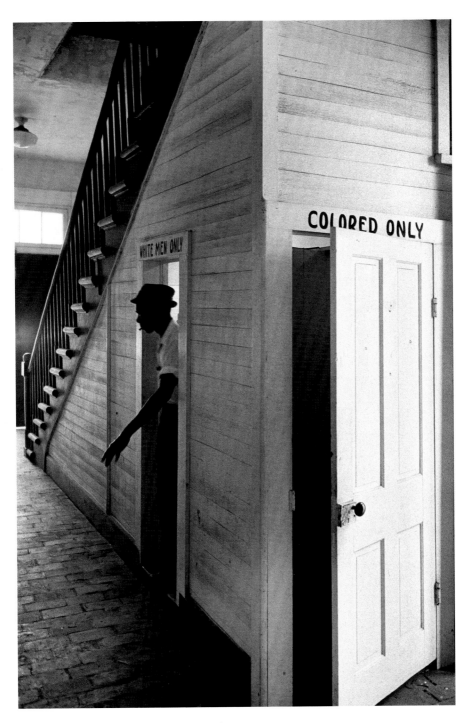

_ Clinton, USA 1964. A black man coming out of a
bathroom for whites only in the courthouse.

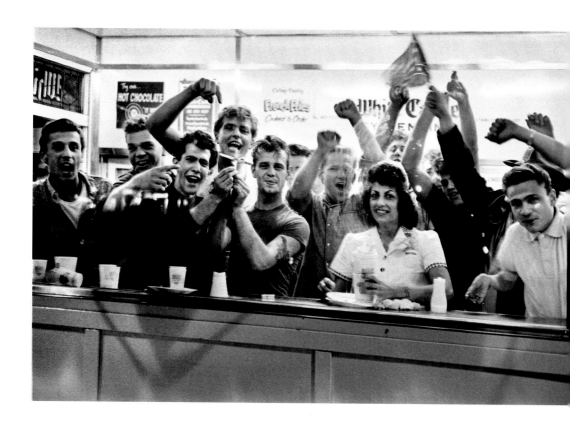

_ New York, USA 1965. The reaction of some cus-
tomers in White Castle restaurant in Bronx, against
the rally in favor of an increase in the number of jobs
for blacks.

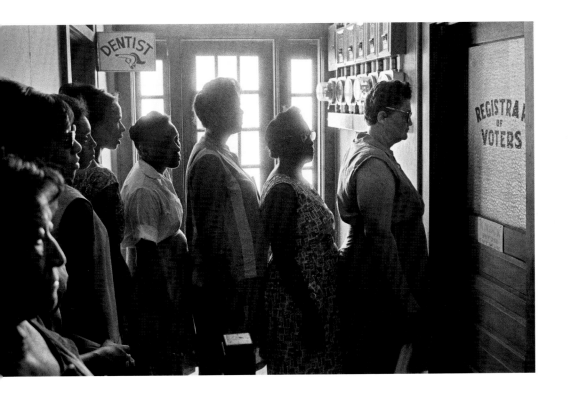

_ Clinton, USA 1964. A group of mainly African-
American women queue in front of the registry office
for their voting rights.

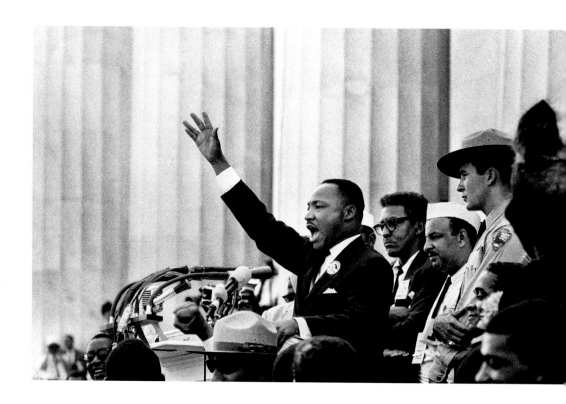

_ Washington D.C., USA 28 August 1963. Martin
Luther King during his famous speech "I have a
dream".

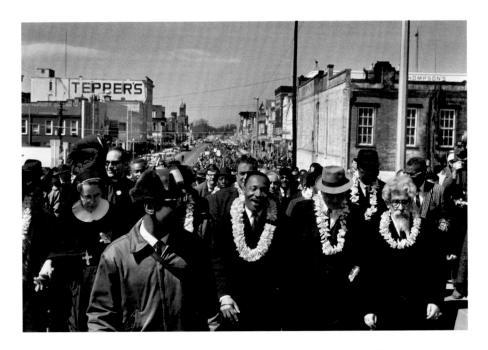

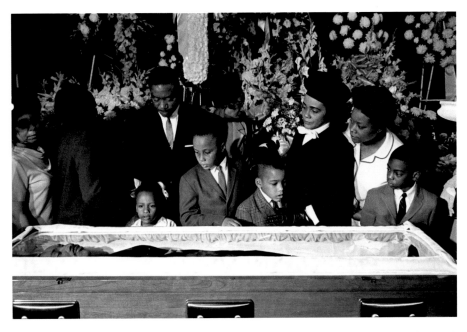

_ Alabama, USA 1965. Martin Luther King in the long march from Selma to Montgomery, for racial equality and voting rights.

_ Atlanta, Georgia, USA 1968. Martin Luther King's family in front of his open coffin, in Ebenezer Baptist Church.

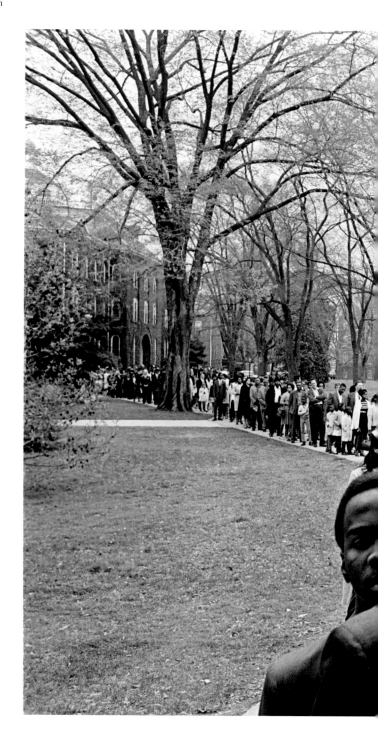

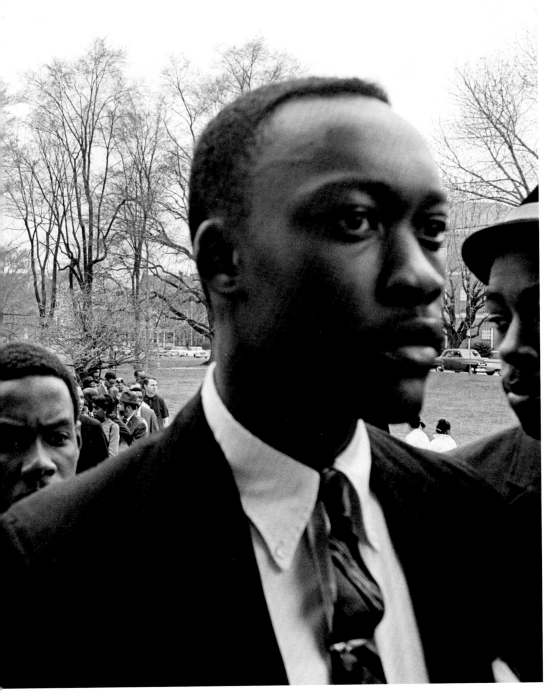

_ Atlanta, Georgia, USA 1968. People paying their last respects to Martin Luther King in the Spelman College Campus, before his funeral

_Vietnam Inc.

Philip Jones Griffiths

Philip Jones Griffiths
Vietnam Inc.
War explained through economics

"There are photographers who are still hammering home simplistic maxims about 'man's inhumanity to man'. This affords little insight into the subject. What we need is to understand the reasons why men set out to kill one another – a good place to start would be the realm of economics. Then, perhaps, we will be able to find another way to solve our differences".

Philip Jones Griffiths went to Vietnam for the first time in 1966, as a photographer for Magnum Photos. His love for the country and its inhabitants drew him back to recount his stories for more than thirty years. "I am not a war photographer," states Griffiths, "I have been back to Vietnam twenty six times since the war ended. War photographers don't go back to countries once the war's over, they go on to another war".

On his arrival in Vietnam, Griffiths travelled around every province in the South and two things became immediately clear: the huge cultural gap between the Americans and the Vietnamese – a difference that would inevitably define the outcome of the war – and the imperialistic attitude of the Americans towards the local inhabitants. He was also conscious of another issue: he could either join a photojournalistic agency and document the conflict and see his photographs published on the front page of the *New York Times* every day, or he could stay with Magnum and relate the story of a country with greater intensity and awareness, in an attempt to leave longer-lasting and more meaningful evidence. He chose the latter option, facing severe financial difficulties, though sharply aware of his role as a photojournalist: "To me, there is no point in pressing the shutter unless you are making some caustic comment on the incongruities of life. This is what photography is all about."

Vietnam Inc., published in 1971, is one of the most powerful photographic testaments to surface from the war. The outcome of three years' coverage, the

book set forth a new editorial concept that had a disruptive effect both in the world of photography, and in the then prevalent American conception of the war. In more than 250 photographs, punctuated by text, Griffiths describes a country devastated by war, but also life that goes on, resisting destruction. The author talks about the Vietnamese population with great respect, of its world of rice fields and villages, of the smiles of simple men and women, moulded by an ancient tradition. He recounts with a depth of knowledge not only the horrors of war, but, in particular, the structure of a society that American politics tried to alter with bombs. "What American politics tried to accomplish," wrote Griffiths, "was to destroy the village as a social unit. American politics needed South Vietnam to adopt a new creed: the doctrine of democracy, of free-enterprise and capitalism".

Vietnam's lush vegetation was the setting for a devastating and unbalanced clash between two societies based on, and inspired by, extremely different values: the agrarian Confucian culture that had characterized the Vietnamese people for two thousand years was under severe attack by US consumer capitalism.

These photographs show nature violated, burnt by napalm, bombed and poisoned by a military strategy that only saw it as a threat. It was an indifferent and incomprehensible violence, which took place in front of men who were used to considering, as Griffiths wrote, "any show of force as a proof of inferiority." The images show the demolition of villages, a pillar of the US war strategy, and the forced "relocation" of the rural population into cities where they could be "free" – a mystifying word used by propaganda to disguise the real objective: the creation of a nation of consumers that could be controlled through the production of profit.

Griffiths's work leaves room for both the humiliation, and the calm dignity of the Vietnamese population, and for the disorientation and inadequacy of the American soldiers, lost in an alien place and caught up in a war which had progressively become more unintelligible. Griffiths wrote: "The bored sniper at the window, a Vietnamese man bathing in a bomb crater, the soldier pointing his rifle to the head of a six-year-old child and then gives him a plate of rice and a pat on the shoulder."

In the first war in history ever to appear on international screens, and thus the

first conflict to dominate public opinion, Griffiths's work has been, and still is, a thought provoking tool and a magnifying glass on the truth.

Griffiths published two other very important books on Vietnam: *Agent Orange* portrays the devastating consequences of the dioxin-containing herbicide that the US Army used to destroy the forests where the Viet Cong found food and shelter; *Vietnam at Peace* is the chronicle of the long and difficult post-war period, and of the changes that the country has endured throughout the years.

War never ends with the withdrawal of troops and with the signing of a peace agreement, and this is even truer for the Vietnam war, as Griffiths has always insisted.

"One of the horrible things about the War in Vietnam is the that war, for those people, has never really ended." *a.ta.*

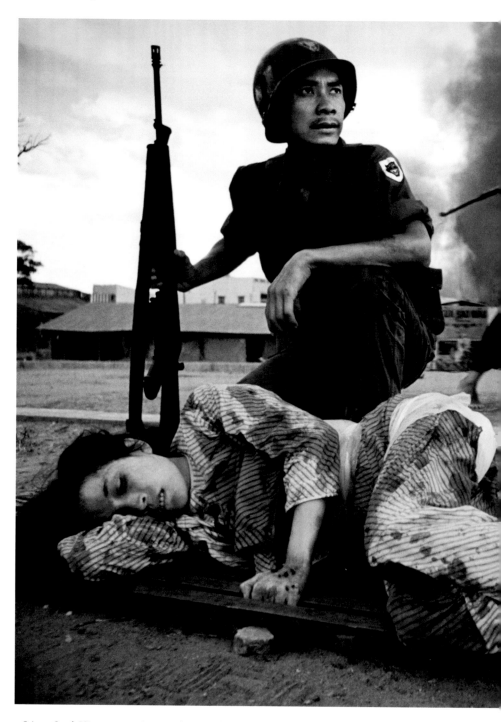

_ Saigon, South Vietnam 1968. A woman lying on the
ground, wounded by a shot fired from a helicopter.

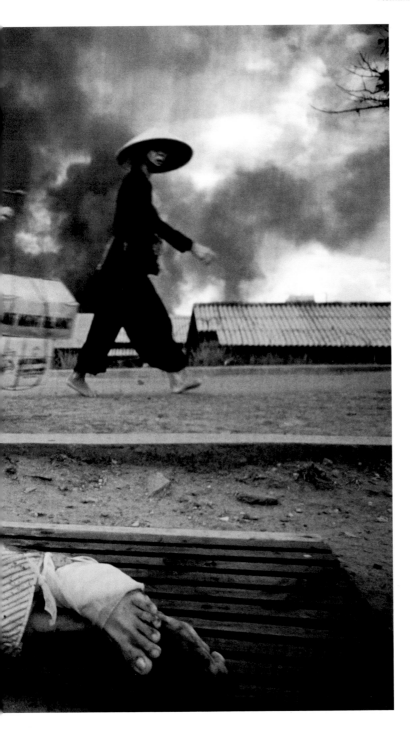

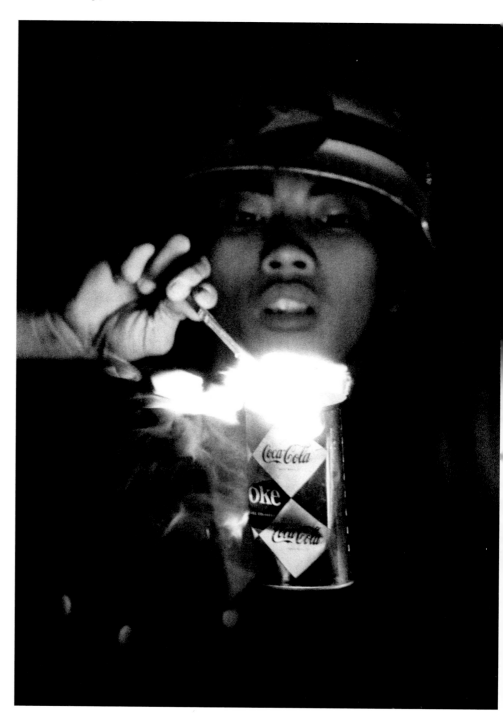

_ Saigon, South Vietnam 1967.

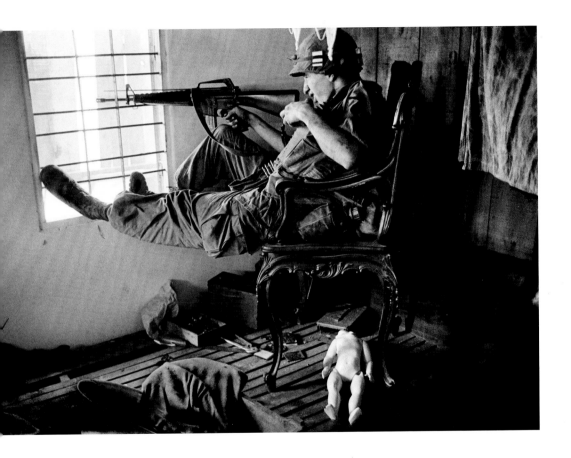

_ Saigon, South Vietnam 1968. An American sniper during a town bombing. Despite the seemingly relaxed attitude, the soldier is in the range of the enemy fire. A few minutes later the building will be destroyed by a rocket.

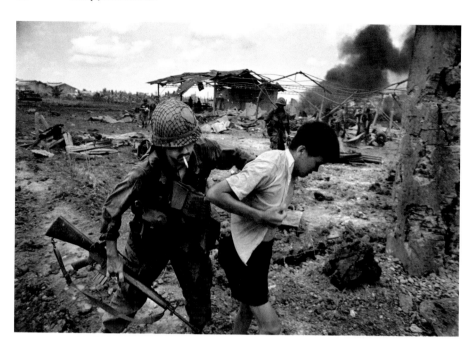

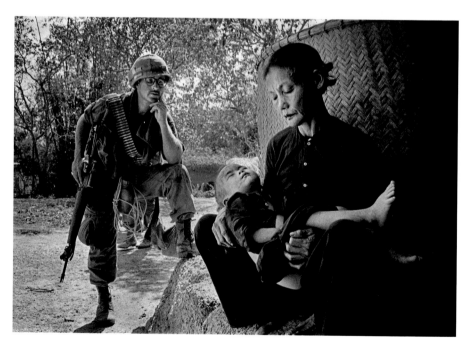

_ Vietnam 1968. An American soldier picks on an in-
nocent farmer.

_ Vietnam 1967. An American soldier in a village du-
ring a routine operation, known as "find and destroy."
The mission entails the elimination of men, the de-
struction of hideouts and bunker, leaving defenceless
women and children under artillery fire.

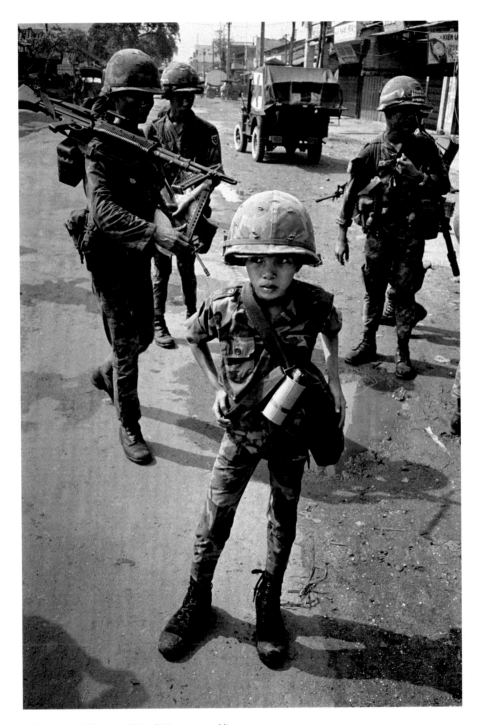

_ Vietnam 1968. Ten year old South Vietnamese soldier, called a "little tiger" for killing two Vietcong women cadre. His mother and his teacher, it was rumoured.

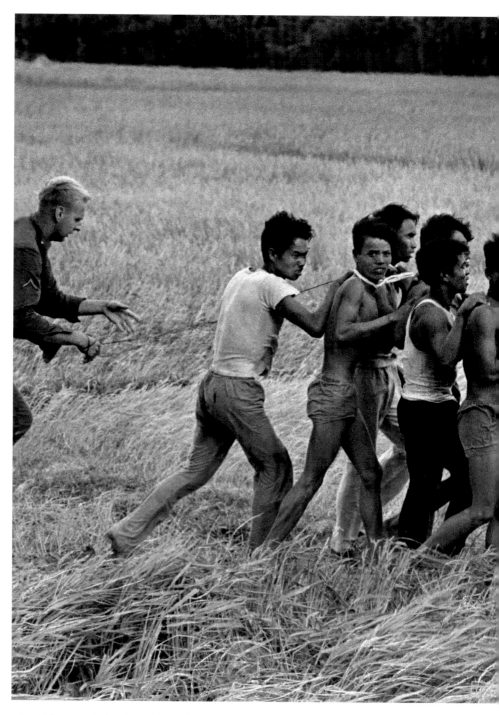

_ South Vietnam 1967. American soldiers with a group
of captured Vietcong suspects.

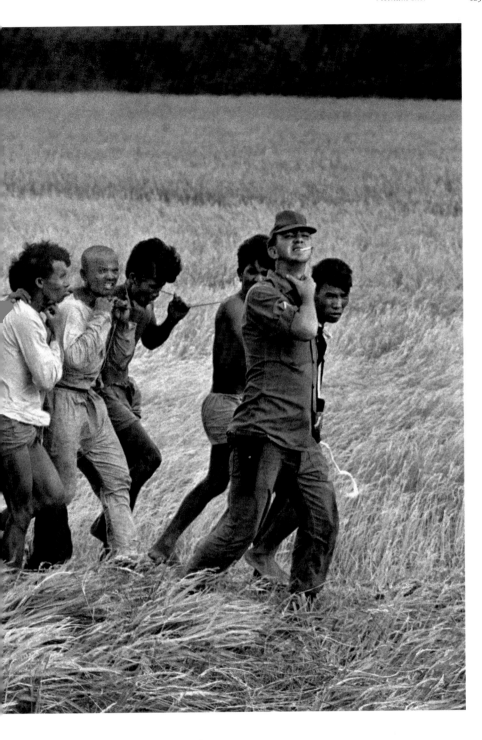

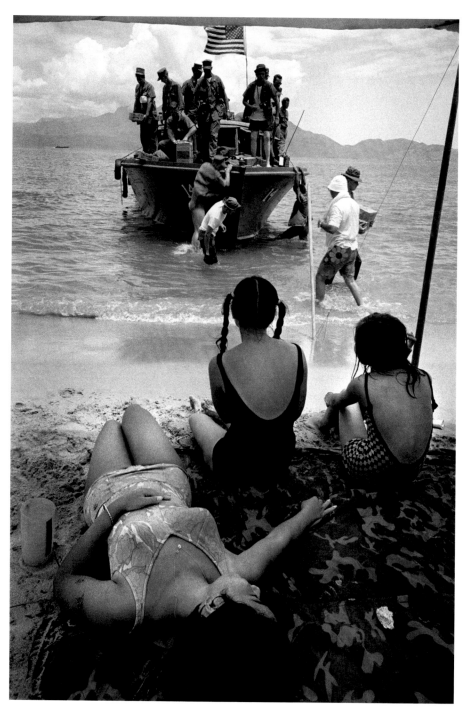

_ Danang, Vietnam 1970. Marines land on a beach to organize a barbecue to boost the morale of the troops and promote the American way of life.

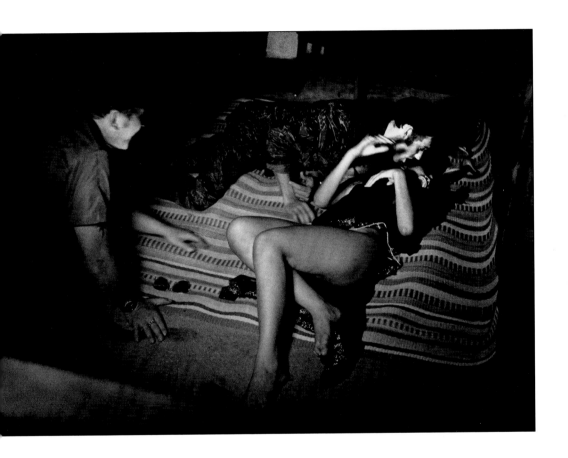

_ Vietnam 1970. Two American soldiers abuse a dancer
after her performance for a group of navy officers on an
improvised stage.

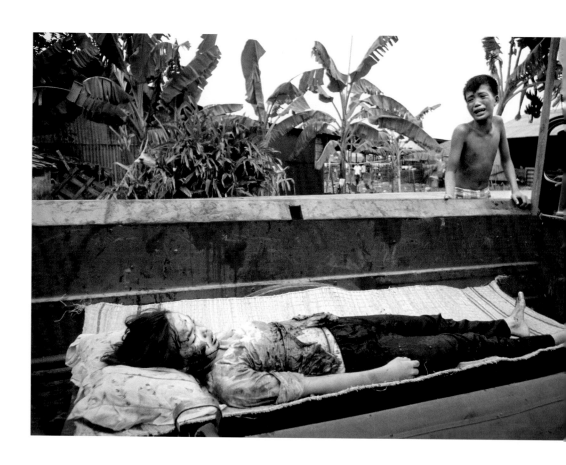

_ Saigon, South Vietnam 1968. A child finds his sister's
body, gathered by the firemen along the road.

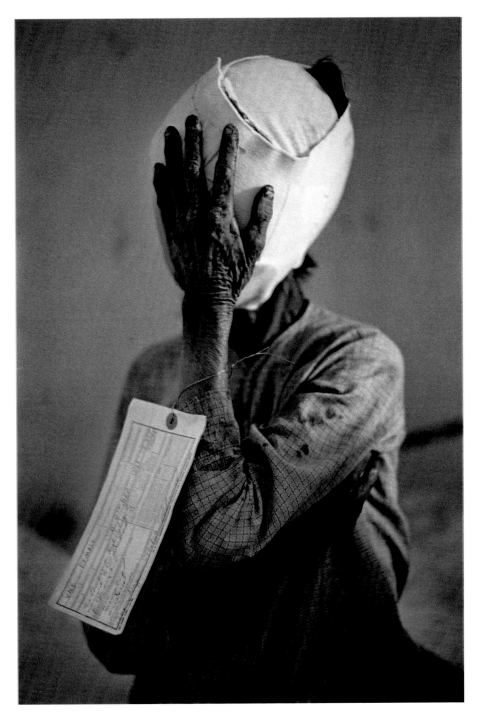

_ Vietnam 1967. A woman injured by fire and exceptionally tagged with the designation "Vietnamese civilian". The wounded were normally tagged "Vietcong", "Suspect" or "Confirmed."

_Red-Color
News Soldier

Li Zhensheng

Li Zhensheng
Red-Color News Soldier
Censorship during China's Cultural Revolution

Li Zhensheng's first personal camera was a Japanese 120mm that he had received from a collector in exchange for a stamp collection. At the end of the fifties he started to take photographs with a group of aspiring photo journalists equipped only with one Brownie 120mm which they took turns to use. His great opportunity arrived when the Film School where he had been studying had to shut down because of lack of funds, and the students were asked to complete their training with a course on photojournalism. In August 1963 Li Zhensheng started working as a photographer for the Heilongjiang Daily in the city of Harbin, the capital of Heilongjang province that borders the ex-Soviet Union, China's former ally. The new China was founded in 1949, after the victory of Mao, but the seemingly flourishing situation soon turned out to be a mere illusion. Liu Shaoqui conferred Mao the task of reconstructing the country and, with the aid of liberal reforms, China seemed to rapidly recover. However Mao's popularity plummeted, both at a national and international level: Khrushchev harshly criticized Mao's politics and interrupted all diplomatic relations. In order to regain credibility, Mao turned to the masses with the motto "Nip the counter-revolution in the bud." His aim was to remove Liu Shaoqui and rule over a newly thriving China. Large groups of students poured into the countryside to learn how to share the toil and the hardship of the farmers, increasing the revolutionary fervour. Mass demonstrations and rallies were organized to scorn landowners, rich farmers, and counter-revolutionaries in a sort of witch-hunt against all class enemies. Li Zhensheng was one of the first to join the Young Pioneers movement, the first group of youths to wear the red scarf. He left for the countryside in 1964 only to return to his job at the newspaper two years later, in 1966. In May of the same year, the Cultural Revolution began. Newspapers, music, dance and opera were a popular ground for the diffusion of revolutionary principles and a powerful means to promote the figure of the "Great

Helmsman", Mao, whose quotations were collected and diffused in what became the new Chinese Bible: the Little Red Book. The motto was to "Destroy the old to establish the new." Mass demonstrations proliferated and thousands of people destroyed statues and sacred books, repudiating Buddhist scriptures and humiliating those who still believed in them. In a period of mass celebration, but also of intimidation and repression of the enemies of the revolution, the photographers were not allowed to collect and publish anything that could jeopardize China's image. Inspections were very frequent and often the guards opened the cameras, damaging the negatives and the camera's components. Very few reporters took part in mass events. One of these was young Li, with little experience but with a strong desire to learn. In order to wear the Red Guards' armband and, thus, take photographs during demonstrations without any harassment, he founded a rebel group at the newspaper where he was working. Any negatives which could damage China's image were destroyed. But, unlike other photo reporters, Li Zhensheng never handed anything in. He personally developed his own negatives, dividing the ones that were suitable for publishing from the ones that were not, placing the latter in his office, in a special drawer where he had made some secret openings. "I didn't know if I was doing it for the revolution, for myself or for the future, but I knew that I had to do it." He attended every denunciation session and every mass event. He took pictures of the accused with their faces stained with ink, mixed with blood and tears, their heads hanging low with placards dangling from their necks, exposed to the masses who publicly insulted them. In the first few months of 1967 the rebel headquarters of the Revolutionary Workers Party in Shanghai overthrew the Town Party Committee and local government. The Red Guards in Harbin took over the Heilongjiang Daily and closed it down, establishing an organ representing the Red Guards in its place. As a member of a Revolutionary Committee, Li Zhensheng became head of the personnel and vice commander of the Division for Political Issues. These were only the first signs of a change that, in 1968, was to put an end to his fortune. Squads, formed by leaders of revolutionary groups, re-established the power and control of the Party within the local Revolutionary Committees. Li Zhensheng expressed his dissatisfaction. Directly accused and purged from the Permanent Commission, they started to investigate his family, his career, and his political activity, looking for reasons to incriminate

him. After a denunciation session he was banned from taking photographs and his cameras were confiscated. Fortunately, Li had moved his secret negatives from the studio to his house, hiding them in a gap under the floorboards. In 1969 he was sent to a re-educational school with his wife at Liuhe, where people were expected to work hard every day and study Mao's works during the nights in order to be reformed. Two years later, in May 1971, Pan Fusheng, head of the local committee of the Heilongjiang region, was deposed and Li returned to Herbin. The newspaper directors were replaced and the Permanent Commission was abolished. Li Zhensheng was readmitted to the newspaper after publishing an article in which he publicly criticised himself, hence proving his rehabilitation. In 1972 China was torn between two opposing factions: the one led by Jiang Qing, Mao's wife, with the "Gang of Four", and the more moderate faction led by Zhou Enlai and Deng Xiaoping. Worried about a clash with the Soviet Union, Mao opened up to the USA, marking the end of China's segregation. When in January 1976 Zhou Enlai died, shortly followed by Mao in September, Li Zhensheng shot a reportage of their funerals, taking close-ups to capture the suffering and the tears running down peoples' faces. But he soon realised that people were less distressed for Mao's death than for the loss of Prime Minister Zhou Enlai. People had started to mull over the future of their country. The Central Committee in Beijing broke up the "Gang of Four", putting a definite end to the Cultural Revolution. Nevertheless, China struggled to emerge from the deep-rooted mechanisms of power that marked the contradictory phase of China's history after Mao. Li Zhensheng punctually portrayed and gathered these contradictions until 1980, creating what can be considered the only true and complete historical photographic record of the Cultural Revolution and its outcome. His images remained secret until 2003, apart from 20 photographs which were published in 1988 and on account of which Li Zhensheng won the first prize at China's National Photo Competition held by the National Press Association. His photographs and life story were gathered by Robert Pledge and Jacques Menasche of Contact Press Images in a touring exhibition and in a book called Red Color New Soldier (Phaidon Press, 2003). "I want to show the whole world what really happened during the Cultural Revolution, how this made people fight against each other, and how we all were victims, from those who were beaten or killed to those who inflicted suffering onto others." *a.tu.*

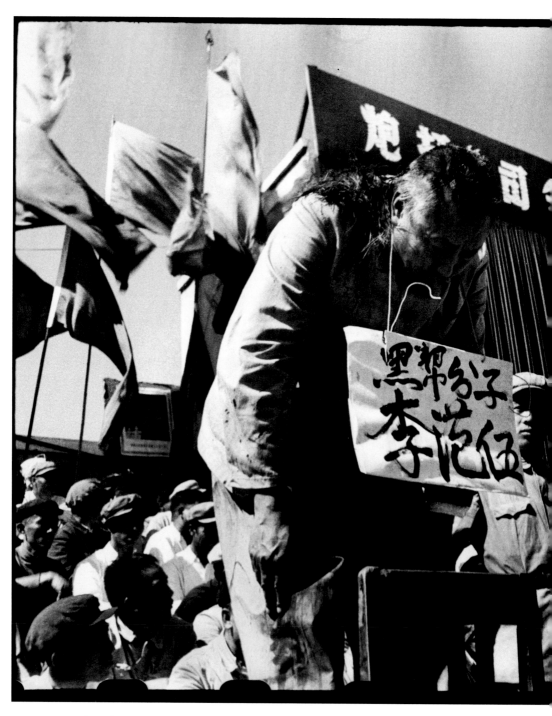

_ Harbin, China 12 September 1966. Li Fanwu, local
governor of the province of Heilongjiang, is accused
of political ambition for his remarkable resemblance
to Mao and has to bend forward for hours after the
Red Guards had shaven his hair off.

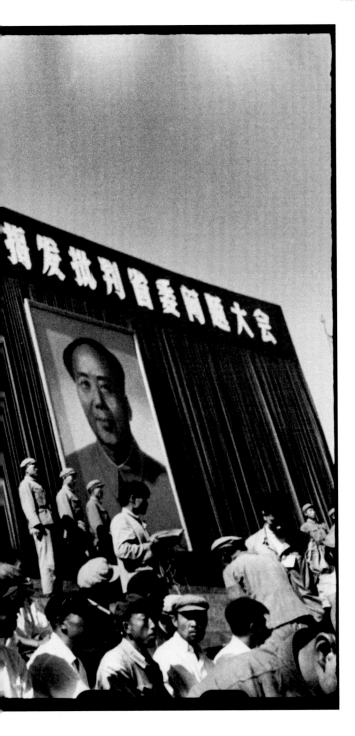

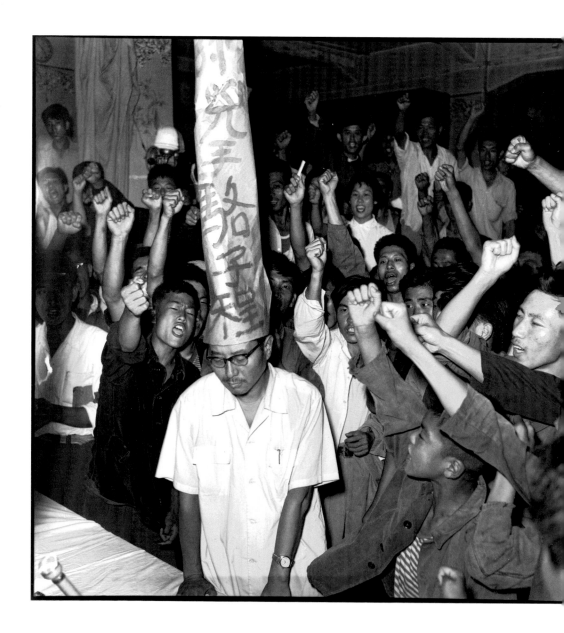

_ Harbin, China 25 August 1966. The staff of the
Heilongjiang Daily accuses Luo Zicheng, head of the
work group designated by the Provincial Party Com-
mittee, of following the capitalist publishing line and
opposing mass movement. His dunce cap reveals his
crimes.

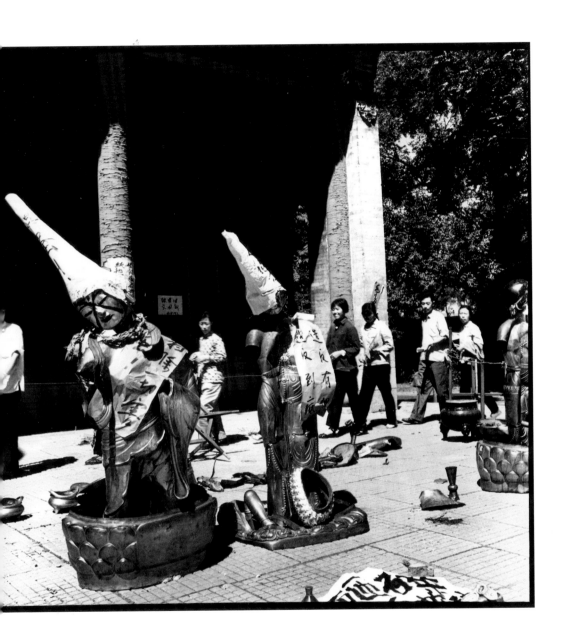

_ Harbin, China 24 August 1966. Immediately after
the destruction of the Jile Temple, the statues are de-
secrated with paper dunce caps.

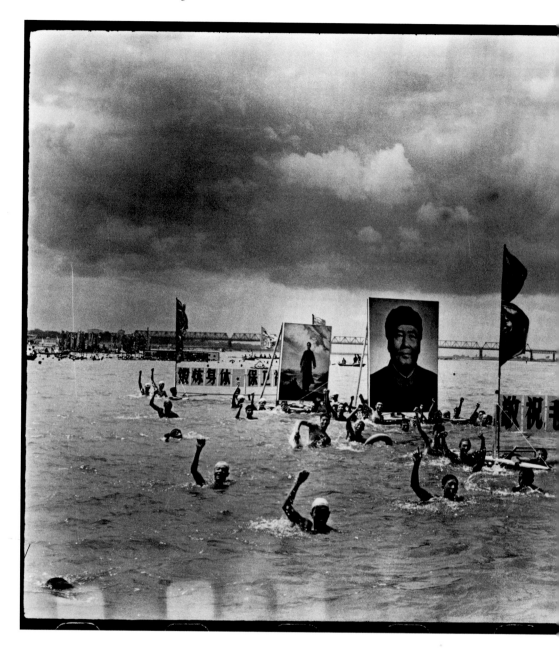

_ China 16 July 1967. On the Songhua river to com-
memorate the first anniversary of Mao's swim in the
Yangtze, a moment which had marked his return to
power and the beginning of the Cultural revolution.

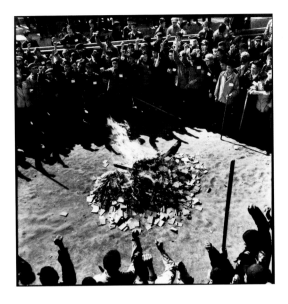

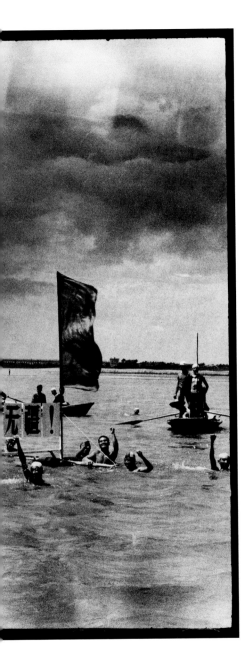

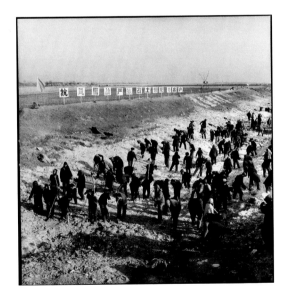

_ Harbin, China 19 September 1966. The shares, government securities and savings books which had been confiscated during house searches are burnt during a public rally held by the Red Guards.

_ China 17 December 1974. The "educated youths" from the cities and the local farmers till and irrigate the frosted ground to prepare it for sowing.

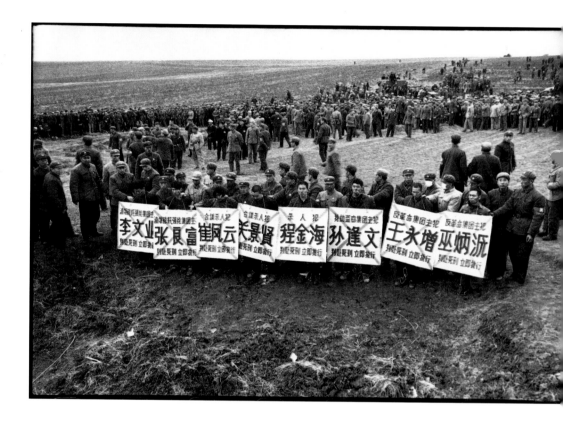

_ China 5 April 1968. After a public trial, seven men and a woman are sentenced to death and taken to the outskirts of Herbin, where they are lined up with their backs to the crowd which has gathered to watch the execution.

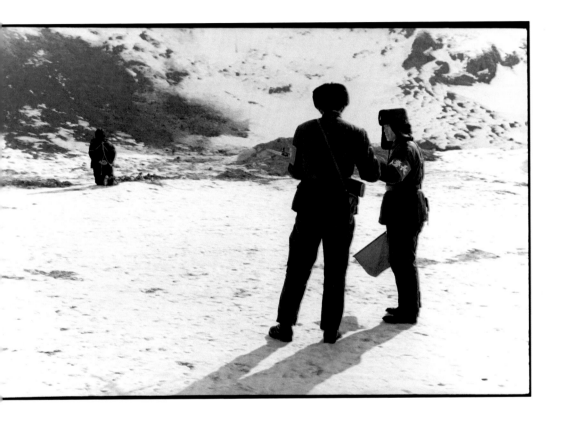

_ China 8 February 1980. Wang Shouxin, ex rebel and Party secretary during the Cultural Revolution, is accused of embezzlement in the wake of widespread corruption. Her trial was deemed as the judgment of "the most corrupt person of the foundation of new China". She was eventually sentenced to death and shot.

_Fit to be Untied

Gianni Berengo Gardin
Carla Cerati
Luciano D'Alessandro

Gianni Berengo Gardin, Carla Cerati, Luciano D'Alessandro
Fit to be Untied
The psychiatric revolution in Italy

"It was 1965: not long before Basaglia and not long after Goffman and his experience in Great Britain. I met Sergio Piro, the director of the mental institutions in which I had worked for three years. I must admit that at the time I had little interest in closing mental institutions and wanted to focus my attention on the loneliness of man. I was enthralled by the idea of the great ontological solitude... As it happens, everything got out of hand and the result became a political act of condemnation, as a result of the times and the extreme importance of this dramatic situation. It was the only possible outcome: the mentally ill did not produce any income, did not work, were of no use to anyone and, therefore, were segregated in a ghetto. In those days, hardly anyone knew what was going on in those laagers, and my work fitted in quite neatly with the general framework. The book (*Gli Esclusi*) was published In January 1969 and that was my first Sessantotto". (Luciano D'Alessandro)

Our 1968 anti-establishment movement was concerned with mental institutions: between the 60s and 70s Italian protests raged against the way they were run, giving rise to the reform known as Legge Basaglia, the Basaglia Law.

Franco Basaglia was made medical superintendent of Gorizia's mental institution, where he obtained a first-hand experience of the dramatic truth behind Italian psychiatric hospitals: gates, bars, doors and windows constantly shut out the world, and chains, bolts and locks imprisoned those inside. Secure beds, straitjackets, cold baths, electroshock therapy and lobotomy were common remedies. The new superintendent decided to remove all forms of physical constriction, making sure that the sick people had the freedom to stay in the open air. The patients were to be regarded as people with problems, men and women who were facing a critical moment in society and with their families. They were no longer to be considered as internees in a mental asylum, but

guests in a "therapeutic community." Basaglia had the urge to show society a truth that had been hidden for far too long, and enthusiastically accepted Carla Cerati's proposal to apply her experience as a photojournalist to such an important task.

"At the end of the sixties", She says, "I was deeply stirred by Avedon's reportage on psychiatric hospitals and I started to think about how I could work in an Italian mental institution… At the same time, Einaudi published *L'istituzione negata* and *Che cos'è la psichiatria*, by Franco Basaglia, who was fighting a battle in Gorizia in favour of closing mental institutions. I contacted him and he was extremely keen on allowing me to take photographs… At first he had a much bigger project in mind, a photographic book on all repressive institutions… Then, considering the urgency of attracting public attention on the conditions endured by patients in the mental hospitals, he decided to focus his attention on mental institutions alone, where it was easier for him to gain access. I say 'allowing us' because, partly out of friendship, partly out of shyness I asked Berengo if he wanted to come with me."

In 1969, also on account of the social and institutional transformations brought by the Sessantotto movement, the depravity of the mental institutions came to light thanks to two books. The first, *Morire di classe*, was edited by Franco Basaglia and Franca Ongaro Basaglia for Einaudi's "political series, with the purple cover," and included the photographs that Carla Cerati and Gianni Berengo Gardin, taken in the mental institutions of Gorizia, Ferrara, Florence and Parma. The second book, the abovementioned *Gli Esclusi*, was written by Luciano D'Alessandro and documents a three-year study of the Materdomini mental institution in Nocera Superiore.

Photographers following Basaglia's line, the so-called "basagliani", used their cameras to change the widespread stereotype of madness and the mentally ill, and to restore their value as individuals who were forced to endure violence every day. They were madmen to be untied who became the protagonists of the eponymous film by Silvano Agosti ("Fit to be Untied"). The authors lived in the mental institutions, sharing the every-day lives of all those who inhabited them. Gianni Berengo Gardin says: "We intended to show the conditions in which the patients were kept, rather than the patients' ailments. All things

considered, if we had portrayed the ailments we would have been committing further violence on the patients and this wouldn't have helped them."

In Carla Cerati's photographs the subjects hardly ever show their faces. There is only one picture in which a man stares into the camera. "He attacked me immediately after. He had felt violated by that shot," Cerati remembers. From then on, the author tried to "distract" the subject and almost hide behind the camera lens: a form of respect that Cerati felt she owed her interlocutors. Berengo Gardin observed and exposed the instruments of torture and the areas of confinement, focusing more on "the subjects' complicity" and trying to "capture their attention," to put it in Carla Cerati's words.

D'Alessandro is completely at one with the patients' solitude. He started by researching man's loneliness and chose to denounce the institution without abandoning his original assumptions.

Driven by the principles shared with the new Democratic Psychiatry movement, the photographs of these authors document mental institutions and mental illness from a new point of view.

The photographs taken by Berengo Gardin, Cerati and D'Alessandro enabled Basaglia to reach his goal: "to use the institution against itself," preparing the way for the closure of mental institutions. In 1978, Law 180, also known as the Legge Basaglia, was passed. It did not only decree the obsolescence of psychiatric hospitals, but also a cultural change, with the recognition of patients' rights and of their quality of their life.

"…It was important to stir indignation, to give rise to a reaction that could support the approval of Law 180… Those who wanted to change the law thought that photography would provide an effective means of communication. The famed Law 180…was, in Basaglia's mind, just a beginning, something that would have gradually been adjusted as it came into force, starting from a practical level." (Gianni Berengo Gardin) *a.tu.*

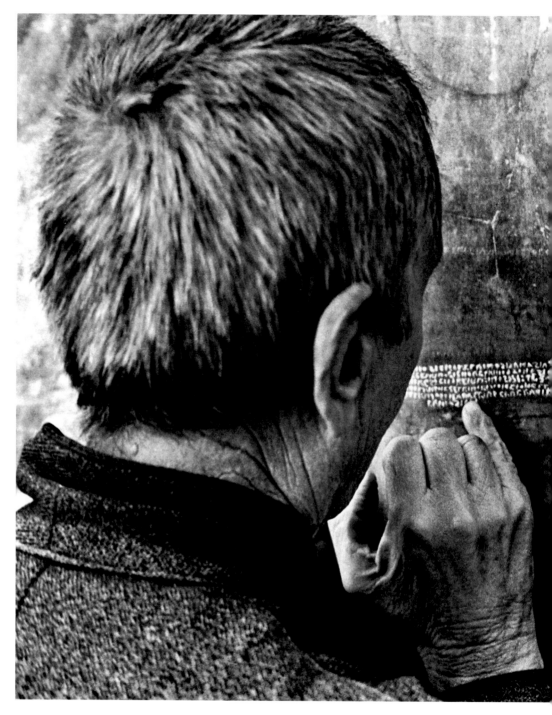

Luciano D'Alessandro _ Salerno 1965-1968, Materdomini Mental institution in Nocera Superiore.

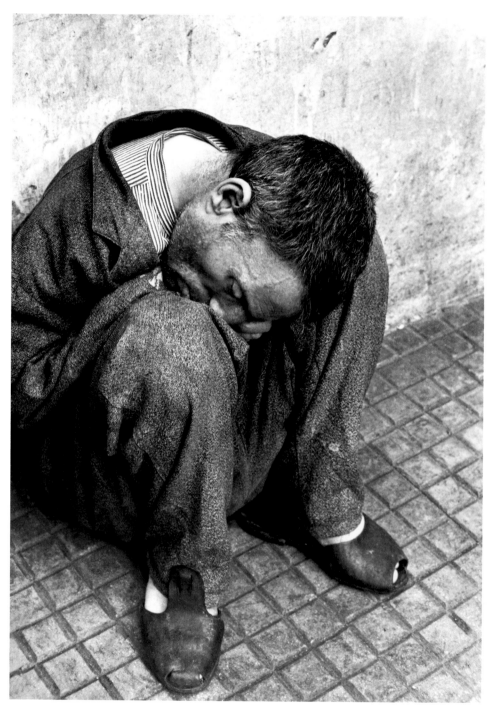

Luciano D'Alessandro _ Salerno 1965-1968, Materdo-
mini Mental institution in Nocera Superiore.

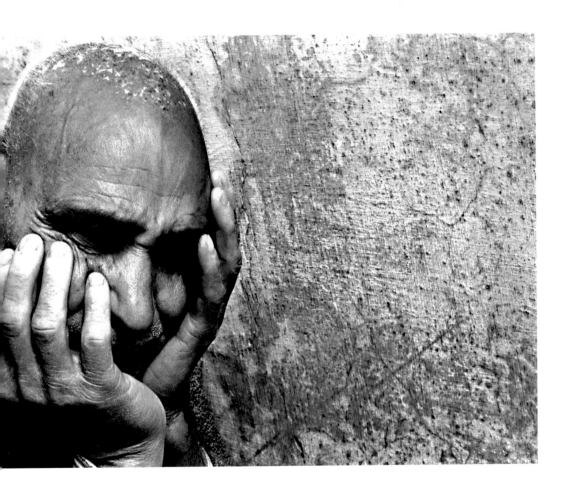

Luciano D'Alessandro _ Salerno 1965-1968, Materdo-
mini Mental institution in Nocera Superiore.

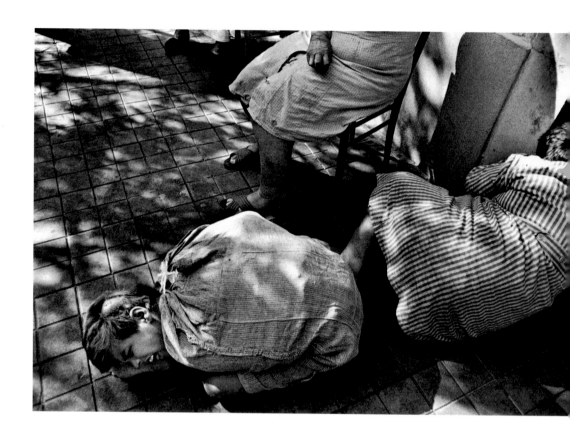

Carla Cerati _ Florence 1968, Psychiatric Institute.

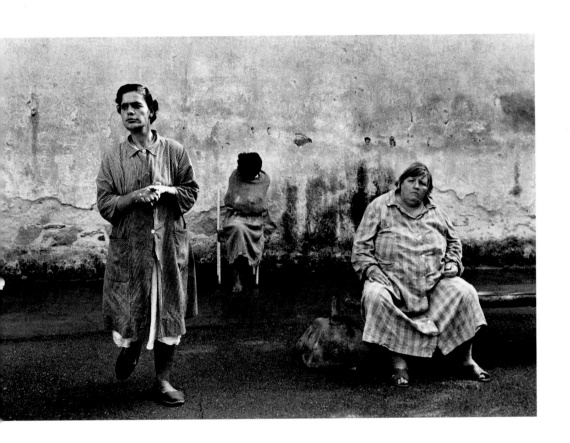

Carla Cerati _ Florence 1968, Psychiatric Institute.

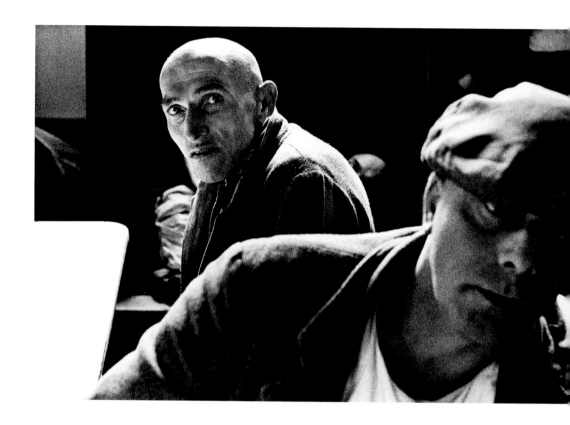

Carla Cerati _ Parma 1968, Psychiatric Institute.

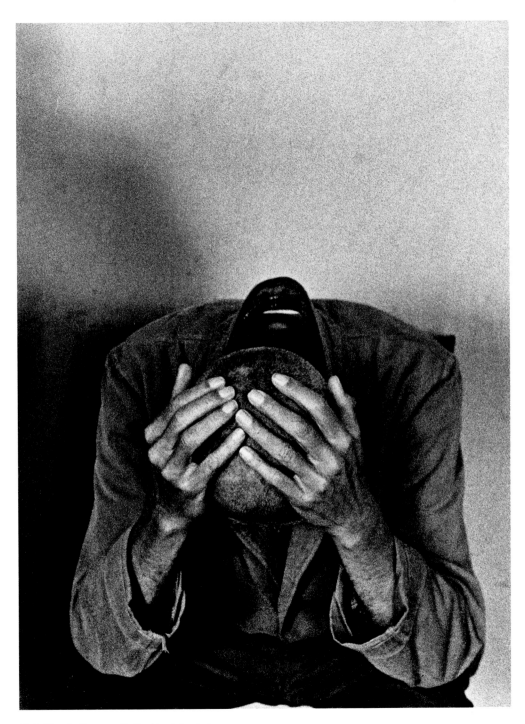

Carla Cerati _ Parma 1968, Psychiatric Institute.

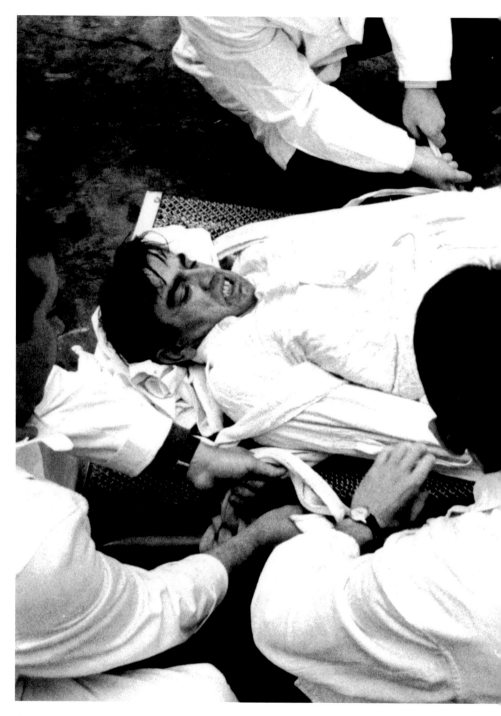

Gianni Berengo Gardin _ Parma 1968, Psychiatric
Institute. In extreme cases, the patients are tied down
to their beds with straps.

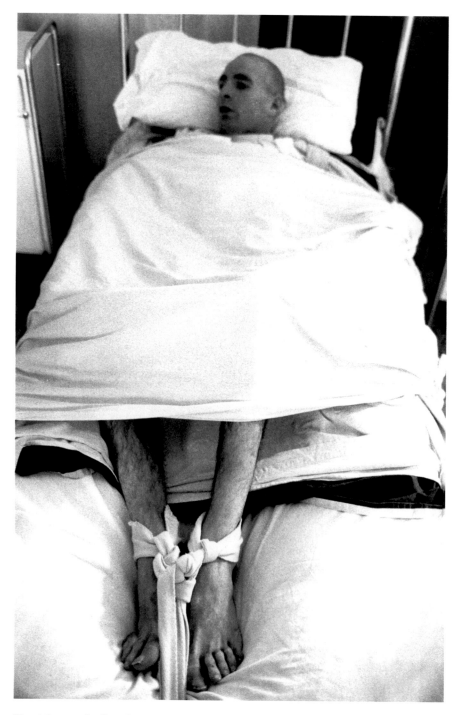

Gianni Berengo Gardin _ Parma 1968, Psychiatric
Institute.

Gianni Berengo Gardin _ Gorizia 1968, Psychiatric Institute.

Gianni Berengo Gardin _ Parma 1968, Psychiatric Institute. The Psychiatric Institute's keys hanging from the custody officers' belts.

_A free outlook

Josef Koudelka

Josef Koudelka
A free outlook
The broken dream of the Prague, spring 1968

The photographs taken in 1968 in Prague by Josef Koudelka show the benefit of having an unbiased critical eye. One which, when used with a certain degree of visual anger, can help one to understand one's own life and the events that sway it.

On the other hand, if speaking about photographic talent as a sense, and if someone really is "better" than others at scrutinizing reality, Josef Koudelka has that gift. The author has covered a vast number of intricate fields, but his work has been largely characterized by an urge to be free, a necessity that almost equals his talent. Josef Koudelka has always been aware that the secret of his photographs – haunting images that have become archetypical in photographic history – is their freedom of movement, of adjusting his eye and awareness to match the rhythm of his pace in the world. Be it focused on the landscape of his motherland of Moravia, or on the planks of a stage where Czech theatrical companies staged performances of "Ubu Re", or perhaps, while roaming around in search of eastern European Gypsies to photograph on the *panoramas* of our world, Koudelka's approach has always been to observe everything through his rare gift for poetic transfiguration. A gift which his critics have always regarded as "extraordinary".

His interest started with a Moravian baker, Mr. Dycka, an enthusiast of landscape photographs who occasionally showed his images to his customers, including Koudelka. It was the very same Dycka who would later teach him how to develop and print a proof. Years later, when studying aeronautical engineering at the Technical University in Prague, Josef learned how make enlargements. Koudelka left his job as an engineer only in a second moment, after experimenting and breathing photography in his own way – in other words, totally.

In the summer of 1968, during the Soviet invasion of Czechoslovakia that put an end to the dream of a new "Spring," Koudelka was in Prague. Russia had been threatening to invade the country since January, and Czechoslovakia had made clear earlier in the year what it thought of "Real Socialism". Even if Alexander Dubček's "socialism with a human face" did not aim at overthrowing the old regime and moving away from the USSR, the threat seemed tangible. If the opportunity of having more freedom to create parties which were not aligned with the Communist Party, or to have the chance to express oneself either directly or through independent newspapers didn't seem to pose a great threat to Soviet Socialism, it definitely represented to the USSR, the intolerable prospect of rebellion in the Cold War climate. In the night between August 20th and 21st, around 600 thousand soldiers and between 5000 and 7000 tanks invaded the country. In that same moment, the largest part of the Czech army, obeying secret orders of the Warsaw Pact, was sent to the East German border to aid the invasion and to prevent the West from sending any help.

The dawn of August 21st 1968, when the occupation of the country by "allied" troops had become a tragic reality, Josef Koudelka, as other fellow citizens, might have thought it was some kind of bad joke. But the tanks along the streets were more than mere visual *nonsense*, they were a violence, a violation of freedom that Koudelka felt deeply. But, he had his camera and so went down to the streets to start taking photographs. He snapped without stopping, without fear, but with the urge to do so simply because he was there, in the city he knew so well, where he lived and where all this was taking place.

The photographs recount the tanks in the streets, the anger of all those who tried to stop the violence – even with their own bodies – the demonstrations, the houses, the tears and the desperation.

It almost seems as if the camera is surprised by those scenes, by its continuous transfer between the movements of the masses to the eyes and expressions of individuals, by the brave and almost reckless actions of vulnerable people facing the tanks or attacking them armed only with a stone, while their other hand clenches a bag of their documents. The war invaded the streets among citizens trying stubbornly to live their own lives, to reaffirm their right to freedom, to fight against the chaos taking place in their city. The man with

dark glasses in the shadow, holding the black-edged placard in memory of Jan Palach, is but the tip of a multitude that only wanted to express covert anger and constrained sorrow.

Much has been said about this group of photographs, which are so different to the rest of Koudelka's work, and of their political value. As if this voice of the gypsies, the stage-photographer capable of amazing geometrical inventions, had decided, for once, to pick up his camera and denounce the atrocities surrounding him. It is, in fact, a coherent research on reality, intended as "a living entity" (Petr Kral), in which these images must be inserted and considered. The political values are not separated from the author's vibrant and emotional, visionary and aesthetic, deep and personal views. If the photographs taken in Prague, 1968 are the chronicle of an intense political period and denounce the violence that occured, they also provide a unique and dazzling report of it.
The freedom that the Russians came to crush with their tanks is not only the freedom of an entire population, but also the personal freedom of a man, a young photographer in his thirties, who only asks to express himself by taking pictures with an independent stance – the only approach that gives a sense to his work.

The photographs clandestinely reached New York's Magnum Photos where Elliott Erwitt, the current president, decided to release them. A year later, these very same images, published anonymously for precaution, showed the world the affront of a military occupation and the greatness of the author's critical eye. In 1969, during a trip to Great Britain with a theatre troupe, Koudelka saw his photographs published in the *Sunday Times* and contacted Magnum, with whom he studied the possibility of defecting by obtaining a regular permit to take photographs of gypsies living in Western Europe. Once back in Czechoslovakia, he left the country to complete this "mission," but never returned until the fall of the Berlin Wall. *a.m.*

_ Prague 22 August 1968. It is past midday and the street is empty. In the afternoon the square was supposed to host a demonstration against the Soviet invasion. The people deserted it after discovering that it had been or-ganized by the occupants to justify the repression.

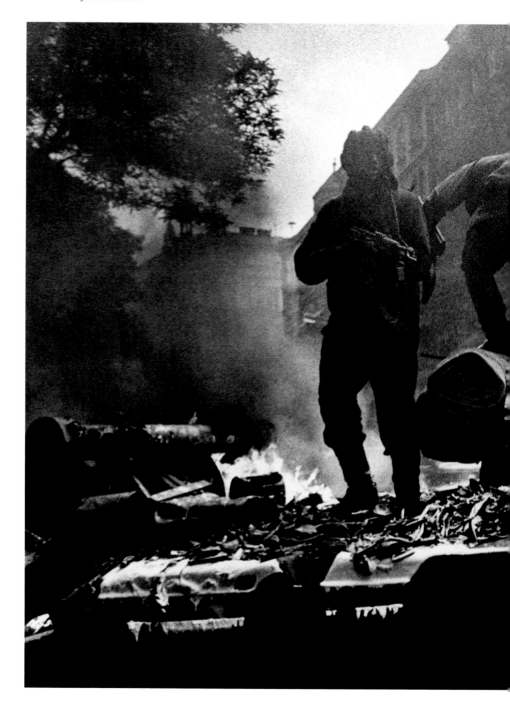

_ Prague 21 August 1968. Czechs face Soviet tanks.

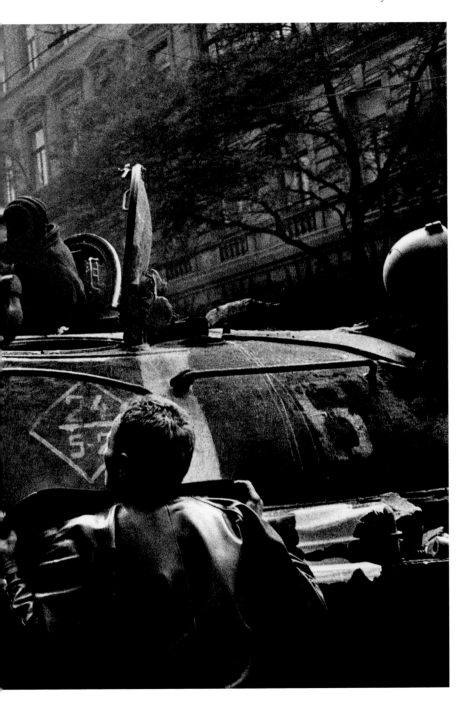

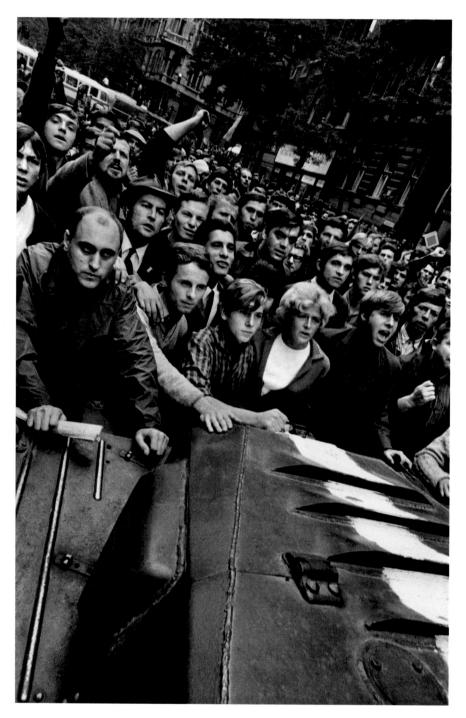

_ Prague 21 August 1968. The crowd tries to drive
back a tank.

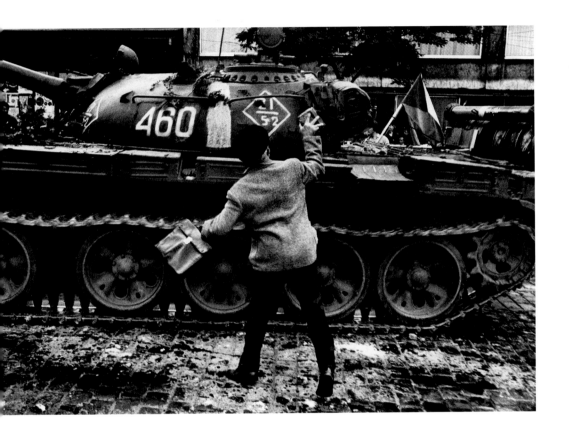

_ Prague 21 August 1968.

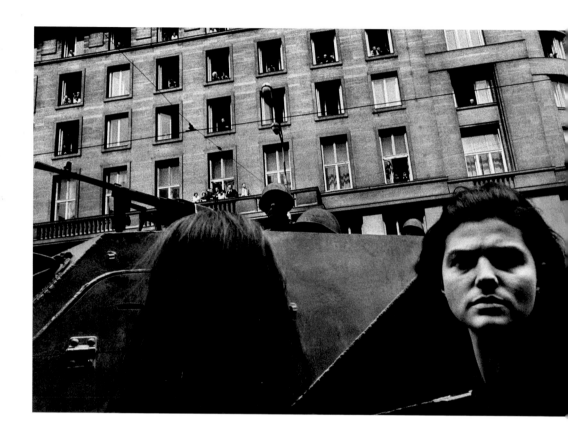

_ Prague August 1968.

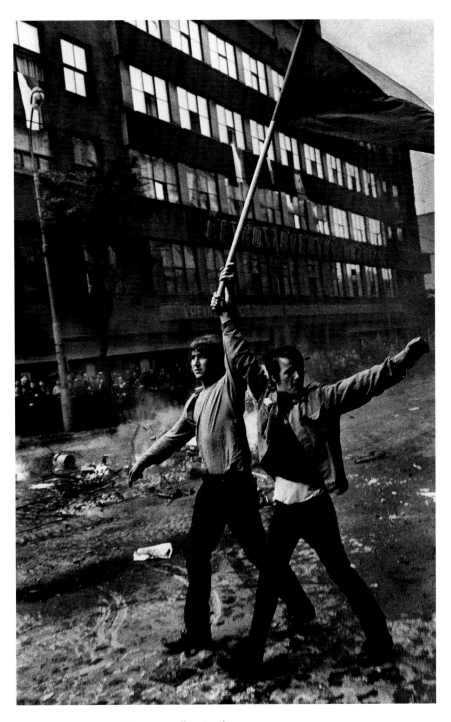

_ Prague August 1968. Citizens proudly raise the
Czech flag.

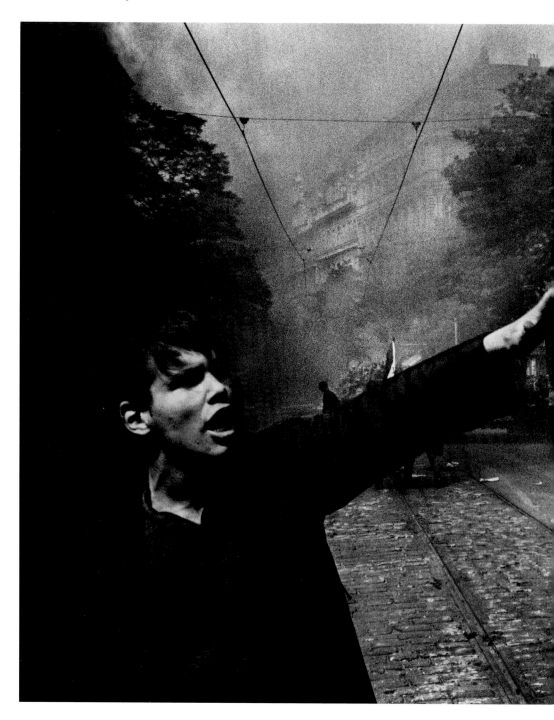

_ Prague August 1968. A gesture of defiance against
Soviet soldiers by a young man after the invasion.

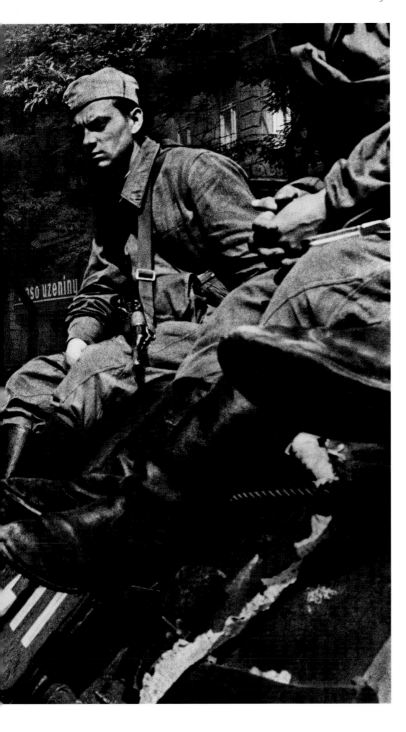

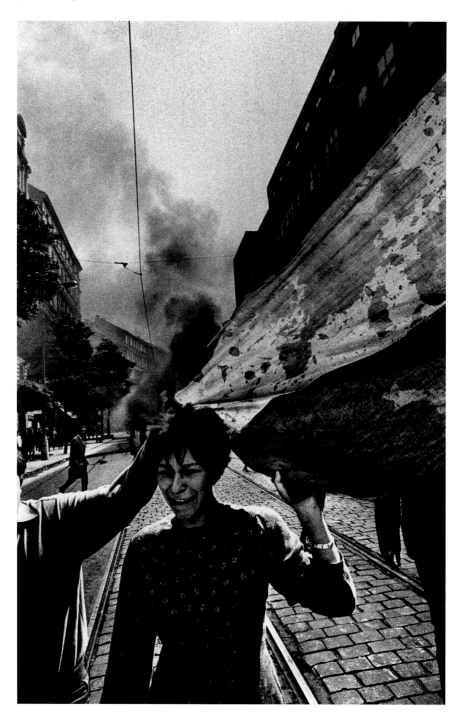

_ Prague August 1968. In tears for the fate of her
country, a woman raises a blood-stained flag.

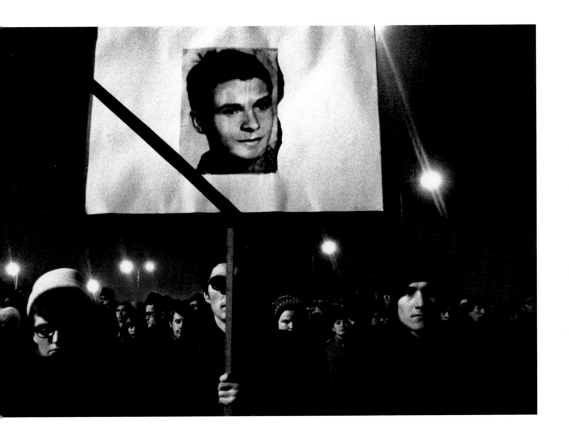

_ Prague 25 January 1969. Jan Palach's funeral, who
lit himself on fire in protest against the invasion of
Warsaw Pact troops.

_Minamata disease

W. Eugene Smith

W. Eugene Smith
Minamata disease
Mercury poisoning in Japan

Minamata's name is tied to the biggest natural disaster in Japan's history and, concurrently, to one of the worst cases of industrial pollution in history. It is a dramatic episode that started in the fifties in a fishing village in the Bay of Minamata, on the island of Kyushu. The disaster was triggered by the enormous amounts of mercury that had been dumped in the sea for decades by the Chisso Corporation, a petrochemical company that had been producing acetaldehyde by the bay. The plant had been discharging waste-water directly into the sea where plankton absorbed the mercury, transforming it into a highly toxic substance. Minamata disease was first discovered in 1956, and damages the brain and the central nervous system, deforms limbs, affects the ability to see and hear, and causes severe genetic birth defects. Around 12,000 people were affected by this terminal illness. Even if they were aware of the consequences of mercury poisoning before 1956, Chisso indifferently persevered in its criminal misconduct, denying any responsibility. It took twelve years before the company was found to be morally guilty. W. Eugene Smith arrived in Minamata in 1971 with his wife, Aileen Moko, whom he had married on their arrival in Tokyo. They stayed for three years, living and fighting with the victims of the disaster, reporting their sufferance and actively taking part in the legal battle against Chisso. By the time they arrived in the village, 46 people had already died: more than a thousand shared the same fate in the following year. Smith's career as a photographer, stubbornly built up since the thirties and based on his social conscience, found an ideal opportunity in the Minamata tragedy. His photographic report is both disruptive and delicate, and comprises some of the most famous and grievous images of his entire production.

If few people outside Japan were aware of the fate of this fishing village de-

stroyed by mercury pollution, Smith's photographs changed that and helped to bring the world's attention to this tragic event.

The photographer visited homes to disclose the stories of human suffering, surrounded and condemned by a poisoned sea. He followed the anguished fishermen carrying out their ancient and simple trade, once crucial for their survival and now turned into a hazard.

Smith did not only portray what he saw, but also what he sensed, and in Minamata he not only showed man's suffering, but also his battle against it.

In the images of deformed bodies, of the blind stares, of the hands that the illness had caused to become useless, Smith celebrates the human dignity that the victims continued to carry despite their deformities. Minamata gave Smith the opportunity to bring so-called "concerned photography", according to Cornell Capa's definition, to its highest levels. It is a type of photography that tells the truth, confident that the essence of photojournalism does not lie as much in objectivity as in the ability to record while reaching for a goal. He says: "Photojournalism is documentary photography with a purpose."

The civil, human and artistic passion that Smith brings to his work enables him to create powerful photographs that can't be ignored. The Minamata photographs gradually got darker, more dramatic and less journalistic. The strong sense of identification with the victims bestowed the author with a special vision, giving him the sensation of taking photographs from within their minds. The journalistic impact was disruptive. The victims sued Chisso, asking for compensation for the years of suffering and asking the company to clean the bay's water, which still contained mercury. Eugene Smith took part in the protest, following the victims' pressure groups and recorded, once again, their steps towards justice.

In January 1972, while he was taking photographs of a rally in front of Chisso's headquarters in Ichihara city, Smith was violently attacked by the company's corporate guards, who brutally hit him in the stomach, dragged him by his legs and beat his head on the pavement. The photographer's body, already weakened by a war injury after a fragment of a grenade struck his back, never made a complete recovery. His right eye was affected and the blows probably caused a dislocation of his spine, which gave him continuous pain during the following years.

From 1972 public opinion started to rally against Chisso and the powerful photographs taken by Smith, which also appeared in the Japanese press, played a fundamental role in the presentation of the story. On June 2nd 1972, *Life* published the first series of eleven photographs taken in Minamata with the title: "Death flow from a pipe".

In April 1973 it was *Newsweek*'s turn and the following year *Camera 35* printed a large number of the Minamata photographs, accompanied by a text written by Eugene and Aileen Smith.

When, on 20 March 1973, the court ordered Chisso to make its first compensation payments to the victims, a newspaper title read: "The day Tomoko Smiled". The title bears the name of a young victim, who was also the subject of one Smith's most beautiful and moving portraits – after the girl's death Aileen Moko decided to stop the publication of this image in respect of her family.

The following year, W. Eugene Smith, who was ill, returned to America, determined to transform the Minamata reportage into a book with texts written with Aileen. Free from the limitations of a magazine, he wanted to recount the story of a deliberately perpetrated ecological abuse. The book, issued in 1975, was acclaimed all over the world: a perfect merger between words and photographs, an example of the will to narrate through pictures tied in a sequence and entwined to the text in a single expressive entity.

Only in 2004 did the Supreme Court acknowledge the responsibility in the ecological disaster of the local authorities and the government, and ordered the payment of substantial compensation. However, it is commonly thought that more than 3000 people are involved in this dispute and are still waiting for their illnesses to be compensated.

W. Eugene Smith died in October 1978; on the day of his funeral a message written by some of the men from Minamata was read. It stated: "Your history is our courage itself. We pledge our inheritance of the mighty footsteps you left behind at Minamata." *a.ta.*

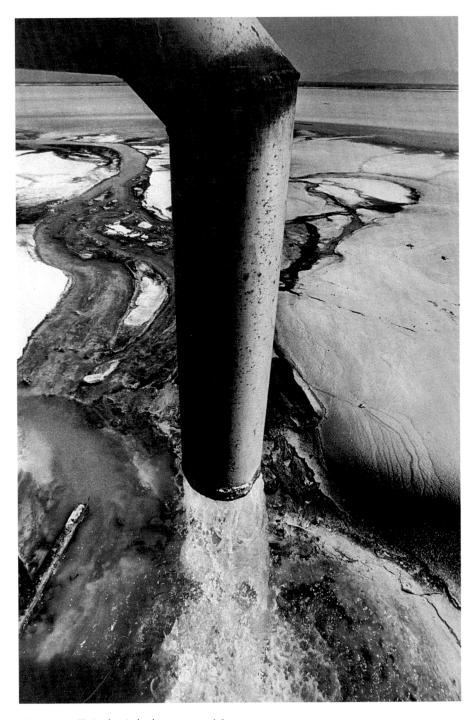

_ Japan 1971. Toxic chemical substances containing mercury leak from Chisso's chemical plant's wastewater pipes into the bay.

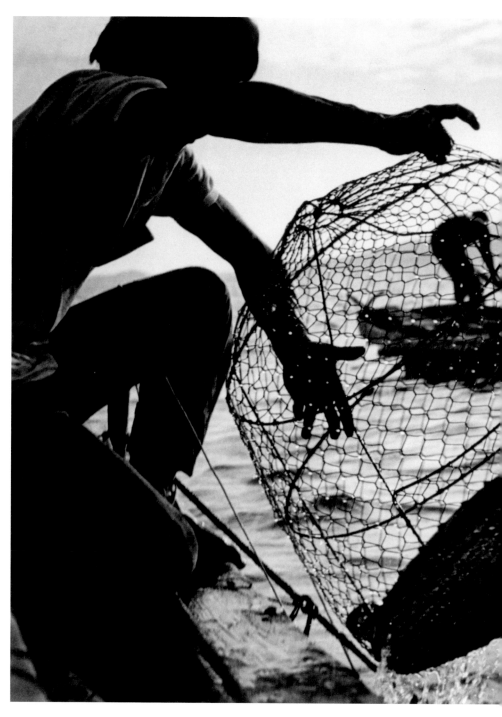

_ Japan 1971. Fishing in the Bay of Minimata.

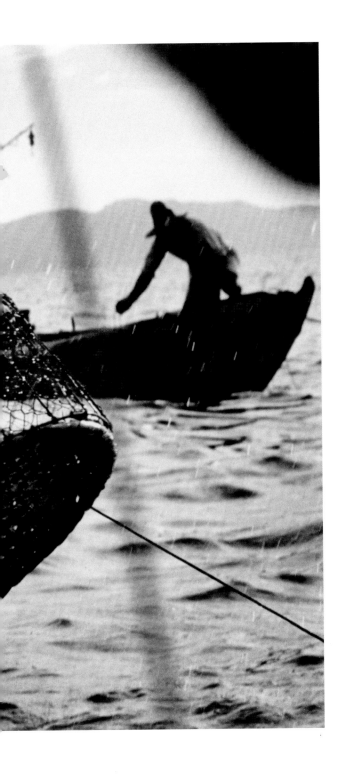

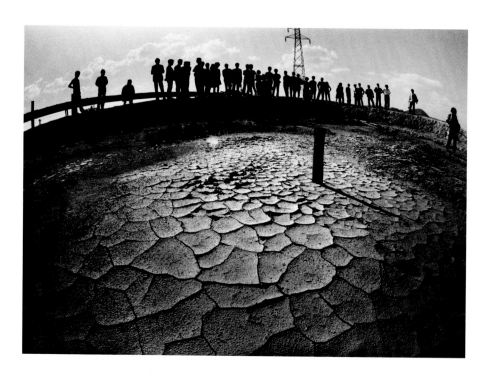

_ Bay of Minamata, Japan 1971. A waste-water tank
in Chisso's chemical plant.

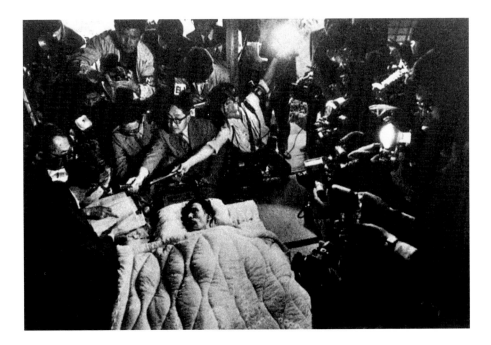

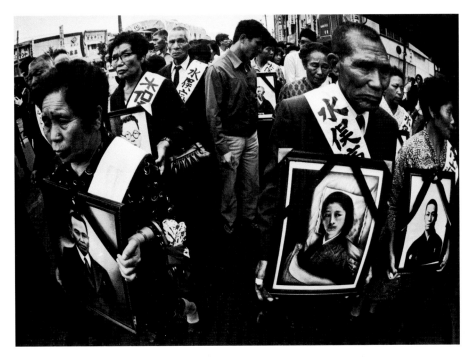

_ Japan 1971. A Chisso representative with a person affected by "Minamata disease".

_ Japan 1971. Relations of the people affected by "Minamata disease" show photographs of their dear ones on the last day of the Chisso trial.

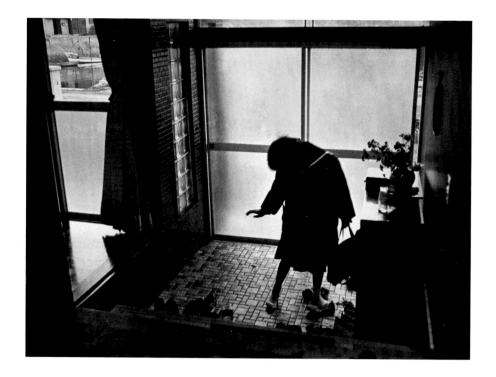

_ Japan 1971. Shinobu Sakamoto, 17 years old, a vic-
tim of the disease from birth because of chemical pol-
lution, goes home after school.

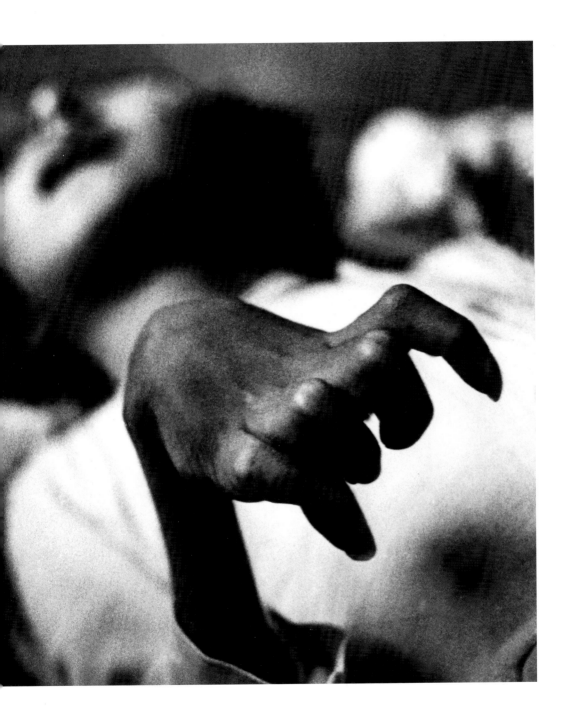

_ Japan 1971. Iwazo Funaba's hand deformed by the disease.

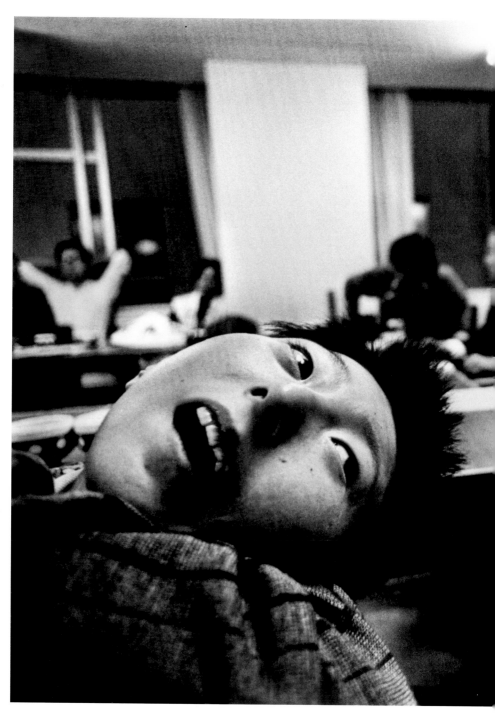

_ Japan 1971. Tomoko Uemura, a victim of mercury poisoning, in front of the commission on chemical pollution, during the Chisso trial.

_The silence
of Bhopal

Raghu Rai

Raghu Rai

The silence of Bhopal
The chemical horror of an ecological disaster

Midnight had just struck in Bhopal, a town in the Indian state of Madhya Pradesh, where Union Carbide, the multinational company, had a chemical plant producing a herbicide called Sevin. The plant was equipped with six safety systems but, to save money, none of them were functioning. Soon after midnight more than fifty tons of a lethal gasses leaked from the chemical plant, and swept across the silence of Bhopal with a devastating effect.

Two thousand people died on that same night, the most from heart attacks and fulminant respiratory failure. By the third day after the accident, the number of deceased had risen to 8,000. The estimated number of victims has reached staggering proportions: 20,000 people died in the following years, 50,000 were now left with disabilities and, to this day, 150,000 people still painfully survive the effects of the chemical poisons with chronic diseases affecting the lungs, brain, stomach and reproductive system, while the chemical substances continue to contaminate the waters and soil. One newborn out of two, affected by the gas while it is still in its mother's womb, dies within the first month after birth. Others survive with atrocious malformations. When Raghu Rai arrived in Bhopal from Delhi, on the morning after that terrible night, he was faced by desperation. "People were escaping and abandoning their homes without bothering about their clothes or objects. Pregnant women were running like mad: many lost their child on the street or in hospital. The gas leaked out of the factory shortly after midnight for about half an hour: 50 tons of poison moved in one direction. Whoever was in the neighbourhood died, and only after 4:30 AM did the authorities begin to ask the population to go back. It was soon clear to me that people had no official assistance and would have remained in that condition for a long time."

Deeply stirred by the pain and horror he was witnessing, Raghu Rai started

to take pictures. His photographs informed the world of the catastrophe, and the horror of a population that was paying for someone else's misdeeds. The chemical plant had been established to produce Sevin that, according to Warren Anderson, the president of the multinational company Union Carbide, should have represented "India's Green Revolution." However, when a terrible famine hit a number of Indian regions making the use of pesticide unnecessary, most of the plant was abandoned and left in "care and maintenance" status for economic reasons. Accident prevention expenditure was drastically reduced. Many studies carried out in the following years proved that Union Carbide had always been aware of the risks connected to the cuts on safety measures and, for this reason, Bhopal probably represents the greatest violation of human rights for serious non-compliance with industrial safety rules to this day.

No one has ever been put on trial. Union Carbide, taken over in 2001 by Dow Chemicals, has declared that it does not want to be held responsible for the disaster. Warren Anderson has evaded a summons issued by an Indian court in 1991, and the United States have rejected an extradition request. The industrial site was hastily abandoned without any treatment of the area, which is still highly contaminated with many toxic chemical substances.

Bhopal's tragedy does not belong only to the past, but is still painfully present, and Raghu Rai's photographs are determined to tell us the story, although it is little-known outside India. His images are a simple and eloquent expression of deep sorrow and of an injustice that provokes shame.

One photograph in particular has become the icon of pain. The "Burial of an Unknown Child" shows the ashen face of a baby girl, barely a few days old, about to disappear under the dark soil of Bhopal. An adult hand stretches out from the background for a last, tender caress on that little face, its eyes wide-open but veiled by a layer of dust.

"This expression", remembers Raghu Rai, "was so touching and powerful that it encapsulated the entire tragic event."

Raghu Rai's pictures are drenched in the very same shocking and total silence that he has always remembered as being one of the strongest and most terrifying elements of that dreadful morning. "What I saw was to change my life ... what

startled me most was the silence of death… I vowed then and there to continue my work, to do all I could to show the world what happens to people when corporations are not held liable for their operations, when they are allowed to cut costs and safety standards when they operate abroad."

In the past twenty years, Raghu Rai has returned to Bhopal repeatedly to shoot evidence of the effects of an ongoing disaster, to shake people out of indifference and to put across the importance of the event with his photographs. The outcome is an intense photographic project that was presented to the "Rio to Johannesburg" summit in an exhibition promoted by Greenpeace, who has been strongly involved in the battle for both justice and treatment in the area. "Exposure: Portrait of a Corporate Crime" displayed in India and in a number of European countries, is a committed, sharp overview of the lives that have been paralyzed by this tragedy; a testimony of a past and a present condemned by the indifference of institutions and their cowardice, and a forewarning for the future. a.ta.

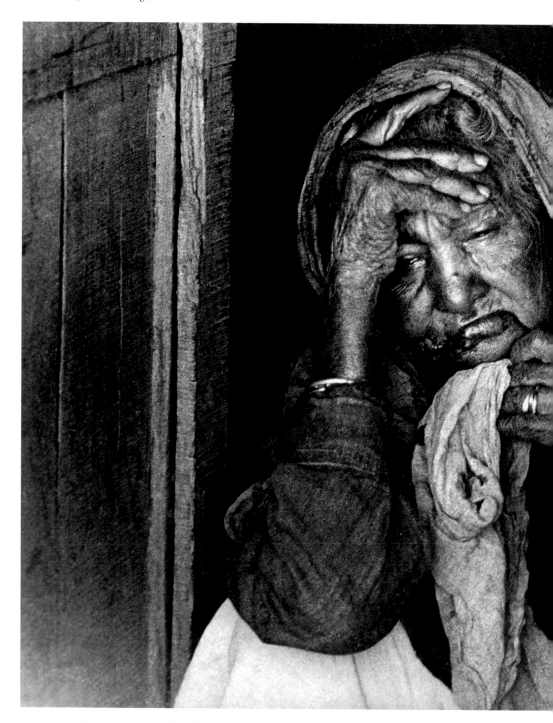

_ Bhopal, India 1984. This old woman has suffered
severe injuries because of the gas. The rest of her fam-
ily died.

_ Bhopal, India 1984. The city seen from above.

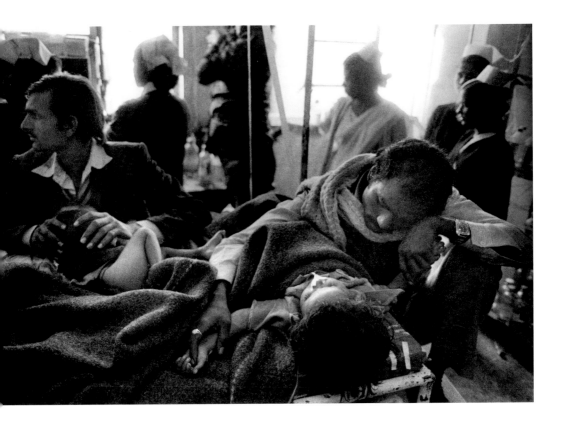

_ Bhopal, India 1984. Immediately after the disaster, thousands of sick children move to the government -owned Hamida Hospital, because their parents are too ill to look after them.

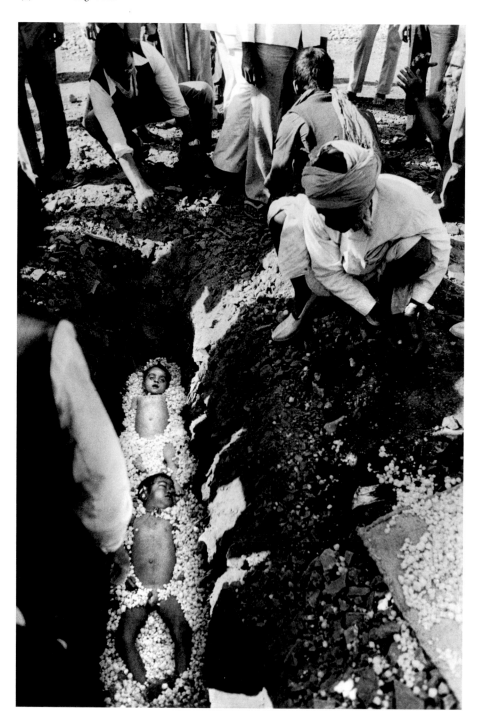

_ Bhopal, India 1984. Burial of nameless children, victims of the disaster. Over 8000 people died in the first days and the crammed cemeteries do not have enough room individual burials.

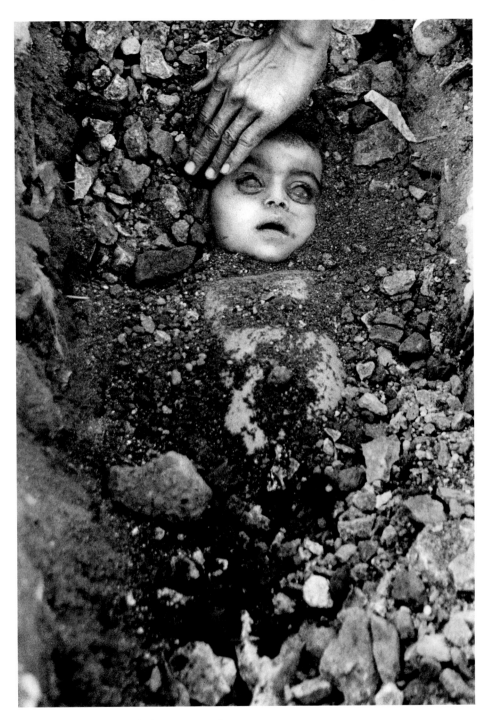

_ Bhopal, India 1984. Burial of a young, nameless
victim.

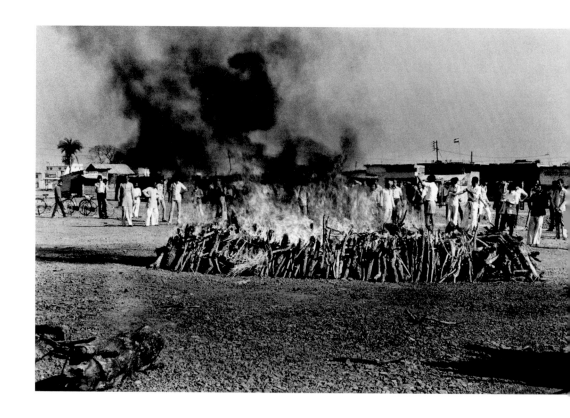

_ Bhopal, India 1984. Mass cremation near a common grave.

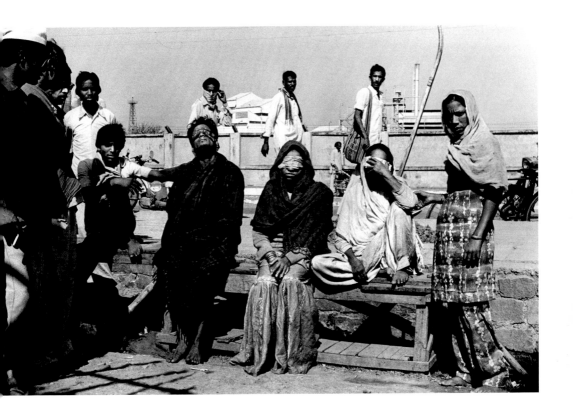

_ Bhopal, India 1984. Survivors of the disaster, with seriously damaged eyes, in front of the Union Carbide plant.

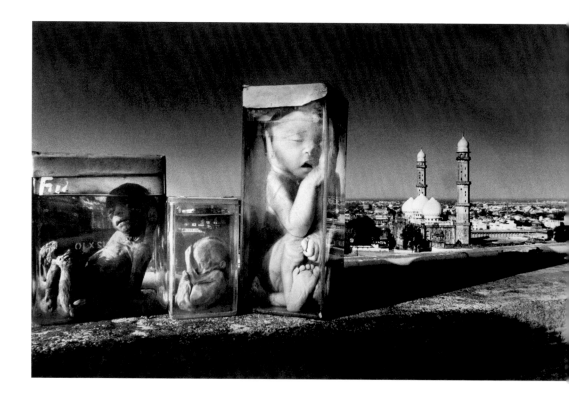

_ Bhopal, India 2001. Some stillborn foetuses after the
outflow of toxic gas, saved by Doctor Sathpathy at the
Hamida Hospital.

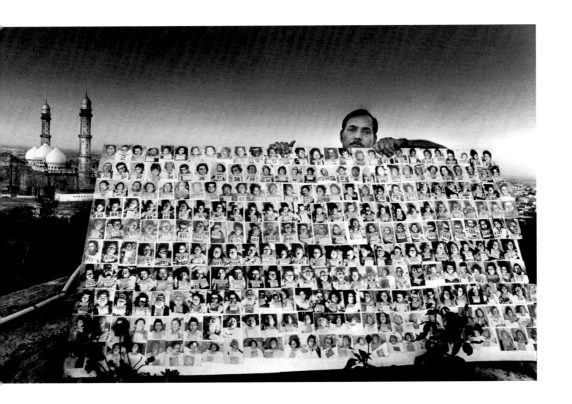

_ Bhopal, India 1984. Doctor Sathpathy is the
pathologist at the Hamida Hospital who performed
more than 20.000 autopsies, issuing certificates with
which the families could claim compensation.

_The essence
of the desert

Sebastião Salgado

Sebastião Salgado
The essence of the desert
Famine in Sahel

How many people had already heard of Sahel when Salgado's photographs started to circulate in 1986? How many knew or understood the consequences of the terrible drought that has been devastating this part of Africa? As Jean Lacouture wrote in *Sahel. L'homme en détresse* (1986), "Doctors without Borders and Sebastião Salgado opened my eyes on this issue, and I am sure it will be the same for many of you."

Mali, Sudan, Ethiopia, but also Niger, Chad, Burkina Faso (in those days called Alto Volta): these countries are all located in the Sahel belt, on the border of the Sahara, and face the common problems caused by scarce rainwater and very few natural resources. On top of this, in the eighties, a long and harsh famine dealt a hard blow to the area. Its consequences can be summed up in a few staggering figures: it affected twenty countries and 150 million people, 30 million in desperate need of food, leaving ten million refugees and probably up to 250,000 deceased.

Under the aegis of Médicins sans Frontières, which has taken first-hand action to aid this region, Salgado used his art to narrate the deprivation, desperation and, as in all his photographs, the profundity and greatness of human dignity; a dignity which is almost divine in its determination to go on, finding the strength to resist in its own pain and forcing the dry and hostile landscape to accept its humanity.

A Brazilian from Minas Gerais, Sebastião Salgado has an academic background, having studied economy and sociology, and having worked as an economist before picking up his camera, almost by chance, in the seventies. From that moment he realised that maybe this extremely ductile and direct instrument could show the world much more than essays and charts. "With my personal

history as an economist, sociologist and anthropologist, it was inevitable that my photography would hold a strong social conscious. My entire background – my interest in social issues, my schooling, my further research in the fields of sociology, anthropology and geopolitics – is reflected in my photography. For me, photography is a matter of continuity"

His career in photography is dazzling, strewn with success and acknowledgements. In particular he engages in exceptionally extensive projects which absorb him for periods lasting up to six or eight years, building them up by assembling a series of different reportages tied by a common thread. At the end of the project all those images converge, supporting each other in a single, vast, and often epic vision of man and of the way he inhabits this world. This applies to *Workers: Archeology of the Industrial Age* – a research on manual labour at the end of the twentieth century, or to *Migrations*, the project dedicated to migration, as well as the new challenge he has been tackling in more recent years: *Genesis*, a search for the traces of that primordial world where man and the environment lived in harmony. At first glance, each one of his works seems utopian. Each project undoubtedly stems from his eyes, but also from the studies he carries out before he sets off, from his thirst of knowledge and genuine curiosity, and from the urge to be a part of the very same suffering and pleading humanity he is investigating. And every time, once the project is over, we wonder how those photographs, with their classical layout and with their strong biblical allusions, manage to epitomize that unbelievable utopia in front of our eyes, inhabited by hundreds of people, by dark skies, by sudden blazes of light and of hope. "If a young photographer asked me how to become a photojournalist today, I would advise him – as I usually do – to stop, to break away from photography for a while and study sociology, anthropology and economics instead. Once you have acquired a full knowledge of this historical moment, it is possible to connect your photographs to reality and to history. Only then does photography free itself from any restrictions. Any photograph must be able to fit into a process. If this is clear, then it is possible to be a part of this system".

Sahel was one of his first great projects, to which he dedicated himself with his usual conviction and passion. His strongest desire is to use his camera as a

means of learning and communicating, an instrument with which he can reveal and show, with pain and passion, what is still unknown and what so many try to forget. If a photograph seems too conventional, it is because the very same situation it portrays is conventional. Salgado tackles ancestral dilemmas such as hunger, death, the need of a home, the struggle for life, and shows them without any disguise. His critical eye is intense and concerned: he not only feels, but also appreciates and understands. From Timbuktu to the Red Sea, these photographs primarily reveal the strongly entwined relationship between man and the environment, between people suffering because of drought, sickness and wars, and who seemed silhouetted alongside and made of the same essence as the desert that surrounds them, that very same desert where they live and against which they struggle. Here lies the great strength of these images and Salgado's distinctive touch. Very few manage to build up their works as Salgado does: he develops an idea that is at the same time visual and social, where the classical pose stems from a deep reverberation, from the strength of an ancient urge, from a virtually indestructible evil as old as humankind. *a.m.*

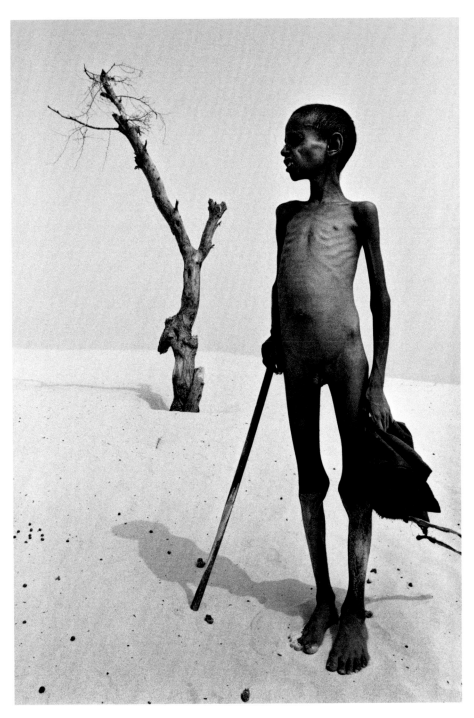

_ Mali 1973. Lake Faguibin, that once gained its waters
supply from the yearly flooding of the Niger, was dried
up after the great drought in 1973. All the men moved
to Libya, the Ivory Coast of Nigeria, leaving behind the
women, elderly and children.

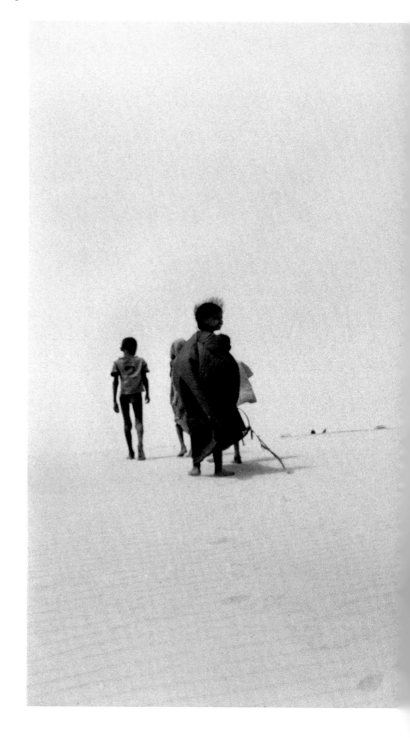

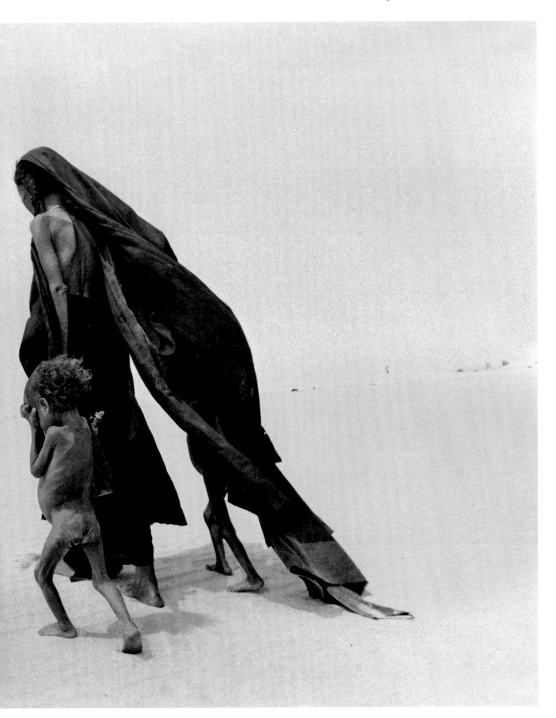

_ Mali 1984-85. In an attempt to survive, women and
children leave the area of Lake Faguibin at a blazing
temperature of approximately 50°C (122°F).

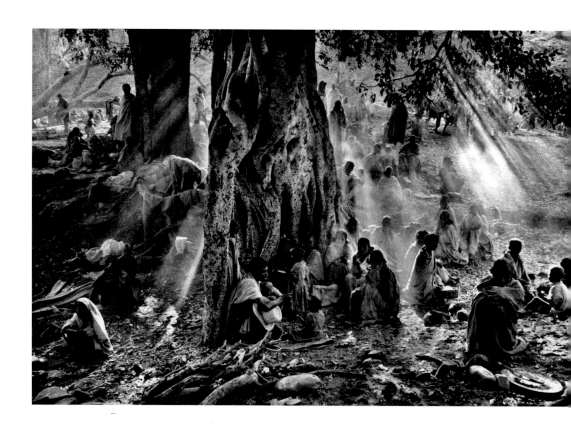

_ Sudan 1984-85. Refugees rest at dawn after a long
night walking, hiding themselves under the trees to
avoid the surveillance of Ethiopian MIG airplanes.

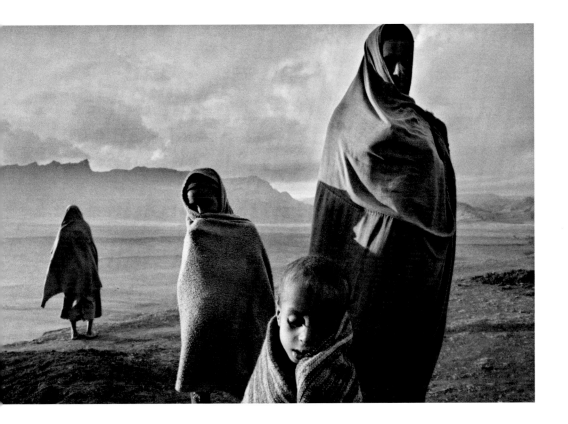

_ Ethiopia 1984-85. Wrapped in blankets to shelter
from the cold morning wind, Sudanese refugees pray
in Korem camp.

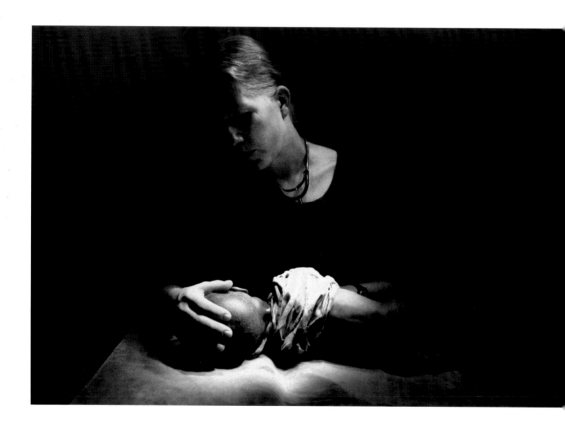

_ Ethiopia 1984-85. In the camp in Bati, doctoress
Dorothée Fischer cures a child from an abscess with
a small incision.

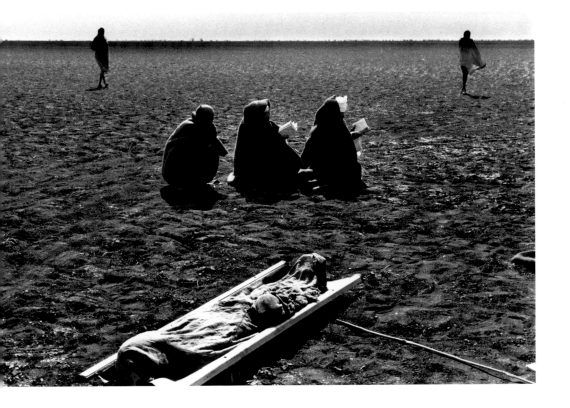

_ Sudan 1984-85. Despite the good conditions of the
El Fau camp, mortality is high especially because of
the lack of food.

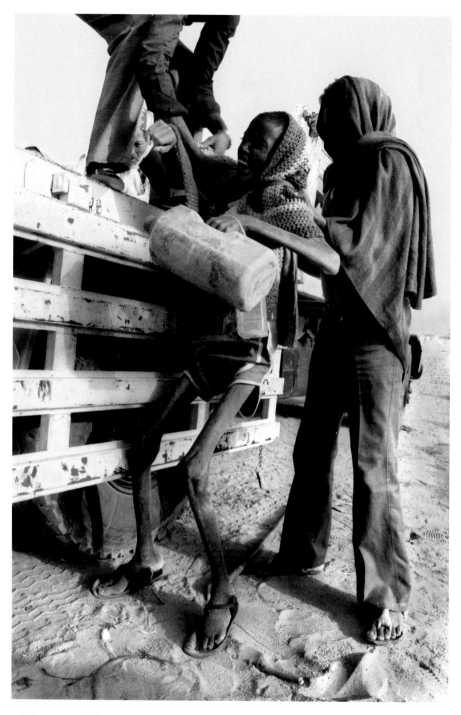

_ Sudan 1984-85. Refugees arriving in El Fau from campo Teculabab, after travelling for 400 kilometres in a truck under the sun.

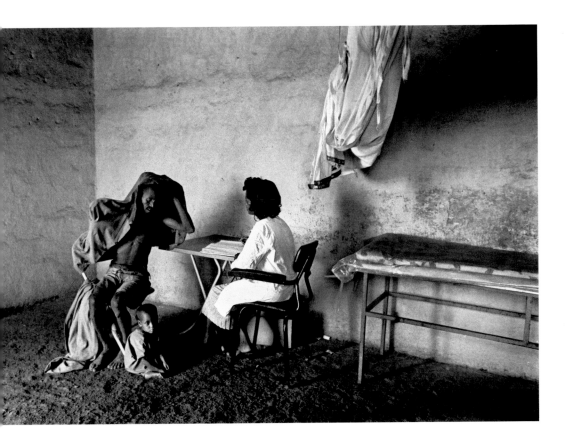

_ Ethiopia 1984-85. The dispensary of Alamata, run
by World Vision International, is a temporary recep-
tion centre that hands out medicines and food to peo-
ple living in the villages in northern Ethiopia.

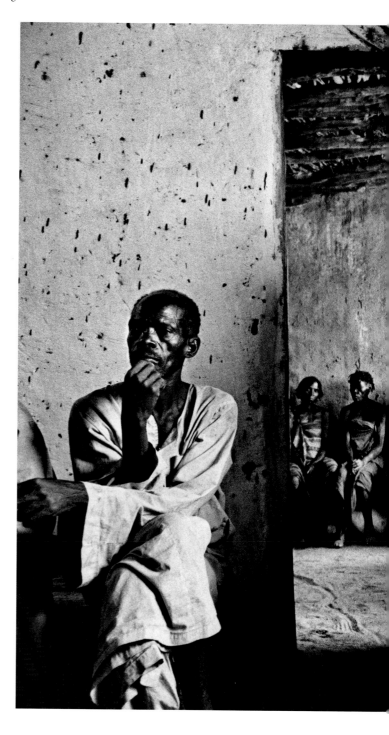

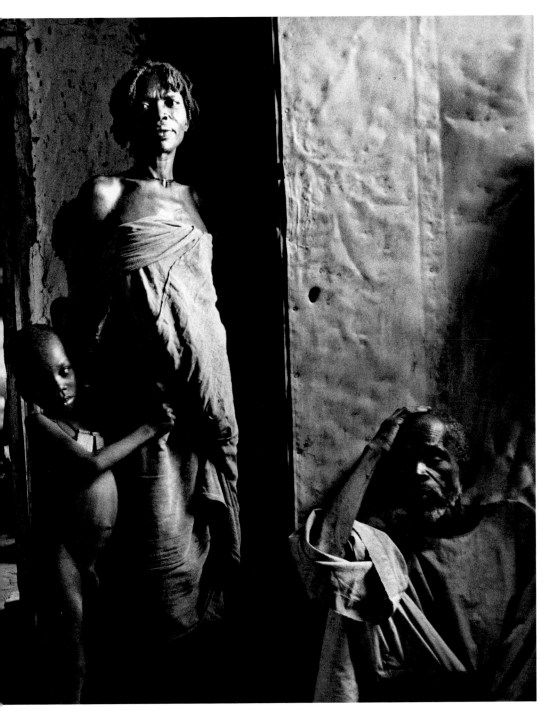

_ Chad 1984-85. The dispensary of Ade, on the Sudan border. This is where people from central Chad seek refuge on their way to refugee camps in Sudan.

_The importance of
bearing witness

Igor Kostin

Igor Kostin
The importance of bearing witness
The Chernobyl disaster

"The system had some cracks and I wedged my way inside. I witnessed the downfall of a regime. Even more than the fall of the Berlin wall, Chernobyl is, for me, the real symbol of the end of the Soviet Union."

Just before the dawn of April 26th 1986, life in Pripjat was suddenly brought to a standstill. At less than seven kilometres from the quiet Ukrainian city of around 50 thousand inhabitants, reactor number 4 at the Chernobyl nuclear plant exploded.

The radioactive cloud, two hundred times more powerful than the one recorded in Hiroshima, was swept by the wind and contaminated hundreds of thousands of square kilometres between northern Ukraine, southern Belarus and the Brjansk region of Russia. The toxic substances triggered an outbreak of thyroid cancer among children and more than 300,000 people had to leave their homes.

That 26th April, in the middle of the night, a phone call woke Igor Kostin, a photo reporter for the press agency Novosti, with the news of a fire at the Chernobyl nuclear plant. He immediately set off by helicopter from Kiev. However, once he arrived above the roofless reactor, he only managed to take about twenty photographs before the camera blocked. Back in Kiev, he noticed that the negatives were all black: the wave of radioactivity was so strong that it had broken the camera and burnt the films. Only the first shot, the one that suffered the least damage, was still visible. That photograph was released all over the world, but it has never been published by the Novosti press agency.

Troubled by both the depth of the catastrophe itself, and the authorities disturbingly silent reaction to it, Igor Kostin dedicated his life to Chernobyl's exposition. His work is not only a testification to the horrific days surrounding

the disaster, but also the devastating human, animal, and environmental consequences it has caused throughout the years.

"I have never considered the option of staying at home, or worse still, of taking the first airplane to escape from the radiations. I have to stay here, in the Ukraine."

Igor Kostin remained in the area with the 800,000 "liquidators" who, virtually barehanded, worked in shifts at the plant to clear up the radioactive debris. They were soldiers, army reservists, workers and farmers, from the Ukraine and Belarus. Most of them were volunteers who offered their courage and lives to accomplish this incredible duty. In the summer of that terrible year, Kostin decided to move closer to the plant and lodged in a school with some other liquidators familiarly called "the roof cats".

At night, the "cats" worked on top of the roof of Reactor 3, which was covered by a huge amount of highly radioactive debris spewed out by the explosion. They had to run up the stairs, wearing protective lead suits weighing about 35 kilos, and had less than forty seconds to heave a shovelful of debris down the huge hole that had formed where block number 4 once stood: the time-span was sufficient to absorb a higher dose of radiations than the maximum acceptable dosage a human being should receive in his entire life. Igor Kostin returned to the roof five more times, next to the "cats", to document their courage so that they would be remembered, seeing that society would not be capable of doing so. "Once they got down from the roof, they discreetly evaporated, with their kind eyes and their laughter. When heroes don't have a name, they are treated as if they had never existed. And they disappear".

Many liquidators fell ill, many died, and others managed to survive.

Even Igor Kostin's health has suffered, and on January 3rd 1987, he was taken to the famous Hospital number 6 in Moscow and, later, to a hospital specialized in curing radiation-related illnesses in Hiroshima. He has had the fortune and the strength to survive and to continue to work on his project, gathering evidence of the catastrophe. He carries on taking photographs of the evacuation of tens of thousands of inhabitants, of the efforts to seal the plant, of abandoned cities, of the decontamination of houses and fields with washing, of the burial of entire villages, of vast open-air cemeteries full of contaminated

vehicles, of the old people who refuse to abandon the lands where they have always lived and where radioactivity was already three hundred times higher than the acceptable level. He portrays the sick people in Moscow's Hospital number 6, the children born with severe malformations, the grief of men who were unprepared to face a disaster which the authorities have concealed with lies. Igor Kostin is a key witness of these events; he has turned his commitment and dedication into a necessity, the mission of his life. Labelled "legendary" by the *Washington Post*, his testimony is powerful and intense because it speaks of a suffering that has not only been observed, but experienced first-hand. When asked what drove him go back to Chernobyl again and again regardless of the health risks, Kostin simply replies: "It's the reporter's duty. You can't speak about the truth if you are not among the people you are speaking about, if you don't see their heroism or their daily suffering with your own eyes."

Twenty years later, Chernobyl is still an open problem, not only for the Republics of the ex Soviet Union, but also for the rest of the world. The consequences of this irreparable disaster loom over present and future generations, and record an increasing number of cases of cancer, malformations and diseases affecting the nervous system every year.

But Chernobyl is still a mystery. Exact figures on the scope of the catastrophe have not yet emerged. There is one certainty, however, and that is since the first day of the accident, all information has been falsified.

"I have accomplished many photographic reports through the years, but Chernobyl has changed my life and has turned me into another man. [...] That catastrophe has transformed me morally. It purified me, cleansed me. After Chernobyl, it was as though I had been born again …". *a.ta.*

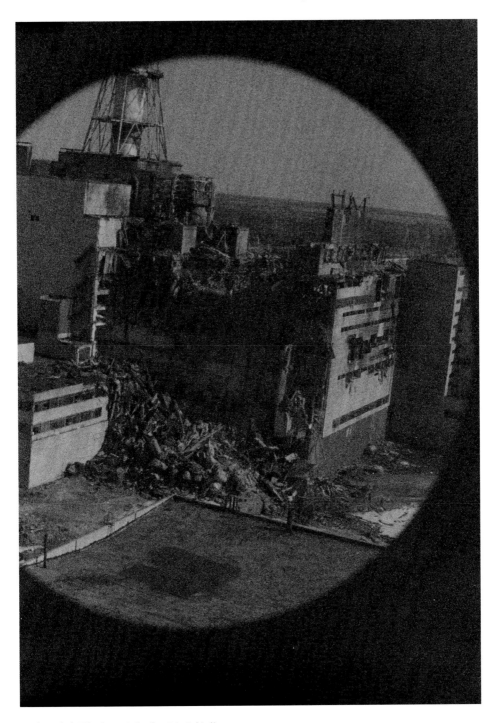

_ Chernobyl, Ukraine 26 April 1986. A bird's-eye view of reactor number 4 of the nuclear plant. It is the only photograph taken on the very same day as the accident.

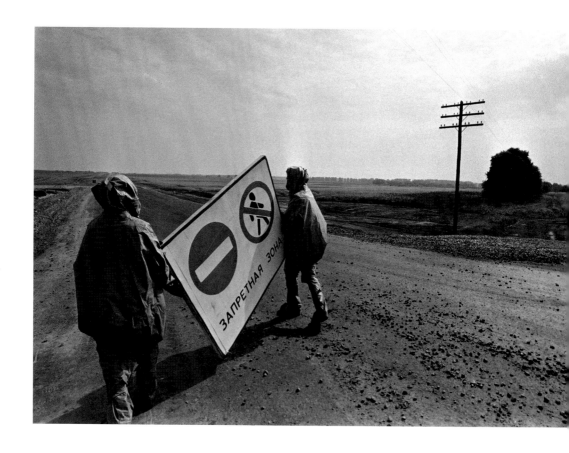

_ Chernobyl, Ukraine May 1986. Two volunteer "liquidators" with their anti-chemical war protection uniforms, useless against radiation, put up signposts stating "Exclusion zone" in a 30km radius area around the plant.

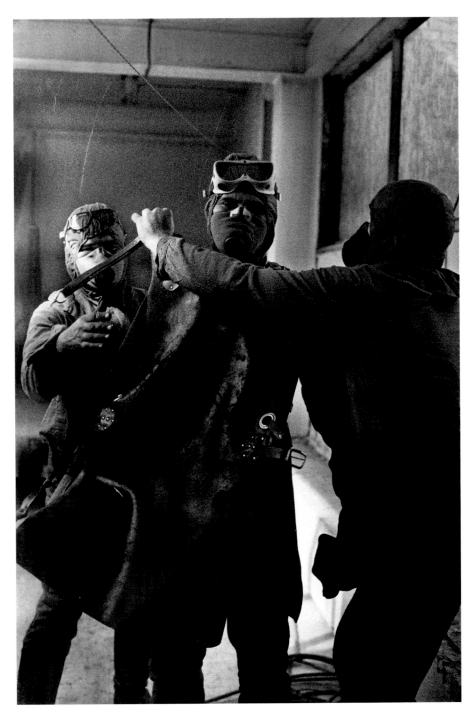

_ Chernobyl, Ukraine September 1986. A group of "liquidators" wearing protective gear, weighing around 35 kilos, made from lead to cover the back, spine and chest.

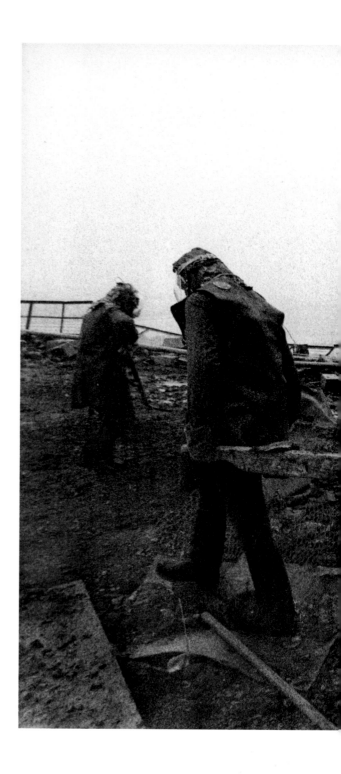

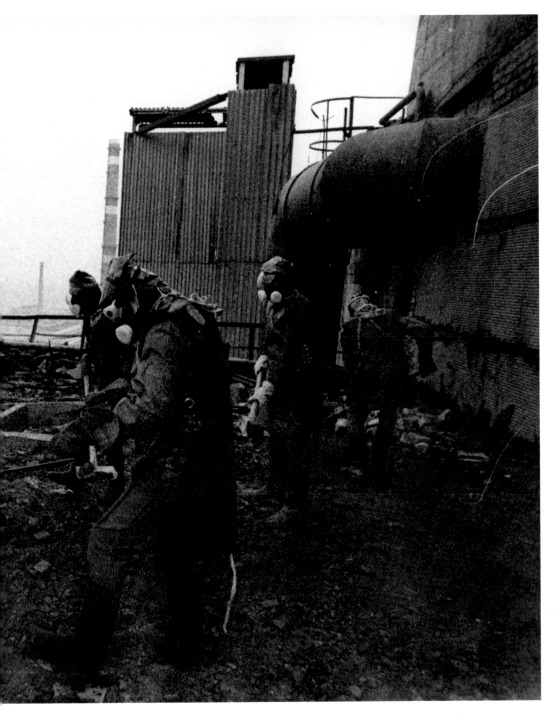

_ Chernobyl, Ukraine 1986. Before erecting the concrete sarcophagus, groups of "liquidators" are sent on top of reactor number 3's roof to clean it from the debris. Each shift had to last less than 40 seconds.

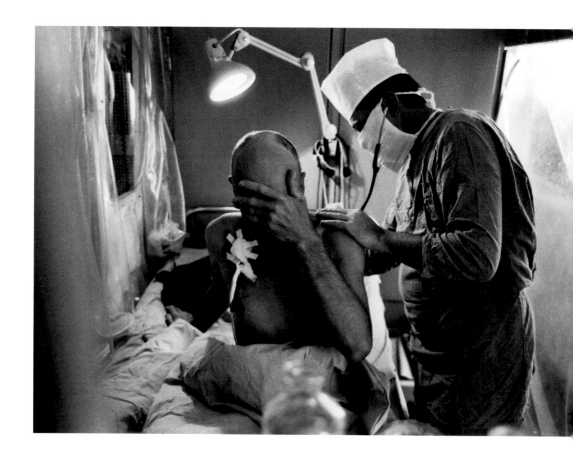

_ Moscow 1987. A bone marrow transplant operation
in Clinic n. 6, a military hospital specializing in cu-
ring radiation-related diseases.

_ Chernobyl, Ukraine 1986. A "liquidator" in the
evacuated village of Tatsenki.

_ Chernobyl, Ukraine 1990. Kostin sent his photographs of animals born with genetic mutations, including this one, to Mikhail Gorbaciov and to a member of the Supreme Soviet. No commission to investigate the event was set up by the government.

_ Chernobyl, Ukraine 1986. In the months following the catastrophe, the area surrounding the plant was constantly washed in an attempt to fix radioactive dusts to the ground.

_ Chernobyl, Ukraine 1990. Nadia is one of the many children born with serious disfiguration after the disaster. Many have been abandoned by their parents.

_In private

Donna Ferrato

Donna Ferrato
In private
Domestic violence in America

"As with all injustice, there is the reality, and there are the myths spread by those trying to deny the reality. I have seen the reality of battered, broken, and mutilated women."

One of the common myths that still surround domestic violence is that if a man hits his wife or girlfriend it is a private matter – in other words, nothing more than a family quarrel, an argument or a lovers' tiff. An area protected by thick walls and closed doors is "private"; an intimate place, of family honour and emotions, that doesn't make any noise. Myths can create stubborn prejudices but they cannot hide the truth – not forever, in any case. In the preface of her book *Living with the enemy*, published in 1991, Donna Ferrato wrote: "Much of the book was born out of frustration – first, because I felt powerless in the face of the violence I had seen, and second, because for a long time no magazine would publish the pictures. It was only when I received the W. Eugene Smith Award in 1986 that magazine editors began to take the project seriously."

For ten years, starting from 1981, Donna Ferrato conducted an in-depth research on domestic violence in the United States, living with couples in their own homes, visiting maximum-security prisons and shelters for battered women and following, for quite some time, the police in their emergency calls. The outcome is a series of shocking photographs, which are disturbing not only for the situations they show but also for the fact that they were allowed to be taken at such an intimate level. They have proved to be fundamental in raising a nation's awareness on domestic violence, and they have revealed the truth that people are killed in their own homes. Different forms of violence, such as dread, blackmail, reprisals or physical and psychological abuse can be a daily reality in some homes. Even Donna Ferrato had trouble in fully grasping the dark and secret side of family life.

It all started by chance: it was 1981 when the American photographer was asked to work on couples and she met Lisa and Garth, husband and wife, who, according to the photographer: "They were the epitome of the American success-story: beautiful, seemingly in love and rich. She enjoyed great sexual freedom, and he consented to that – he loved the idea that women could experiment. So I asked to document their lives and stay with them for a while, in their beautiful home in New Jersey where everything seemed beautiful." However, not all that glitters is gold, and the first flaws gradually started to appear. One night, while she was sleeping in the couple's home, Donna heard someone shout. Alarmed by the sudden noise, she instinctively picked up her camera and went to see what had happened. "When I first saw Garth hit Lisa, I couldn't believe my eyes" she said. "Instinctively, I took a picture. But when he went to hit her again, I grabbed his arm and pleaded with him to stop. He hardly acknowledged my presence, nor did he seem to care that anyone was watching." For months, Donna didn't develop the film containing that indecent act of violence. But then she discovered that Lisa had been sent to a clinic by her husband, against her own will. It all became clear – she realized that "private" could also be a place of abuse and appalling violence of which we all must be aware. "I thought that my camera was my best weapon," she said. Even her profession as a photographer took a different turn: the stunned anger for the violence that she had witnessed became the core of her mission of discovering and reporting this devastating phenomenon. It is believed that, in the United States, someone beats a woman every 15 seconds. These assaults are the cause of 20%-30% of the visits of women to casualty departments, and more than half of the women who die from homicides are killed by their current or former partners. The American photographer carried out thorough research, spending a long time in the centers where women find a first shelter from domestic fury, often with their children. She listened to their stories, breaking down the wall of pain, shame and embarrassment that surrounded them. She discovered that, as Ann Jones wrote in the book's preface, "abused and silenced by the men in their lives, they were abused and silenced again by the law." Domestic violence is one of the most concealed social incidents, a consequence of a patriarchal culture that has been established and legitimated

by religion, tradition and by the same judicial system. It is part of a culture that considers the home and the female body as man's private realm: for years, abuse on women was not treated as an offence against the person but as an offence against morality, often leading to only trivial punishments for the aggressors. In *Living with the Enemy* there are women who have committed murder to save themselves or their children after years of outstanding violence. Many are in prison serving a 15-year sentence or a life-sentence with no chance of parole, after trials where their lifetimes spent enduring abuse were not taken into consideration.

In 1991, after publishing the book and following the request from a New York's women's shelter, Donna Ferrato organized an exhibition of her photographs to raise funds. It turned out to be a great success. To cope with the huge amount of similar requests from shelters around the United States, Ferrato founded a non-profit association, *Domestic Abuse Awareness, Inc.* (DAA), with the aim to expose violence against women and children and eradicate it through awareness, education and action. Today DDA is internationally recognized as a centre for information on domestic violence and Donna Ferrato's photographs have been exhibited far and wide, in schools, universities, on television programs, newspapers and magazines. In recent years the laws have changed and it would be no surprise if this was partially on account of the influence of projects like *Living with the Enemy*, which have helped to knock down a long-established criminal wall of silence. Domestic violence violates the most basic human rights: the right to physical and psychological integrity, the right to freedom, safety and health, the right to avoid torture and, not infrequently, the right to live.

Some have criticised Donna Ferrato's photographs, stating that in some cases the violence they show is too private to be portrayed. But, as Ann Jones wrote in the book's preface, the appropriate question for photojournalism is not "Is this violence too private to be imaged?", but rather, "Why haven't we seen it before?"

a.ta.

_ Minneapolis 1988. An eight-year-old child shouts
"I hate you! Never come back to my house" to his
father who is being led away by the police after at-
tacking his wife.

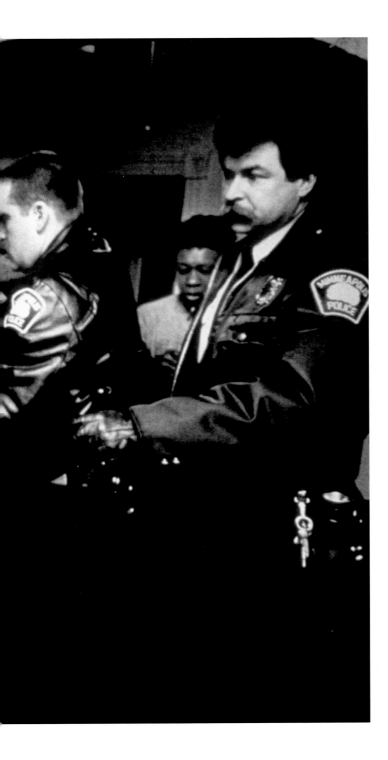

_ New York 1982. Lisa is assaulted by her husband in their bathroom in the middle of the night. Garth was accusing her of hiding his cocaine pipe.

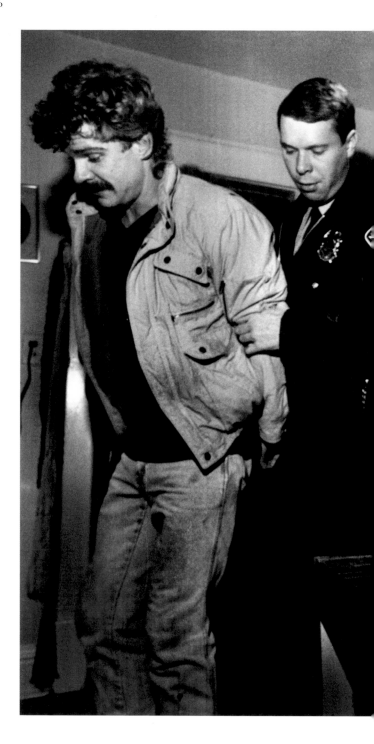

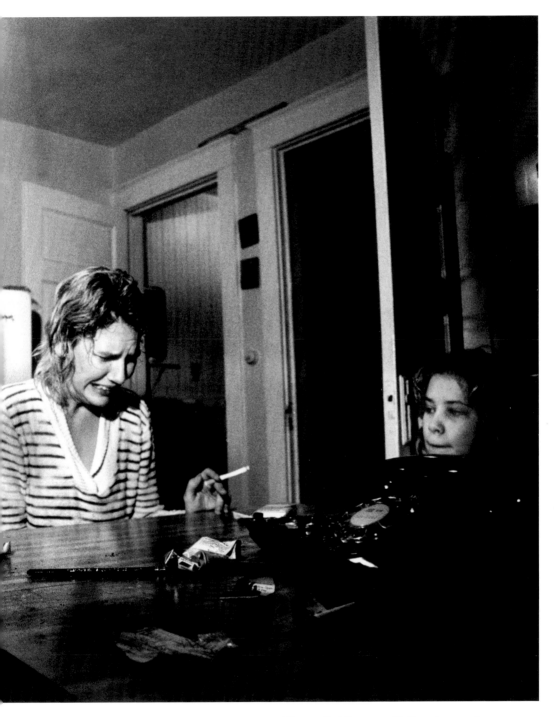

_ Minneapolis, Minnesota 1988. Karen is tears as her boyfriend is arrested after he had hurled her against the bathtub.

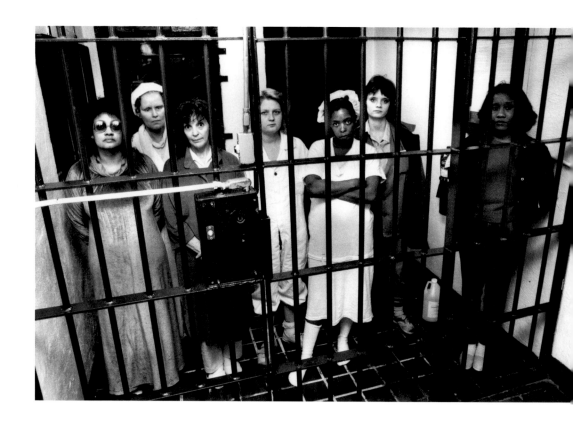

_ Jefferson City Missouri, USA 1990. Some prisoners
in Renz, a maximum security jail for women, whose
crime was their defence of their lives and of their chil-
dren's lives against their husbands' violence.

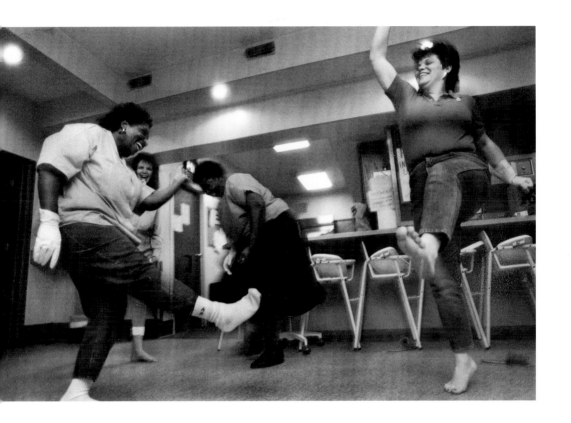

_ Pittsburgh, Pennsylvania, USA 1988. A moment of
happiness in the shelter for battered women.

_Gathering evidence

Gilles Peress

Gilles Peress
Gathering evidence
Genocide in Rwanda and in ex Yugoslavia

He states that he is suspicious of languages. He believes that photography is a language that speaks on its own and communicates without the mediation of ambiguous or misleading words. He once declared: "What I like about photography is that it answers questions I never thought I could ask." Often, when he is deeply immersed in reality, he feels the images of the world forming autonomously and imprinting themselves on the film, without any need of his involvement.

The French-born Gilles Peress spent a lot of his time trying to understand the world, without being afraid of stopping in front of blind fury, of profound desolation, of the infinite but human hatred breaking out all over the world in different forms which are, at times, terribly similar to each other.

After studying Political Sciences and Philosophy at prestigious institutes, Peress suddenly developed the desire to be aware of what was going on in the world, to understand how things really stood: "As you know, the Bible says that 'in the beginning was the word' but I think and believe that in the beginning was seeing and that in seeing you can get to ideas that have not been labelled yet – pure ideas that precede the word, and ideas that have the possibility of escaping propaganda and predictability".

Understanding is the key for everything, the engine that drives us to work, that solicits and expects not only photographs, but also communicative projects to stimulate this very same understanding. "I work much more like a forensic photographer," Peress once said in an interview. "In a certain way, I am collecting evidence. I've started to take more still lifes, like a police photographer, collecting evidence as a witness. I've started to borrow a different strategy than that of the classic photojournalist. The work is much

more factual and much less about good photography. I don't care that much anymore about *good photography*. I'm gathering evidence for history, so that we remember."

He has devoted much of his life to studying genocides. He has made two photographic books on this disturbing topic, each representing two distinct, yet similar, projects in which his photography "speaks" with intensity and describes, transmits, shakes and solicits the reader to ask himself difficult questions. They are those very same questions that, perhaps, we have never dared to raise ourselves.

The Silence gathers photographs taken in Rwanda in 1994. The opening photograph, taken in Kabuga on May 27th 1994 at 4:15 portrays a prisoner: "a prisoner, a killer is presented to us, it is a moment of confusion, of fear, of prepared stories. He has a moment to himself." Then come the photographs, divided in four sections: *The Sin* – with the weapons, the bodies, the massacres beyond human understanding and the deep wounds of the survivors; *Purgatory* – taken in Tanzania and in Zaire, with its gradual return to an idea of life consisting in getaways, concentration camps and refugees in a harrowing search for water, with death just a glance away; *The Judgement* – yet again in Zaire: it is a seemingly ruthless judgement, harsh and atrocious, that speaks about famine, destitution and death, of bodies heaped with a bulldozer into a common grave, where it is hard to distinguish one face from another. The last part, like the first, takes us back to the 27th of May, 1994, in Kabuga, three minutes after the opening picture. In this photograph, the killer almost seems to lift his eyes sideways. "As I look at him, he looks at me," Peress notes.

This episode of exchanged glances sums up the entire story of *The Silence*.

It is an immense, appalling tragedy for which those responsible have never accepted culpability.

But it is also a story of individuals. The victims were not killed by indefinite entities or nationalisms but by the hands of other human beings capable of such violent hatred.

From 1992 to 1997, current events led Peress to Bosnia and Croatia. There he was faced by another immense genocide, the proportions and consequences of

which were still unknowable. Peress followed Eric Stover, a doctor and human rights expert, led his team in a search for mass graves between Srebrenica and Vukovar.

The graves is about this long and thorough investigation, carried out with patience and professionalism by pathologists and anthropologists who worked together to uncover the truth behind the mass murders. Sometimes there were only faint, seemingly insignificant traces on the ground: a boot, a rag caught in some branches, a mirror, or maybe even just a track in the grass. They searched for signs that testified human presence and evidence of a massacre that perhaps took place a few steps away. These pits, sometimes 100 feet long, revealed clutters of bones to recover and study, to reconstruct and, possibly, restore a name and a dignity. To dig and retrieve these human remains was an immensely excruciating task.

Every object, every single piece of material, every bone fragment was testimonial evidence, a confirmation that couldn't be disregarded but that had to find its exact collocation, just like pieces of a jigsaw puzzle.

Gilles Peress seems to be saying that true value can only be found in memories. It is important to try to understand what happened, to be aware of the truth, regardless of any apparent political lie, and to never forget. And, to finish, he offers this documentation to young people so that they may learn from this catastrophe and take preventative action against another one.

The final words of the book are: "Only the victims have the right to forgive. Forgetting is also unthinkable as it would be a dishonor to the dead and their memory. The most disturbing truth is that we are at the end of the 'Never Again' century and genocide is happening again. Bosnia's nightmare – like Rwanda's – is not hers alone and, until we accept the moral imperative of acting swiftly to stop genocide and crimes against humanity and punishing those responsible, it will happen again". *a.m.*

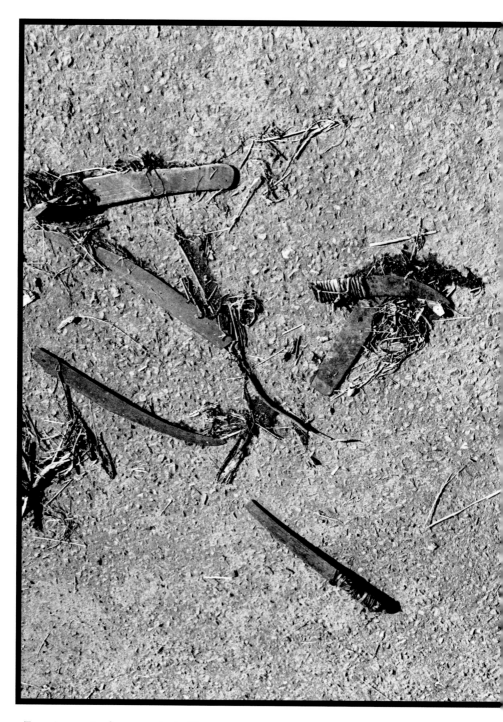

_ Tanzania 1994. A refugee camp in the Ngara re-
gion, near Rwanda's borders.

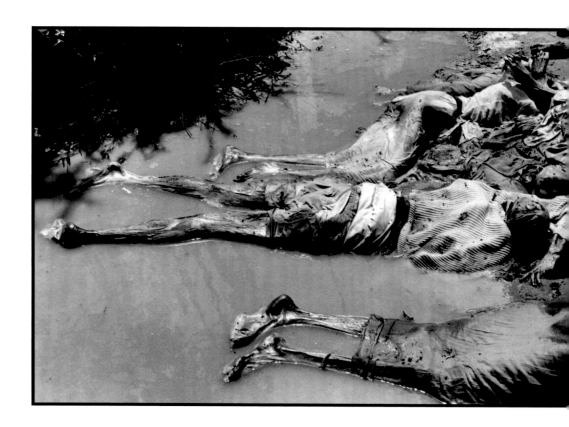

_ Nyarubuye, Rwanda 1994. Bodies of Rwandan
refugees killed in the church in Nyarubuye by Hutu
militia, otherwise known as "interahamwe".

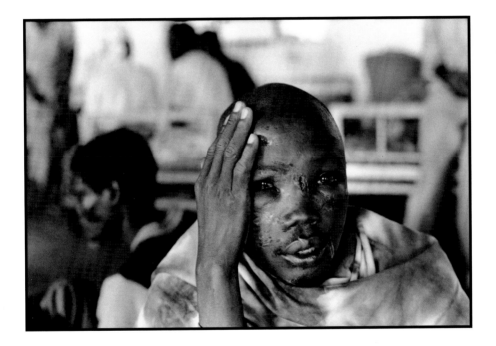

_ Kabgayi, Rwanda 1994. A hospital near a concentra-
tion camp.

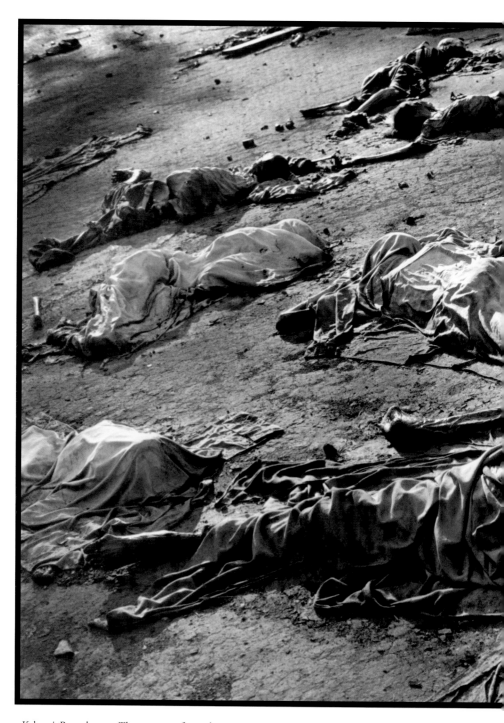

_ Kabgayi, Rwanda 1994. The massacre of some loot-
ers, captured and killed in Rukara church by govern-
ment troops.

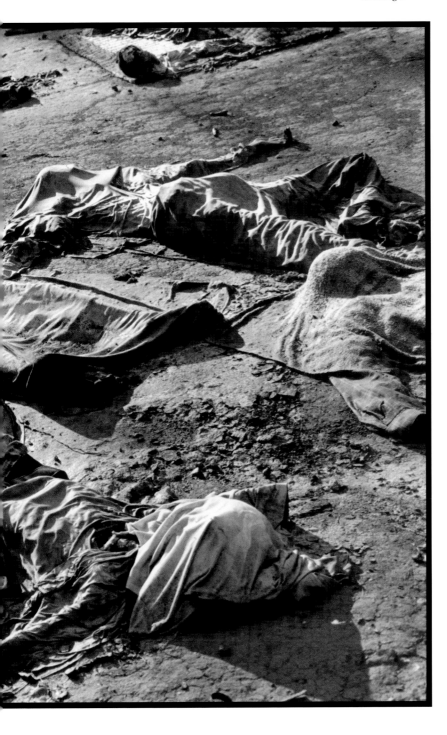

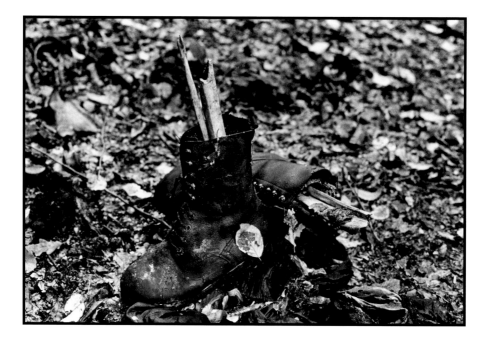

_ Srebrenica, Bosnia 1996. Traces of people who have
been killed and thrown into mass graves.

_ Srebrenica, Bosnia 1996. Some traces of the massacre
carried out in July 1995 by Bosnian Serb troops.

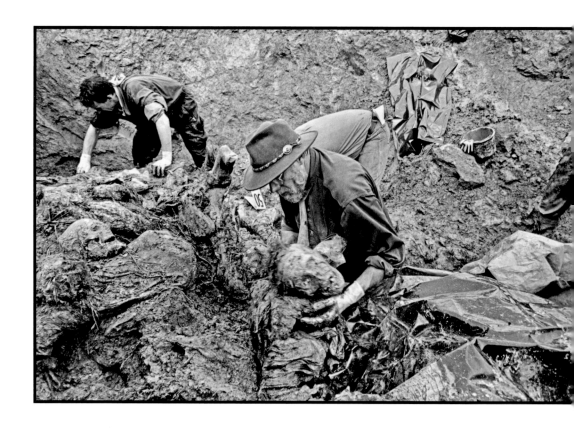

_ Srebrenica, Bosnia 1996. Forensic anthropologist
William Haglund working in the mass grave of a col-
lective farm.

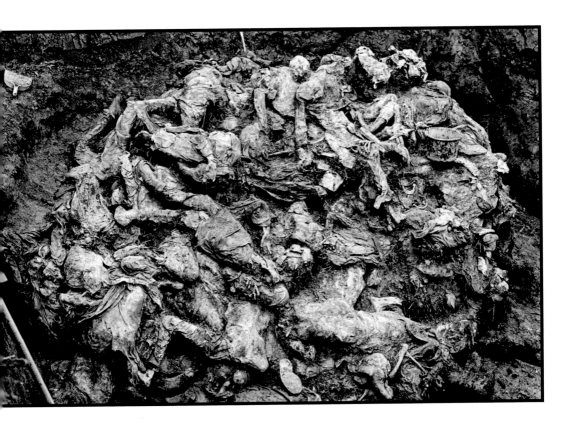

_ Srebrenica, Bosnia 1996. A mass grave in the collec-
tive farm in Pilice, near Srebrenica.

_Sad and necessary

Tom Stoddart

Tom Stoddart
Sad and necessary
Aids in Subsaharian Africa

Tom Stoddart refers to himself as a messenger, not an artist. A man whose task is to return from the most remote corners of the earth with pictures capable of provoking resentment in all those who see them. A man whose mission lies in making sure that forgotten emergencies are covered by the media and reached by the eyes of the public, so that they remain firmly impressed upon the feeble memories of the West; minds which are often too absorbed in an incessantly self-centred pursuit, devoid of any room for dismay.

In the preface to *iWitness*, the book that gathers the most important works of his outstanding career, Stoddart wrote: "It is sad and unnecessary that any of these photographs exist." *Witness* is Tom Stoddart's keyword, the outcome of a personal view of a man who has chosen to observe and report some of the worst humanitarian emergencies that have taken place in the world in the past twenty years, including: the tragic famine in Sudan, the siege of Sarajevo, the conditions of refugees in Rwanda, "ethnic cleansing" in Kosovo, the floods in Mozambique, the war in Iraq and the devastating catastrophe of Aids in Subsaharian Africa.

"The people portrayed are heroes", states Stoddart, "real heroes, unlike those shallow icons from the worlds of cinema, fashion or football...Innocent people trapped and battered by circumstances beyond their control. Ordinary humans in extraordinary situations, displaying immense courage, sacrifice, dignity, and the determination to survive what has befallen them and their loved ones."

This evidence is the communicative capacity of the black and white photographs. They have an ability in and of themselves to describe the intolerable, to convey what cannot be said with words alone: "generations of lives needlessly wasted." His work is the fruit of human empathy, of passion and

commitment, qualities that permeate his images and that grip the mind of the viewer. The rich West has a short memory, one disaster follows the next, wars overlap and humanitarian emergencies are a given fact, a sort of familiar and implicit background.

Instead, the time has come to remember and report.

To remember, for example, that in Africa, particularly in the Subsaharian regions, AIDS kills more than wars and terrorism: of 60 million people in the world infected by this virus, two-thirds live in this area. More than 15 million children were orphaned because of AIDS. Medicine can extend and improve the life of the infected, but for most the costs are prohibitive. HIV is not only a serious health issue, but also a humanitarian, social and political problem for Africa, with devastating effects upon the growth expectations of poor societies. In eight African countries belonging to the Subsaharian region, more than 15% of the adult population are infected, and 9,000 die each day. The epidemic mainly takes the lives of men and women in their most productive years, and the figures of this tragedy are so staggering that the medical and cultural structures of these countries are not able to sustain the extremely high human costs it requires. In Africa, life expectancy is anticipated to fall to 38 by the year 2010. As there is yet no cure or vaccine, the battle against the infection must focus on prevention. Therefore, the communication of information and the sharing of experience is vital to breaking down the wall of silence built around an infection that is still regarded as a shameful taboo.

Tom Stoddart travelled throughout the most affected countries: Zambia, Kenya, Tanzania, Malawi, Zimbabwe and South Africa. He took black and white photographs using close-up lenses, because he wanted to get as near as possible to people and objects. This closeness is associated to the ethics of his photography: in order to be noticed, he must supply evidence, and he hunts for it by getting physically and mentally close to his subjects, focusing on those details that lead to a more intimate connection with the image.

The details in his photographs provide an evidence that remains engraved in the viewer's mind. From city streets and villages, from inside hospitals,

he reports the suffering, the sorrow and the anger for the irrationality of too many deaths alongside the solidarity and closeness of a brotherly bond.

Tom Stoddart has the special gift of capturing those moments in which indescribable destitution meets human courage, strength and compassion.

We can try to encapsulate the great stories in single images that have the power to speak for themselves: for example, the photograph taken in the "The Mother of Mercy" hospital in Zambia, where a nurse delicately holds the skeletal and weak arm of a woman with AIDS. The faces are not exposed and the focus of the image is the charitable gesture of companionship and support. Or the photograph taken in a cemetery in Lusaka, in Zambia, where a lonely man, pictured from behind, digs one of the countless graves in a deserted, almost moonlike landscape, surrounded by flowers that bear witness of more innumerable deaths.

Stoddart, who has been working with the main international newspapers and magazines for some years, has problems in publishing AIDS-related photographs in Africa, "magazines and newspapers want the story but they want you to make the pictures more palatable," he states. He still firmly believes that responsible photojournalism still has the power to deeply influence the perception of what is really going on in the world.

Stoddart obtained that the photographs on the famine in Sudan, published on several international publications, were complemented by the references for making donations to Doctors without Borders and UNICEF: as a result of the instinctive and generous reaction of the readers, a considerable amount of money was gathered. The best kind of photojournalism does not change the world, but it has a civilizing mission that can also be part of a process of revelation and of awareness. As Stoddart claims, "Don't feel sorry when you look at these pictures – feel angry that we need to be reminded of such folly." *a.ta.*

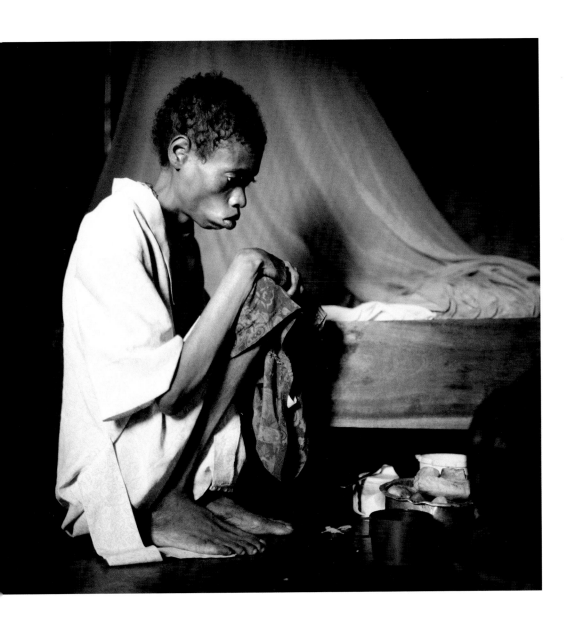

_ Mwanza, Tanzania 2002. Janet John, 23 years old,
AIDS patient.

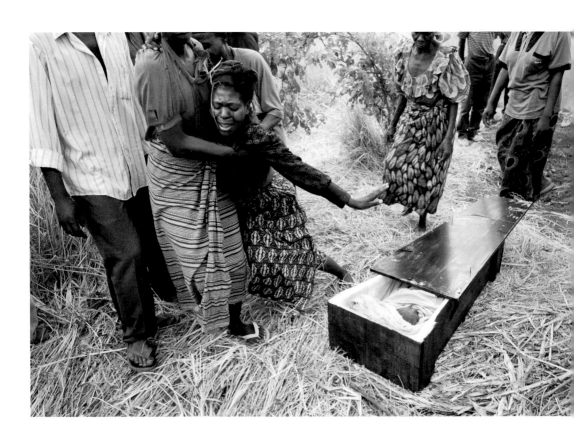

_ Zambia 2002. A desperate mother in front of the tiny
coffin where her son, who died of AIDS, rests.

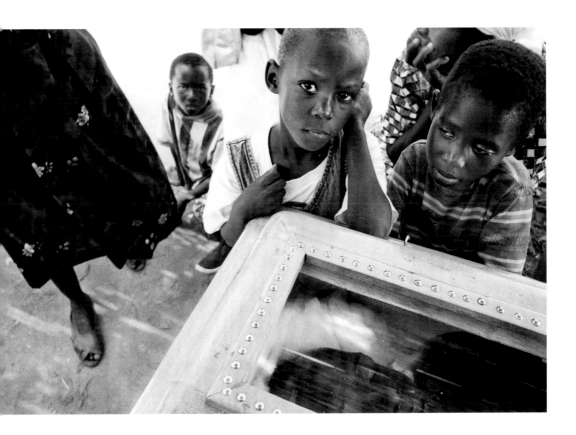

_ Homa Bay, Kenya 2000. Another child is left without a father. AIDS has orphaned 15 million African children in the last twenty years.

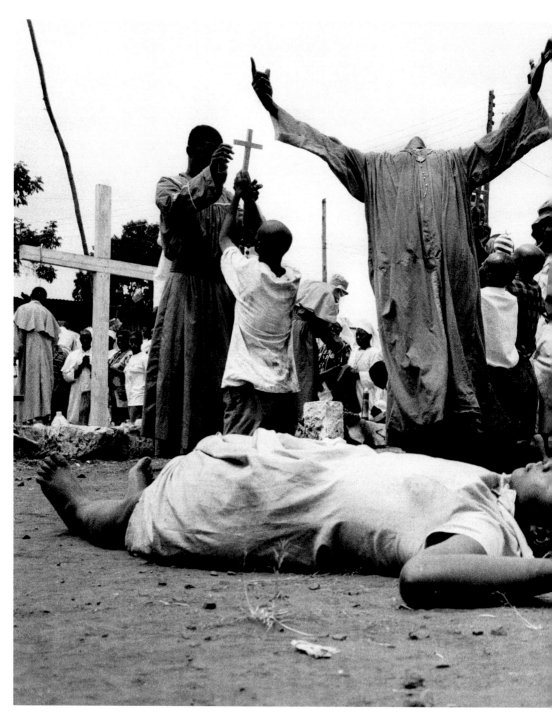

_ Nairobi, Kenya 2002. Priests of the Legion Maria Sect in Fort Jesus trying to exorcise AIDS from one of their followers.

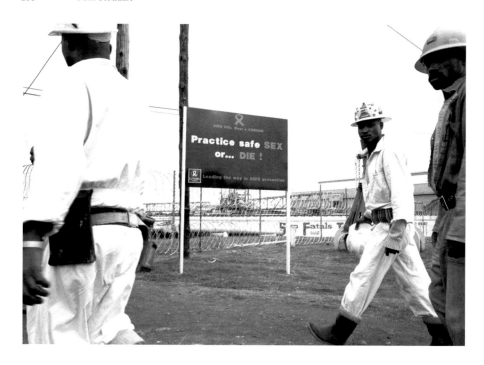

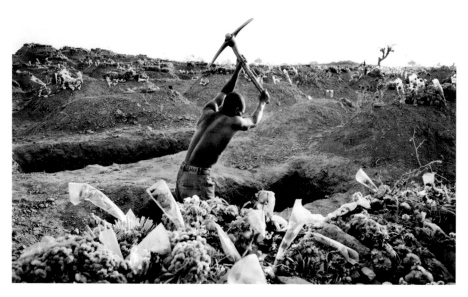

_ South Africa 2000. A poster advising the population to have safe sex to prevent AIDS.

_ Lusaka, Zambia 2002. Sevelino Banda is one of the 126 grave diggers, who bury around 50 people a day, most of whom have died of AIDS.

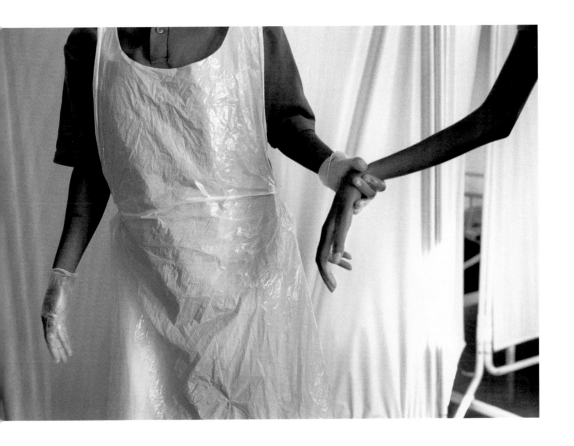

_ Chilanga, Zambia 2002. A nurse in the Mother of
Mercy hospital helps Josephine Mudenda, AIDS pa-
tient , to her bed.

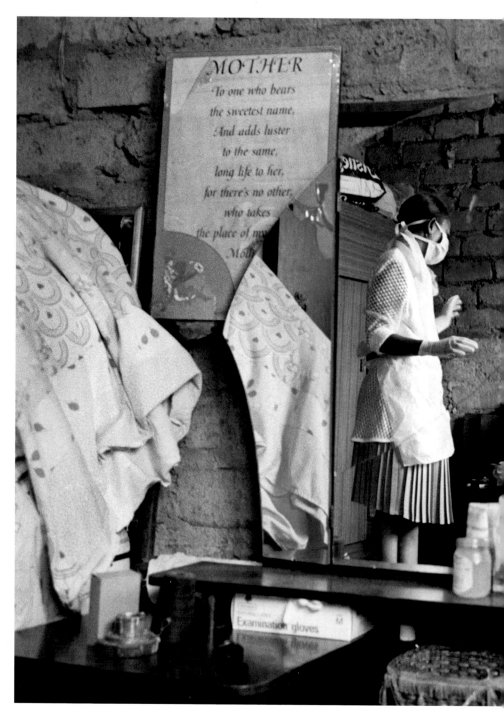

_ South Africa 2000. An man suffering from AIDS is loo-
ked after at the Moretele Sunrise Hospice nursing home.

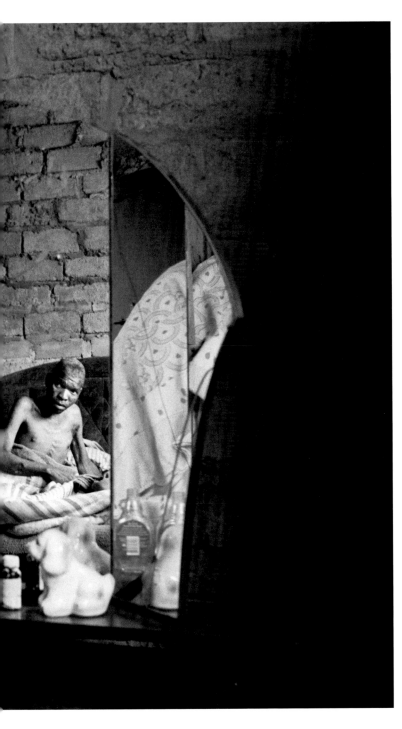

_Revenge and Punishment

Ulrik Jantzen

Ulrik Jantzen
Revenge and Punishment
Women disfigured by acid attacks in Bangladesh

Shahida Akterpoly is only 25 years old. She was one of the most beautiful girls of her neighbourhood. Now, she is sits in a room of the Bangladesh Medical College in Dhaka, her face and body disfigured by unbearable burns.

"I felt the soul leave my body and I was sure I was going to die, I had no idea what had happened". She said during the first treatment, only two hours after the attack. The only thing she remembers is that someone knocked on her door and, when she opened it, she suddenly felt an excruciating pain. She did not even see the man who committed the vile and violent act, but she is convinced that it was an act of jealousy. Jealousy for the happy life she had with her husband.

In some parts of the world it doesn't take much to lose the right to live your life. Shahida is one of the many women from the Bangladesh's hospital – the only one equipped with a centre for fire victims – that Ulrik Jantzen has portrayed in his work. She is but one of the hundreds of women who every year are harmed by similar acts of such brutality and ignobility, they are practically inconceivable to us.

In Bangladesh, but also in Pakistan, a woman runs the risk of being disfigured with acid for a number of reasons: turning down a marriage proposal, choosing a husband in place of accepting an arranged marriage, filing for divorce, or even a dispute over dowry payment. The victims are usually very young, aged between 12 and 27.

The most common attacks are carried out by men who have been rejected. "Beauty is perceived as the asset of the girls and young women" wrote the director of The Acid Survivors' Foundation, "These men want to take away the beauty and therefore they will become useless for the rest of their lives.

No one will marry them." By depriving the girl of her beauty, the attacker also takes away her hopes of building a social life: because of the disfiguring consequences of refusing to marry her aggressor, it will be extremely difficult for her to marry someone else.

In an environment where violence against women is widespread, the justification of these abuses is deeply rooted in cultural and social factors. Women are seen as property and are subject to male authority. Even though in the year 2002 Bangladesh implemented harsh laws in an attempt to stop acid attacks, the law is often ignored. In some countries like Pakistan, there is no form of protection for the victims and a high number of crimes remains unpunished. The pain endured by these women is beyond description; it is a physical and psychological sufferance.

The attacks turn them into disfigured individuals with distorted masks, which are difficult to look at. These women permanently lose the identity that their culture assigns to them as future brides and mothers. And in a country where to be single is an embarrassment for a woman and her family, this is an extremely atrocious act. Most of the victims do not have the courage to appear in public and hide themselves away, at times under a heavy burqa even if they are not Muslims. Often, the victims commit suicide.

In 2001, 25 year old Ulrik Jantzen, a Danish photographer, was in Dhaka, Bangladesh, in the centre for fire victims of the Bangladesh Medical College. He was faced with a chaotic and intricate fresco, full of pain and suffering, similar to one of Dante's Circles of Hell: beyond the bustling crowd of young women were other patients. Jantzen soon learned that the ward also treats children who are victims of a cruel revenge exacted on them because of the misdemeanours of a relative.

In Jantzen's portrayal of the survivors, youthful faces relay the tragedy of marred lives: beauties marred by disfiguring burns, corroded eyes and lips.

He depicts the painful treatments, the rinses after the attack, the dressing of the wounds. But, more important still, he portrays the faces and bodies of those who decide to show themselves, overcoming the embarrassment to denounce such an unimaginable violence. The painful beauty of the images communicates the tragedy of violated human beings, and, concurrently, the

power of their retrieved dignity as they show their faces once more. They believe that their courage to expose themselves will give their daughters, sisters, and women of their country hope for the future.

They are victims but, above all, physical and moral survivors: human beings who, despite the atrocious abuse, still have the will to live.

According to a survey led by the Acid Survivors Foundation, everyday in Bangladesh around 1.5 women are subject to acid attacks. And there are probably many more than that, as many cases are not reported and the figures are not official.

The process of transformation that can stop the violence, the abuse and the absurd prevarication starts by raising public awareness and by reporting the evidence which, unless it has been documented, is practically non-existent. Through its immediacy, photography can break through the barriers of silence and indifference and stimulate an awareness that can influence political opinion.

When Shahida and other women in her condition are portrayed, they carry out an act of defiance and of public accusation. They reveal themselves to everyone, so that everyone can be aware of how easy it is to destroy a woman's life in some parts of the world. *a.ta.*

_ Dhaka, Bangladesh 2001. A victim of an acid at-
tack receives treatment at the Bangladesh Medical
College.

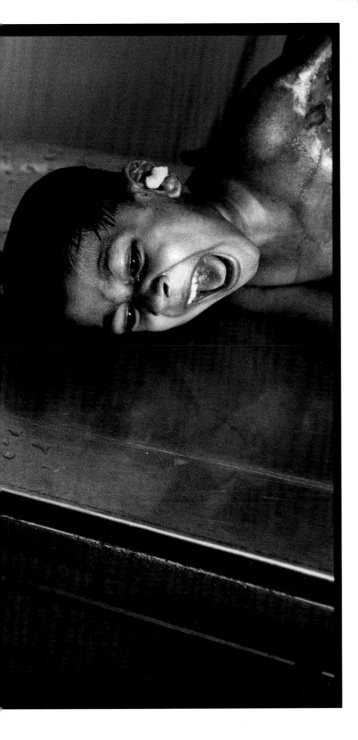

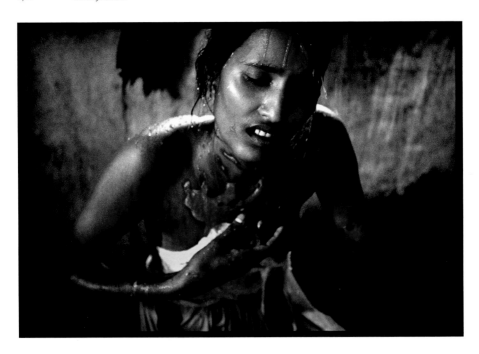

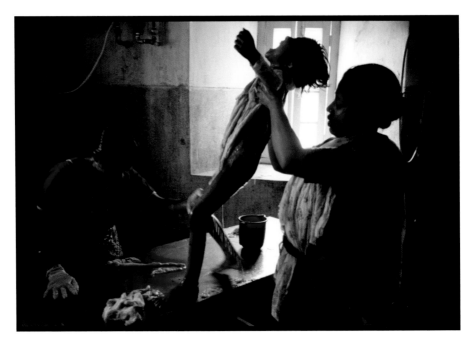

_ Dhaka, Bangladesh 2001. Bangladesh Medical College. Shahida Akterpoly, a victim of an acid attack.

_ Dhaka, Bangladesh 2001. Bangladesh Medical College. A little girl screams, her body is 50% burned. The acid was aimed at the mother, whom she was sleeping with.

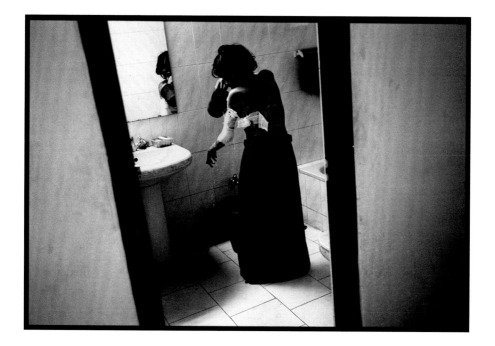

_ Dhaka, Bangladesh 2001. Bangladesh Medical College. A woman tries to wash her wounds with cold water despite the pain.

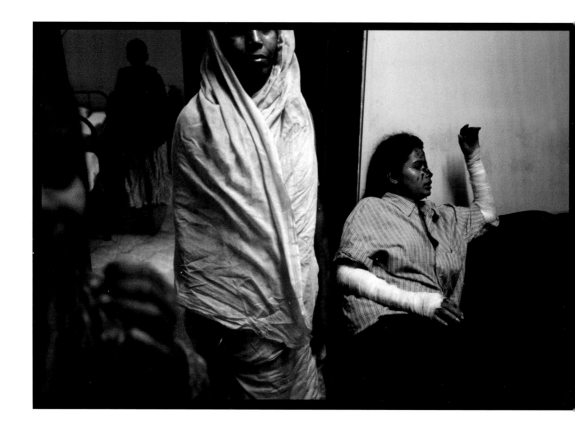

_ Dhaka, Bangladesh 2001. Bangladesh Medical College. Dhaka Medical College is the only hospital in the capital that has a fire-victims department.

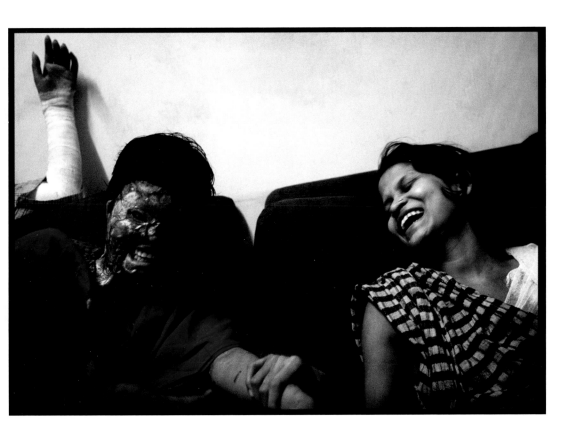

_ Dhaka, Bangladesh 2001. Bangladesh Medical College. In spite of the tragedy, some women have the strength to laugh.

_As we sleep

Juan Medina

Juan Medina
As we sleep
Illegal Immigration in Europe

"In the past years I have documented the conditions of thousands of people who have risked their lives in the attempt to reach the Canary Islands, where I live, gathering evidence of a human tragedy that takes place with shocking regularity."

Juan Medina is an Argentinian photographer based in Fuerteventura. He documents illegal immigration to Spain travelling around the island's coasts.

Mass immigration is a relatively recent phenomenon in Spain. Throughout the nineties Spain recorded a considerable rise in immigration from Latin America, Asia, Eastern Europe and, principally, from Maghreb and Subsaharian Africa.

Since then, thousands have been reaching North African coasts to try and reach Europe. They pay considerable sums to embark on a dangerous crossing, with ruthless smugglers heaping forty or more passengers on small, overcrowded boats built to carry ten people at the most.

Their dream is to reach the Spanish coasts, to then move on to the main European cities, mainly in Belgium, France, and Italy. Unfortunately, 40% of these boats never reach their destination: they either sink or have to return back.

In recent years, Spain, along with other EU countries, has adopted some innovative measures to patrol the waters used more frequently by illegal immigrants.

By using a radar-based control system, the Navy, Police and Coast Guards of Spain, Italy, France, Portugal, and Great Britain control a 72 square mile filter area creating what amounts to a virtual frontier in the sea. In this way, the Spanish *Guardia Civil* intercepts most of the boats smuggling the immigrants off the Canary Islands too.

On the night of 12 November 2004 yet another tragic shipwreck took place, and yet again, Juan Medina was there to witness the events. "I was preparing a report on the arrests that the *Guardia Civil* carries out at sea... That night

the boat was very crowded. The people were so desperate that when they saw the *Guardia Civil*'s boat they all moved towards us to try and climb on our vessel, but their boat capsized and the forty passengers fell into the water. That is when the famed rescue, that ended in tragedy with 11 people lost at sea."

Morir tan cerca, secuencia de un naufragio (Death so Near; Sequence of a Shipwreck), *Donde mueren los sueños* (Where Dreams Die), *Cruel Sea*: under these desperate titles Medina gathers images of men, women and children who dream of a successful and wealthy life – a "European" way of life – formed by many deceptive symbols that reach Africa like drops of hope. Many tackle the long and strenuous journey, regardless of their fate, to escape famine, poverty or the wars that afflict their countries.

The journey towards the Canary Islands is extremely dangerous because of the strong Atlantic currents, but recently it has been frequently chosen as an alternative route to the Strait of Gibraltar or to climbing the fences of Ceuta and Melilla.

When they arrive, the survivors are hosted in immigration centres and then, in most cases, extradited: the limited cooperation with Subsaharian nations means that illegal immigrants can't be sent back to their countries. The authorities issue an expulsion document after which the immigrants have two weeks to leave the country. In these circumstances, many are sent to the Spanish mainland on account of agreements between various NGO's, but after little more than two weeks detention, they soon return to be homeless illegal immigrants without any documents. The bodies of the less fortunate ones, of those who didn't survive the crossing, are washed up on the shores or are found at sea and buried in coastal cemeteries, commemorated by a plaque bearing their number: figures that newscasts list in a matter of minutes in the statistics drawn up by experts, figures that hide the identity of all those who didn't make it.

Juan Medina, instead, insists on finding out who these people are and, in the darkness of the night or in the cold early morning light, he looks for men and women. How they squeeze up to fit into a tiny boat, their faces revealing the terror of drowning, their arms stretched out to try to find a handhold, exhausted men and women who reach the shores and collapsed. Medina looks

for a name and a story even among those who didn't make it, in the lifeless bodies floating in the water, between birds, or in those wrapped in the sacks that stand out, like some absurd trophy, on the golden beaches of the Canary Islands. "Many people ask me if it is necessary to show so much pain. I believe that our duty, as reporters but also as human beings, is to not look the other way". As a journalist, Medina observes the stories of these people and narrates them through his pictures, which do not rely on sensationalism but force those who look at them to stop and think about what is going on "while we sleep." "It is curious to see how we speak about freedom in our world since the fall of the Berlin Wall while concurrently erecting, with growing preventive measures, partitions with which we keep away those who are only trying to survive." According to a delegation of the Co Federal Group of the European United Left – Nordic Green Left (GUE/NGL) of the European Parliament, who visited the Canary Islands in April 2006, the urgency of the situation "requires a strong commitment not only of the Spanish Government, but also of the European Union, that should a adopt a common policy to ensure the respect of human rights and asylum, in addition to implementing the necessary measures for the integration of the new citizens."

Moreover, Medina's work emphasizes how this dramatic and persistent emergency, like a relentless flow, is happening very close, too close to us. "The chief issue is whether we care about the deaths of these people or, rather, if we are just annoyed that this happens on our doorsteps". *a.tu.*

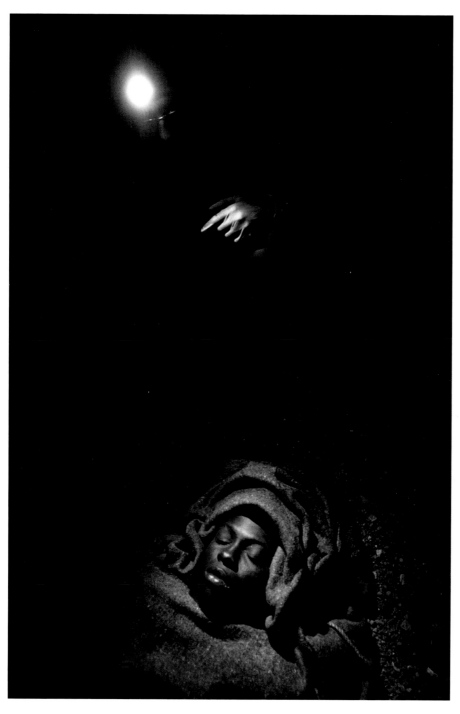

_ Canary Islands, Spain 12 November 2004. A Red
Cross volunteer shines his torch on an African im-
migrant.

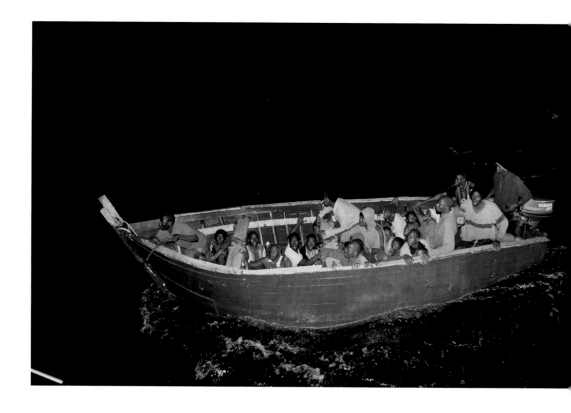

_ Canary Islands, Spain 12 November 2004. A rickety boat with around thirty African immigrants is approached by the *Guardia Civil* during a rescue operation of the coasts of Fuerteventura.

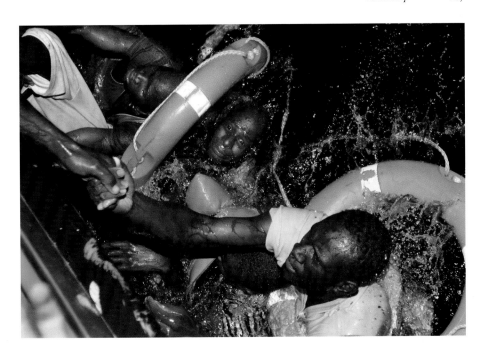

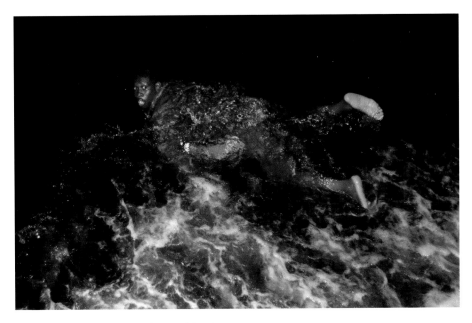

_ Canary Islands, Spain 12 November 2004. The *Guardia Civil* rescuing men who have fallen into the sea.

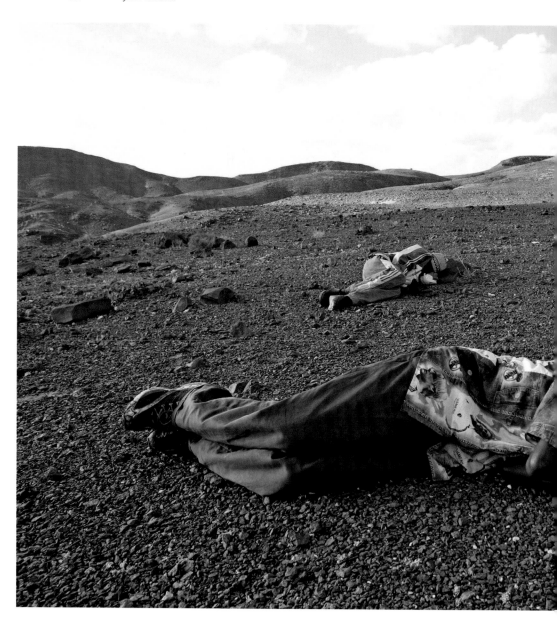

_ Canary Islands, Spain 12 November 2004. Two ex-
hausted African immigrants on El Caracol beach in
Fuerteventura. 65 immigrants have been detained on
the beach after their arrival.

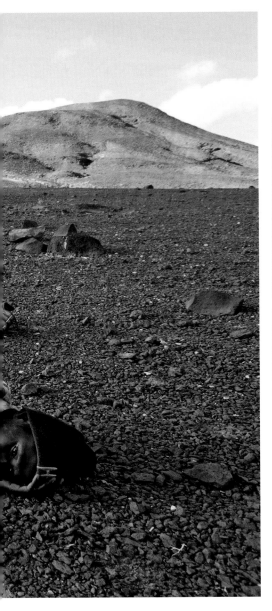

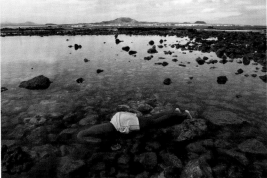

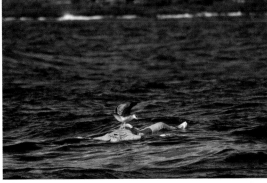

_ Canary Islands, Spain 2004. The bodies of two African immigrants who drowned after their boat sank.

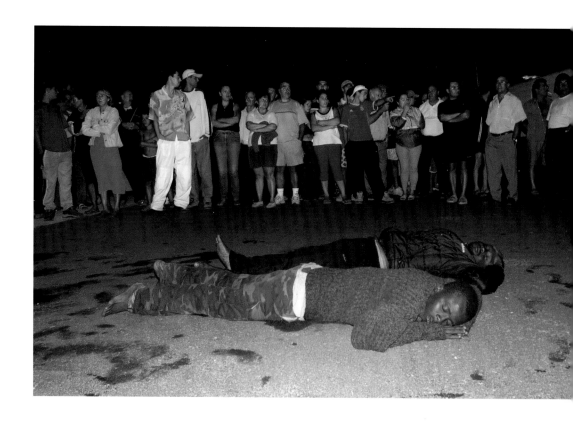

_ Canary Islands, Spain 12 November 2004. Two
worn out immigrants lying on the ground after the
journey from the African coasts, surrounded by a
crowd of curious people.

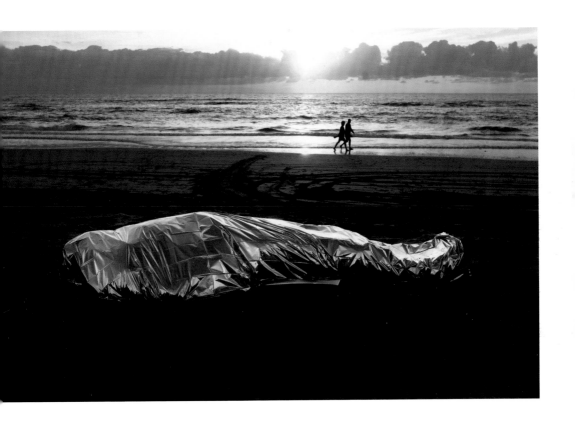

_ Canary Islands, Spain 2004. A man, who has
drowned in a shipwreck, is wrapped in a sack on Ma-
torrai beach.

_The "Omega Suites"

Lucinda Devlin

Lucinda Devlin
The "Omega Suites"
Capital punishment in America

"I wasn't prepared for this. Looming in front of me was a massive, gray bunker. It looked impenetrable. Guard towers ascended at each end and concertina wire was set atop the wall all the way around. I don't know what I was expecting, but my heart was beating wildly as I was asked to remove my bel and shoes...The guard accompanying me was young and not too tall, but he obviously spent a lot of time with weights. He was taut and not just because of his well muscled body. It was also in his demeanour. In fact, this tension was palpable all around me. The doors he escorted me through opened and closed automatically at his signal to the door master, who was herself ensconced in a bullet proof booth. Every sound was magnified, echoing off the cement and steel."

From 1991 to 1998, the photographer Lucinda Devlin, with the permission of the local authorities, took some photographs inside twenty prisons in the States where capital punishment is allowed.

The outcome of this effort is a series of 30 photographs that provide a powerful portrait of American death rows and execution chambers. *The Omega Suites* – the title alludes to the last letter of the Greek alphabet as a metaphor for the finality of capital punishment – depicts and describes the rooms and instruments that America uses to inflict society's extreme punishment: gas chambers, electric chairs, gallows, lethal injection tables and witness viewing rooms. Using a Hasselblad camera and a long exposure time that enables her to exploit the small amount of available light, Lucinda Devlin's color photographs are glacial and intense. The extreme formal rigor of her images unexpectedly contrasts with the portrayed subject, which creates a strong emotional impact. Her approach leaves room for the spaces to express

themselves, and what they communicate is a disquieting indifference on behalf of the institutions.

Regardless of their position on the death penalty, viewers cannot help but feel crushed by the iciness of these barren rooms, with their cold neon lights and bare walls painted in drab, lifeless beiges and greys.

The documentary approach is enhanced by her artistic abstraction centred on simplification: lines, colors, composition and details are the tools used by Lucinda Devlin to examine how architectural settings efficiently reveal the values of the culture that creates and uses them.

Some images are taken from a potential executioner's viewpoint, others by the equally disturbing perspective of a hidden witness, reminding the viewers of their undeniable involvement and complicity in a world we often choose not to see. Intrigued by the formal elegance of Devlin's images, the viewer is driven to an in-depth research that, inevitably, causes an emotional, if not intellectual, repulsion. In the United States, more than 900 death sentences have been carried out since 1976, the year in which capital punishment was reinstated. With 70 percent of the citizens supporting the death penalty, Lucinda Devlin brings to focus one of the greatest and most important ethical questions facing US society today with great artistic sensitivity.

The rooms in which these homicidal events are performed insinuate that the executions are experienced and organized as rituals, including the presence of an audience. An electric chair, in the center of the room, takes on the horrifying features of a clinically hollow and sterile throne. In Atmore Prison, in Alabama, the death room is lit up by the bright yellow electric chair called "Yellow Mama," because it has the same colour as American school buses.

Legal homicide seems clean, simple and silent.

However, attention must be paid to details, shrewdly included in the images, such as the clocks showing us the time and making us grimly aware of reality. The photographs show a hermetically sealed world, characterized by the adoption of drastic measures to counteract threats. In 1989 the Second

Protocol of the Covenant on Civil and Political Rights for the abolishment of capital punishment was approved, but to date only 60 out of nearly 200 nations have observed this agreement. Lucinda Devlin's rooms bear silent witnesses to a judicial system based on processes that Cesare Beccaria, in the eighteenth century, had already branded as absurd.

Her work poses, in visual terms, a contemporary and controversial issue in the belief that "as members of that society, it is incumbent upon us to understand the ramifications of this ultimate punishment that is being meted out behind closed doors and in our names." *a.ta.*

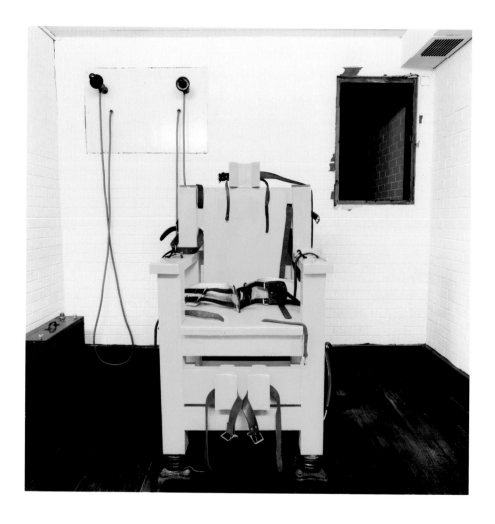

_ Atmore, Alabama, USA 1991. The electric chair,
Holman Prison.

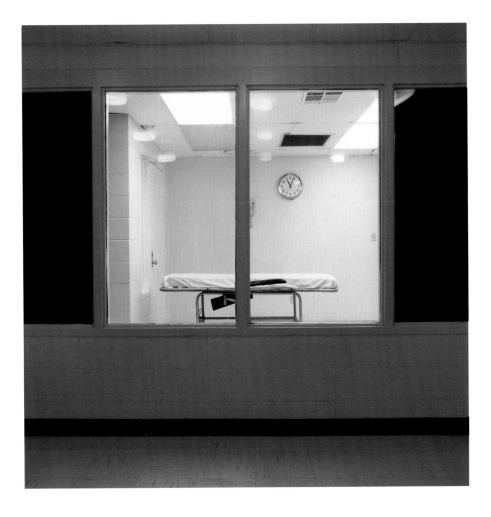

_ Grady, Arkansas, USA 1991. Lethal injection room
seen from the witness viewing room, Cummins Prison.

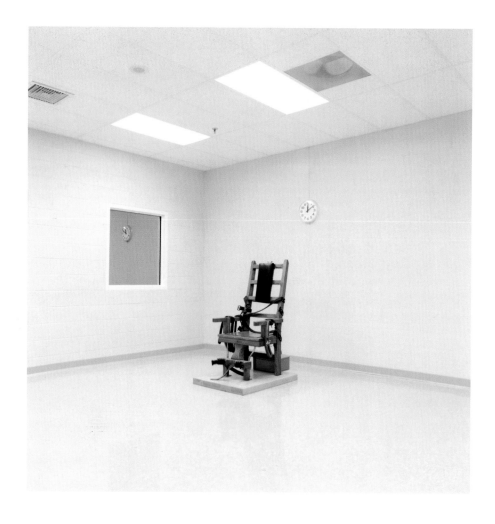

_ Jarratt, Virginia, USA 1991. The electric chair in
Greensville Prison.

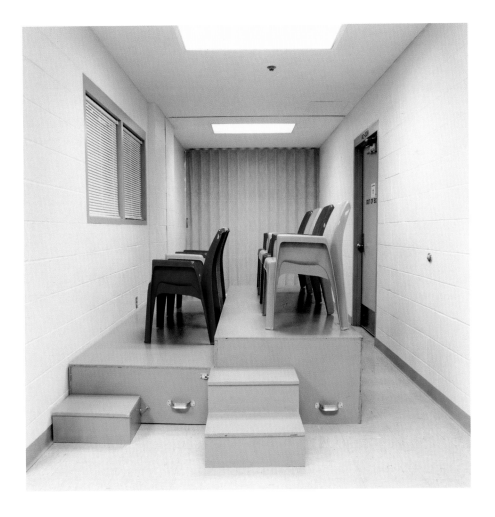

_ Petosi, Missouri, USA 1991. The witness viewing
room, Petosi Prison.

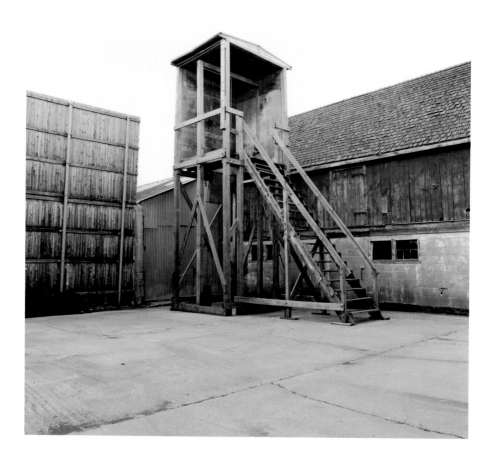

_ Smyrna, Delaware, USA 1991. Prison gallows.

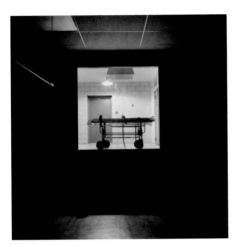
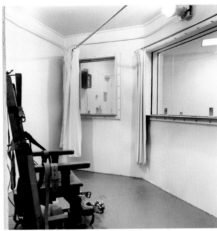
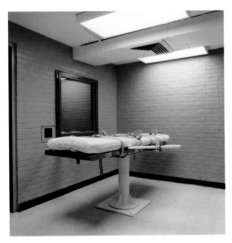
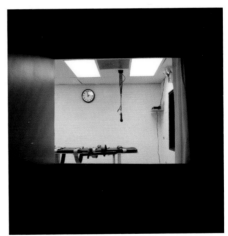

_ Joliet, Illinois, USA 1991. From the witness viewing room, Statevile Prison.

_ Huntsville, Texas, USA 1992. Lethal injection room in the State Prison.

_ Raleigh, North Carolina, USA 1991. Gas chamber in the State Prison.

_ Parchman, Mississippi, USA 1998. Lethal injection room seen from the witness viewing room, Parchman Prison.

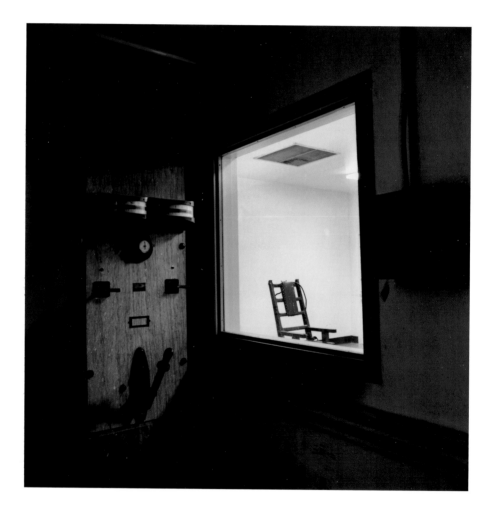

_ New York 1991. The executioner's room, Green-
haven Prison.

_ Florence, Arizona, USA 1992. Gas chamber in the
State Prison.

_ The photographers

Bob Adelman

Gianni Berengo Gardin

Carla Cerati

Luciano D'Alessandro

Lucinda Devlin

Donna Ferrato

Marc Garanger

Lewis W. Hine

Ulrik Jantzen

Philip Jones Griffiths

Igor Kostin

Josef Koudelka

Li Zhensheng

Peter Magubane

Juan Medina

Gilles Peress

Raghu Rai

Jacob Riis

Sebastião Salgado

David Seymour

W. Eugene Smith

Tom Stoddart

Bob Adelman

_ Born in 1930. He has collaborated with numerous newspapers and magazines such as *Esquire, Time, People, Life New York, Harper's Magazine, the New York Times Magazine, Paris Match*. Through his passionate and engaged coverage of the African American Civil rights movement, he has greatly influenced the awareness of public opinion. He has published many books including *King: The Photobiography of Martin Luther King Jr., 2004*. He has received many awards and his photographs have been exhibited in the Smithsonian Institution, the American Federation of Art and many other museums and galleries. His images are included in the collection of the Museum of Modern Art in New York. Bob Adelman has taught at the International Center of Photography and the School of Visual Arts in New York. He lives in Miami Beach.

Gianni Berengo Gardin

_ Born in Santa Margherita Ligure (Genoa) in 1930, he has been working with photography since 1954. After having lived in Rome, Venice, Lugano and Paris, in 1965 he settled in Milan. He published his first images in Pannunzio's *Il Mondo*, working there from 1954. Since then he has collaborated with the major Italian and foreign newspapers. He has produced over two hundred books and countless exhibitions in Italy and abroad. In 1968, together with Carla Cerati, he produced a reportage on Italian

mental hospitals published in the book *Morire di classe* the following year under the supervision of the psychiatrist Franco Basaglia.

He received an award at World Press Photo in 1963. This was followed by countless publications such as *L'occhio come mestiere* and, in 1990, his major anthological collection entitled *Gianni Berengo Gardin fotografo*; the same year he was guest of honour at Mois de la Photo in Paris where he won the Brassaï Prize. He devoted most of his work during the eighties to the Roma communities in Italy and the book *Disperata allegria – vivere da zingari a Firenze* won the Oscar Barnack Award in 1995. In 2004 an anthological volume of his images was published for exhibitions in Paris (Maison Européenne de la Photographie) and Milan (Forma) in 2005.

Carla Cerati

_ Born in Bergamo in 1926. She began to work as a professional in 1960 photographing the theatrical performances of Franco Enriquez. Over the years she has devoted particular attention to portraits, youth, intellectuals and social outcasts. Her portraits of intellectuals from all over the world have been published in the major international newspapers. In 1968, together with Berengo Gardin, she worked on *Morire di classe*, which was published the following year under the supervision of Franco Basaglia. As an author of written texts she made her first appearance in 1973 when

Einaudi published *Un amore fraterno*, a finalist at the Premio Strega. Since then she has published numerous novels

Luciano D'Alessandro

_ Born in Naples in 1933. In 1950 he began to take photographs. At the age of nineteen he began to collaborate with *L'Unità*. After a period in Paris he went to the USSR where he shot his first reportages. On discovering the "Unemployed" in a backstreet in Naples (the subject of a celebrated photo) he began his investigation into the city and its social problems and this became the key subject of his work. In 1959 he began to publish in Pannunzio's *Il Mondo* and he has collaborated with the most important national and international newspapers. Between 1965 and 1968 he made an important reportage on the mental hospital at Nocera Superiore and following this published *Gli Esclusi* (1969). During the seventies and eighties, he produced several books including *Campania* (1972), *Vedi Napoli* (1974) and *Tra la mia gente* (1981). From 2001 he began to experiment with digital photography investing his full professional engagement in this medium. His work was celebrated at the French Academy in Rome with an exhibition in 2006.

Lucinda Devlin

_ Lucinda Devlin was born in Ann Arbor, Michigan in 1947. She graduated in English literature in 1972 at the Eastern Michigan University, where she also obtained her master in photography in 1974. From 1974 to 1975 she worked as a Media specialist at the Mental Hygiene Institute in Ann Arbor. Since 1977 she has taught Photography and History at various US universities. From 1991 to 1998 she travelled the United States visiting many prisons for her project entitled "Omega Suites". Her works can be found in the collections of several museums and institutions including the Guggenheim Museum in New York and the Bibliothèque Nationale in Paris. She has participated in many exhibitions in Europe and the United States including the 49th Venice Biennale in 2001 and the 25th Biennale of San Paolo in 2002. She lives and works in Indianapolis, Indiana.

Donna Ferrato

_ Donna Ferrato was born in Massachusetts in 1949. After studying Fine Arts at the University of Boston, she married and worked as a secretary. Four years later she left her work and her husband to attend a course in Photography and Sociology at the San Francisco Institute of Art.
In 1976 she moved to Paris and collaborated with the Contrejour Gallery. She returned to America in 1978 and in 1979 she joined the photography staff of *Media People* in New York, she also collaborated as a freelance photographer for *Esquire, Newsweek* and the *New*

York Times. In 1982 she joined the photography agency Vision and worked for *Fortune, Forbes, Stern, Bunte* and *Life*. From 1981 she travelled the United States for ten years, working on a reportage on domestic violence in America, which won her the Eugene Smith Award and was published in 1991 under the title *Living with the Enemy*. These photographs have been shown at numerous exhibitions held to raise funds for safe houses for abused women. She founded the no-profit organisation *Domestic Abuse Awareness*, Inc., and she holds numerous conferences in US universities and schools. Her most recent work is *Amore* (2001). Donna Ferrato lives and works in New York.

Marc Garanger

_ Marc Garanger was born in Normandy in 1935. In 1957 as a photographer he shot a number of reportages in Africa, Dakar, Bamako and Sikasso. During his military service in Algeria between 1960 and 1962 he worked as the photographer for his regiment. Shocked by the absurdity and the horrors he witnessed his photographs aimed at denouncing the conflict. The over 2000 photographs he took of Berber women in Algeria earned him the Prix Niépce in 1966. Following this he went to Czechoslovakia and then to the USSR. Year after year, he became more and more involved in the life of Eastern Europe travelling through almost all the communist republics. He ventured as far as Sakha, in eastern Siberia, where he made a reportage on the Shamans. In 2004 he returned to Algeria revisiting the people and places he had photographed during his military service. Garanger is president of the Société des Auteurs des arts visuels et de l'Image Fixe.

Lewis Hine

_ Lewis Wickes Hine was born in Oshkosh, Wisconsin, in 1874. After working in a factory he studied sociology at the University of Chicago. He became a teacher, and in 1901 attained a post as a geography teacher at the Ethical Culture School in New York. He turned to photography because he sensed its potential as a tool for social research. From 1904, he concentrated on the immigrants arriving in Ellis Island, with the aim of showing the human side of immigration. In 1908 he initiated a project on juvenile labour for the National Labor Committee. Hine left teaching and travelled across the USA for ten years. In 1918 he travelled through Europe with the Red Cross. The following year he published *The Children's Burden in the Balkans*. Following this he devoted himself to reporting the world of workers eventually publishing the book *Men at work*.

Ulrik Jantzen

_ Ulrik Jantzen was born in 1976 in Odense, Denmark. He studied photojournalism at the Danish School of Journalism. Then he col-

laborated with the *Berlingske Tidende*. He works principally in fashion, portraits and youth culture. Thanks to his commitment he has concerned himself with important issues such as daily life in Copenhagen prison and anorexia. His projects include a reportage on women disfigured by acid in Bangladesh dating from 2001. In 2002 Jantzen won the Agfa/Das Bildforum prize and he became the travel photographer of the year for Fuji. In 2003 together with Lars Bech he founded the agency Das Büro.

Philip Jones Griffiths

_ Philip Jones Griffiths was born in 1936 at Rhuddlan, Wales. He studied pharmacology in Liverpool and worked as a pharmacist on night duty while he devoted himself to photography, collaborating with the *Manchester Guardian*. In 1961 he became a full time freelance photographer for the *London Observer* and the following year covered the war in Algeria alongside the Liberation Front. In 1964 alone Griffiths travelled to forty different countries as a photo reporter. In 1966 he joined Magnum Photos, becoming a member in 1970, and he went to Vietnam, where he remained until 1968, and returned several times afterwards. In 1971 he published *Vietnam Inc.* In 1973 he covered the Yom Kippur war and worked in Cambodia until 1975. In 1977 he moved to Thailand and to New York in 1980, the year he became

president of Magnum (a post he led for five years). Griffiths collaborated with *Life* and *Geo* shooting a reportage on Buddhism in Cambodia, drought in India, poverty in Texas, reforestation and the long post war period in Vietnam as well as the consequences of the first Gulf War. He has made several films for the BBC and the United Nations office of the High Commissioner for Refugees.

Igor Kostin

_ Igor Kostin was born in 1936 in Chisinau, Moldova, annexed by the USSR in 1940. His childhood and adolescence was spent in dire poverty. In 1959 he began his ten-year career as a first class volleyball player. He completed his studies and became an engineer. He began working in the construction industry in Kiev, as a site manager. He designed machines, filed a patent and won prizes. At the end of the sixties he became interested in photography, left his job and became a freelance photographer for the press agency Novosti. He was sent to Vietnam, Cambodia and Afghanistan, but his not being a member of the Communist Party meant he was continuously under KGB surveillance. In 1986 he was the first photographer on the scene at the Chernobyl explosion. For ten years he covered the nuclear disaster until he fell ill from the radiation to which he had been exposed. He battled against his illness and

overcame it and continues to show the world the devastation caused by the explosion. In 2006 *Chernobyl-Confessions* of a reporter was published.

Josef Koudelka

_ Josef Koudelka was born in 1938 in Moravia, Czechoslovakia. He studied engineering at the Polytechnic in Prague; he began to take photographs with a bakelite camera and in 1961 presented his photographs for the first time in the foyer of the Semafor Theatre in Prague. He collaborated with the magazine *Divadlo* and photographed Roma people while he worked as an aeronautical engineer in Prague and Bratislava.

In the summer of 1968 he was in Prague during the Soviet Invasion. His photographs were smuggled across the border, Magnum distributed them as the work of an anonymous photographer and the reportage was awarded the Robert Capa prize from the Overseas Press Club. In 1970 he left Czechoslovakia finding asylum in Great Britain and he travelled photographing the Roma community, popular fairs and daily life in Europe. In 1974 he became a member of Magnum Photos. In 1975 he inaugurated a solo exhibition at the MoMA and published *Gitans: la fin du voyage*. In 1984, after sixteen years of anonymity the Prague photographs were published under his name. He became a French citizen in 1987; a year later *Exils* appeared. He shot panoramic photographs for the Transmanche mission. In 1990 he returned to Czechoslovakia. He photographed the metalliferous mountains of northern Bohemia (*Black Triangle*, 1994). In 1991 he was awarded the Gran Prix Cartier-Bresson. In 2001 he published the volume *Caos (Chaos)* and in 2003 *Teatre du Temps*. The International Center of Photography in New York gave him the Infinity Award in 2004. In 2006 he published the retrospective volume *Koudelka*.

Li Zhensheng

_ Li Zhensheng was born in 1940 in Dalian, in the Chinese province of Liaoning. In 1960 he enrolled at the Changchun Film School. After graduating he began to work in Harbin as a photographer for the *Heilongjiang Daily*. These were the years of the Socialist education movement, and he was sent back to work in the countryside. He returned to the newspaper in 1966, photographing the celebratory events in honour of Mao, mass manifestations but also the denunciation of "bad elements", enemies of the revolution, public humiliations, beatings of the accused and executions. For years Li Zhensheng hid his material which could not be published because it gave a negative of the new China. At the end of the sixties he was sent to a re-education school together with his wife, whom he had married in 1967. He returned home and to his newspaper two years later. From 1982 Li Zhensheng worked for the

department of journalism at the International Institute for Political Science in Beijing as head of photography. In 2003 his book *Red-Color News Soldier* appeared with a collection of photographs edited by Robert Pledge and Jacques Menasche. At present Li Zhensheng is engaged in writing and research.

Peter Magubane

_ Peter Magubane was born in 1932 in Vrededrop, South Africa. He became interested in photography and collaborated with *Drum Magazine* at the age of nineteen. In 1956 he was arrested following a reportage on anti Apartheid demonstrations. He documented many political events of those years including the "treason trials" and the "anti-segregation protests". In 1958 was the first black South African to win a photography prize in the country. He documented the Sharpeville massacre in 1960. Between 1963 and 1964 he worked in London as a freelance photographer and returned to South Africa in 1966, the following year he began working for the *Rand Daily Mail*. In 1969 he was arrested while photographing the protest outside the prison where Winnie Mandela was being held. After a year the charges were dropped but he was inflicted with a five year ban which made it impossible for him to work. He returned to prison in 1971 and again in 1976 for having covered a student revolt in Soweto. In 1980 he left for New York. He works for several

United Nations agencies, including the office of the High Commissioner for Refugees and UNICEF. In recent years through his images he has told the story of the survival of tribes in post-apartheid South Africa, and the cultural development of the new era.

Juan Medina

_ Juan Medina was born in Buenos Aires in 1963 and has worked as a professional photographer since 1989. As a photographer for the Reuters agency based on the island of Fuerteventura, over recent years he has carried out an in-depth investigation into illegal immigration from Africa to Spain passing through the Canary Islands. He has won several prizes including the 2005 FotoPrés prize, third prize in the *Spot news* category in World Press Photo and the Care International prize 2005 for humanitarian photography at the festival Visa pour l'Image di Perpignan, France.

Gilles Peress

_ Gilles Peress was born in France in 1946. He graduated in Political Science in 1971 at the University of Vincennes. It was during this period that he completed his photographic work on a mining village in the south of France. In 1972 he joined Magnum Photos and was president in 1986-87 and in 1989-90. He follows the issues of immigration in Europe, especially immigration from Turkey. Already in 1970 he was in Northern Ireland

for a project on civil rights, which led, twenty years later to a book entitled *Power in the Blood* – part of a project on intolerance and nationalism at the end of the Second World War. In 1979 he documented the Islamic revolution in Iran (*Telex Iran: In the Name of Revolution*, 1980). In 1995 he published *Rwanda: The Silence* and in 1998 *The Graves: Srebrenica and Vukovar* devoted to two conflicts that he has concentrated on in particular, trying to overcome the limits of photographic narration, intersecting it with written texts and video footage. He continues his commitment in a series of communications projects linked to the language of photography (*Crimes of War*, *Here is New York*, etc.).

Raghu Rai

_ Raghu Rai was born in 1942 in Jnhang, a small village now part of Pakistan. He attended school in India where he graduated in civil engineering. For two years he worked in a governmental organisation until, in 1965, he decided to devote himself to photography, covering the post of chief photographer for *The Statesman*. His photographs began to appear in books and periodicals of international repute and in 1971 Henri Cartier-Bresson, impressed by an exhibition in Paris, invited him to join Magnum Photos. He worked as photo editor for the *Sunday*, then from 1982 to 1991 for *India Today*. Rai has been travelling constantly for years, documenting the life of his country, its vastness, its cultural and geographic diversity and the beauty and poverty of its people. His works have appeared in the most important international periodicals and dailies. He worked on an intense project about the chemical disaster of Bhopal and the consequences of that terrible incident for Greenpeace (*Bhopal Gas Tragedy*, 2002) and on an itinerant exhibition which began in 2004. He has published numerous books on India, Including *Delhi: A Portrait* (1983), *Raghu Rai's India* (2001) and Mother Teresa of Calcutta, *Mother Teresa: A Life of Dedication* (2005).

Jacob Riis

_ The third of fifteen children, Jacob Riis was born in 1849 in Ribe, Denmark. At a very early age he moved to Copenhagen to work as a carpenter until 1870, when he left for New York. After wandering the length and breadth of Pennsylvania looking for work, he returned to New York in 1873, he found a job as a reporter for the daily *New York Evening Sun* and the following year for the agency called Brooklyn News. In 1877 he was engaged as a crime reporter at the New York Tribune. He travelled all over the slums of the city using photography to document the living conditions of immigrants. In 1889 Jacob Riis wrote an essay about the living conditions of the poor entitled *Flashes from the Slums* which in 1890, revised and expanded, became the main

body of the photographic volume *How the Other Half Lives*. In 1892 he published *The children of the poor*. A writer first and photographer second, he published *The Battle with the Slum* in 1892 and his autobiography *The Making of an American* in 1901. Jacob Riis died in 1914.

Sebastião Salgado

_ Sebastião Ribeiro Salgado Jr. was born in 1944 in Aimorés, Minas Gerais, Brazil. In 1967 he graduated in Economy and from 1969 to 1971 he was in Paris continuing his studies. In 1971 he moved to London where he worked for the International Coffee Organisation. Almost by chance he picked up a camera, and already in 1973 he did his first reportage on the drought in Sahel. The following year he joined the Sygma agency and from 1975 to 1979 he collaborated with Gamma, covering Europe, Africa and Latin America. In 1979 he joined Magnum Photos. Up until 1983, he embarked on several trips to Latin America which gave birth to the project *Otras Américas*. In 1985 he worked on Sahel (*Sahel, l' homme en détresse*, 1986) and received awards from Oskar Barnack and World Press Photo. In 1987 he started his project on manual labour which culminated in a book and an exhibition both entitled *Workers: An Archaeology of the Industrial*. He left Magnum Photos and together with his wife Lélia Wanick Salgado, he founded Amazonas Images. In 2000 *In cammino* was born. In 1998 he and Lélia founded the Terra Institute for the reforestation of Atlantic Brazil. Over recent years he has been engaged in a project devoted to the planet we life on and the difficult equilibrium needed for its sustenance: *Genesis*.

David Seymour

_ David Szymin was born in Warsaw in 1911. He studied at the Academy of Graphics in Leipzig and, from 1931 to 1933, at the Sorbonne in Paris intending to become an editor. Thanks to a friend of his family he had his first contacts with photography. He adopted the name "Chim", an abbreviation of his surname, and began to work as a freelance photographer. From 1934 his photographs began to appear regularly on *Paris Soir* and *Regards*. It was during this period that he met Robert Capa and Henri Cartier-Bresson. Between 1936 and 1938 he was in Spain photographing life behind the lines during the Civil War. With the outbreak of the Second World War he moved to New York, where he changed his surname to Seymour. In 1942 he joined the American Intelligence Corps as an interpreter – he spoke six languages – and photography expert. In 1947, alongside Cartier-Bresson, Capa and Rodger, he founded the Magnum Photos agency, and became vice-president and later president after the death of Capa. He continued to shoot important reportages, such as the one on the State

of Israel. During the Suez crisis he was hit by a volley of Egyptian gunshot and died at the age of 45 on 10 November 1956.

W. Eugene Smith

_ William Eugene Smith was born in 1918, in Wichita, Kansas. He soon developed a passion for photography collaborating with a number if dailies during his high school years. In 1937 moved to New York where he began working for *Newsweek*, and two years later for *Life*. His relationship with this magazine was marked by continuous breaks and returns, seeking that artistic freedom which would allow him to be coherent with his own idea of photojournalism. From 1942 Smith was on the islands of the Pacific, first as a Ziff-Davis war correspondent, and from 1945 again for *Life*. In 1945, at Okinawa, he was seriously wounded by a grenade. From 1947 to 1954 he produced a series of "photographic essays" for Life, which contributed to revolutionising photojournalism, including *Country Doctor, Spanish Village, Nurse Midwife, Man of Mercy*. In 1956 he began to work on a project about the city of Pittsburgh. In 1972 he moved to Japan and shot a reportage on the Minamata disaster. He was victim of a physical attack because of his unwelcome documentation activity and in 1975 he returned to the USA and was awarded the Robert Capa Gold Medal for his "photography which required exceptional courage and spirit of initiative". In 1977 he was offered a chair at Arizona University where he taught until 1978 when he died, aged 60.

Tom Stoddart

_ Tom Stoddart was born in Morputh, north east England in 1953. In 1978 he moved to London and began working regularly for national magazines and newspapers. During the eighties he worked for the *Sunday Times*. In 1987 he returned to Beirut, where he had been five years earlier, to photograph daily life inside the Palestinian camp Borj el Barajneh. In July 1991 he was in Sarajevo covering the civil war. A year later he was there again working for the *Sunday Times Magazine* and was seriously wounded during fighting outside the Bosnian Parliament. After a year of convalescence he left for Mississippi for a reportage on the floods. In December 1993 he returned to Sarajevo. In 1997 he had an exclusive on coverage of Tony Blair's electoral campaign. For a long time he has been working on the Aids pandemic in sub-Saharan Africa. This work has had ample resonance through publications and exhibitions. The founder of the Independent Photographers Group (IPG), Tom Stoddart has won numerous prizes, including the World Press Photo in 1995 and the Care International Award for Humanitarian Reportage in 1997. Among the books he has published are *Sarajevo* (1995), and *iWitness* (2004).

Printed in Italy